Diving to the Pharaohs

Text by Jürgen Bischoff
Photographs by Christoph Gerigk

Diving to the Pharaohs

Franck Goddio's
Discoveries in Egypt

Steidl

Contents

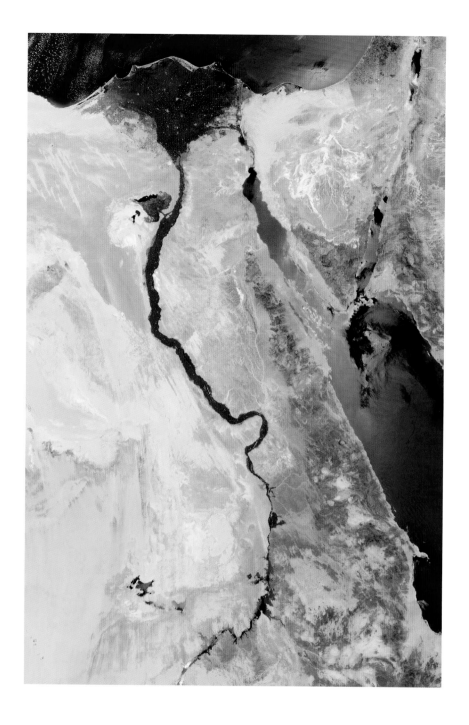

For thousands of years, the Nile with the wide fan of
its ever-changing delta has brought life to the people
of Egypt. Today, Alexandria – where Franck Goddio's
bold underwater foray in search of witnesses to that
ancient civilisation began – lies west of the delta.

Instead of a Foreword
A Visit to Liechtenstein

The images went around the world in the spring of 2001. Laid out on a barge moored at the quayside in the Egyptian port of Aboukir, some 25 kilometres north-east of Alexandria, are three colossal statues of rose-coloured granite – a pharaoh, a queen and Hapi, the god of the Nile flood. For more than 2,000 years, these statues lay broken beneath the sediment at the bottom of the sea. Now they had surfaced once more.

Their discovery was a sensation, proving as it did that the legendary city of Heracleion, hitherto known only from piecemeal descriptions found in ancient writings, had once really existed. However, the discovery of the three colossi was more than that; it was the highly visible result of an exceptionally successful partnership – that between the French underwater archaeologist Franck Goddio, the Egyptian Supreme Council of Antiquities and the Hilti Foundation in Liechtenstein, a charitable organisation founded in 1996 by the Martin Hilti Family Trust and today jointly administered by the trust and the Hilti Group.

Schaan in Upper Liechtenstein, on the western edge of the Rätikon Alps. Inside a bright and airy office building, two sphinxes keep watch. In ancient Egypt, these creatures of fable, with their lions' bodies and kings' or gods' heads, stood guard in front of many sacred sites. The originals of these two replicas also guarded a temple of Isis – on Antirhodos, the royal island in the Great Harbour of Alexandria. Here at the headquarters of the Hilti Foundation in the Principality of Liechtenstein, however, they stand as symbols of that partnership, which at the time of this book's publication will have endured 20 years.

"In all these years," says Michael Hilti, "we have seen things we would never have dreamt of before." Hilti, born in 1946 and former Chief Executive Officer of the Board of the family business, is today one of that board's five directors and also one of the five members of the Hilti Foundation Board. Talking about the archaeological work Goddio performs with the foundation's patronage in the sunken cities of Alexandria, Canopus and Thonis-Heracleion, Hilti reveals his evident passion for and fascination with the project.

It was "pure coincidence," Hilti remembers, that he ever met Goddio at all. That was in 1994, when a group of American businesspeople – a publisher, two industrialists and a famous architect among them – had invited him to lunch in Tulsa, Oklahoma, where Hilti USA had its headquarters at the time. Among the guests were Georg Rosenbauer, Director and Chief Executive Officer of Hilti's American subsidiary, and Michael Hilti, who was then staying in North America. The day promised to be an interesting one because the group from Oklahoma had for years been funding the Institute of Nautical Archaeology (INA), which is affiliated to the renowned Texas A&M University in College Station.

In those days underwater archaeology was still a rarely pursued sub-discipline of archaeology and tainted with a reputation for risk and adventure, and occasionally even treasure hunting. The INA, under its legendary founder the American archaeologist George Fletcher Bass, however, was almost the only institution to pursue this branch of archaeology with scientific accuracy.

Also present at the lunch was a young Frenchman, one Franck Goddio, in his mid-thirties at most, who years before had thrown in his job as a consultant to the French government and devoted his energies entirely to underwater archaeology ever since. He had founded his own institute in Paris, the European Institute for Underwater Archaeology (IEASM), and already had some astonishing discoveries to show for his efforts. That was how the people in faraway Tulsa had come to hear of him.

The circle of sponsors had invited Goddio to the lunch to give a talk on his projects and also to make his acquaintance. "We were all very curious to hear what he had to say," says Hilti. By the end of the day, an agreement had been reached. With his natural charm and some enthralling accounts of his work, Goddio won the sponsors' financial support for a new and important project, the excavation of the Spanish galleon San Andres. Goddio had already located the wreck of the San Diego, a galleon that sank off the Philippines on December 14, 1600. The treasures he was able to salvage from the site of the wreck are now on display at the National Museum of the Philippines and the Naval Museum in Madrid. They brought Goddio international fame overnight.

But the man from Paris had bigger plans. His real objective was Alexandria, the sunken city of Alexander the Great, which was for centuries the brain and heart of the ancient world, and the capital of the Ptolemaic dynasty and of the last pharaoh, Cleopatra VII. Again Goddio appealed to the circle of sponsors in Oklahoma,

but this time the Americans turned him down – the project appearing all too bold, all too speculative. Hilti, however, showed interest.

"I asked him what he saw as the most important project for him, as an underwater archaeologist," Hilti recalls, "and without having to consider for long, he replied: 'Alexandria'." Goddio described how years before, with the permission of the Egyptian Supreme Council of Antiquities, he had conducted electronic surveys in the bay of the present-day port and found indications of architectural structures lying buried beneath the sediment. As yet, though, nothing had been proved, nothing brought to light. Goddio asked Hilti to provide the necessary funding for a five-week mission to verify his suspicions – and was given the green light.

But why Egypt of all places? A region where people have been researching, making discoveries and excavating for over 200 years? "We did not go looking for Egypt," Hilti replies, "Egypt came to us with Franck Goddio." Life, also the life of an entrepreneur, is "like a house with many windows," Hilti explains. "You can open one and always look out on the world only through that one window." Alternatively, you can take the opportunity to look out of the other windows, too. That may mean facing new challenges, "but you also get to see new things, and gain new insights and perspectives." That is how the partnership with Goddio also "opened up dimensions for me personally that I would never have dreamt of before."

And so Goddio set off with his team for Alexandria in the spring of 1996. Meanwhile, in Liechtenstein, Hilti was of course eagerly awaiting news from the excavation vessel. "The first three weeks we heard nothing at all and in the fourth just a few vague details. We were gradually beginning to feel uneasy." But then, in the fifth week, came the long-awaited telephone call: "We found it!" Goddio had located Antirhodos, the legendary island on which Cleopatra is thought to have resided. On the submerged islet, Goddio's team had discovered the head of a marble statue – the first artifact from the ancient Egyptian palace complex to see the light of day once more after well over 1,000 years spent below the waves. The underwater explorations gave an inkling of all that was waiting down below to be brought up.

That was roughly the point at which Hilti and Rosenbauer became fully aware of the relevance, the dimension this project had already attained. "We had completely underestimated it at first," Hilti admits, looking back. "We couldn't simply opt out again at the end of the five weeks, not after these finds had been made,"

Rosenbauer agrees, especially since public funding of the scale necessary to sustain such a project was simply not available.

Given the historic significance of the project, the public's foreseeable perception of it, and also in the light of the anticipated long-term financial commitment it would require, that same year the Martin Hilti Family Trust established the charitable Hilti Foundation. At first, Goddio's dives into the history of the pharaonic kingdom were the only project the foundation sponsored. But that was to change.

"When we saw, on our visits to Egypt, the conditions in which many families there had to live, we asked ourselves whether we couldn't also help to change that state of affairs," says Hilti. And so their journey into the past took the benefactors straight into the here and now. This led to the foundation developing programmes for visually impaired people and aiding slum dwellers by building permanent homes for them using locally available materials. The Affordable Housing Project is one of the foundation's main areas of activity and is now being continued in the Philippines, Colombia, Haiti and India.

Little by little, new projects have come along, including one that fosters the musical talents of children and young people in the slums of Venezuela and Peru, a collaboration with the Israeli organisation Physicians for Human Rights-Israel in Palestine, and another with Médecins Sans Frontières / Doctors Without Borders in Syria, plus educational initiatives in Kenya and solar energy projects in Ethiopia. "We want the projects the foundation supports to produce measurable results, to affect change and to be sustainable. That is very important to us," says Hilti.

In other words, the projects backed by the foundation should produce such rich results and be as sustainable as the work of Franck Goddio. That is why the foundation was soon looking out for a university partner with the extensive expertise required to provide scientific descriptions and analyses of the ever-increasing number of artifacts retrieved from the Egyptian Mediterranean. It found that partner in Great Britain, at Oxford University, where the Centre for Maritime Archaeology, funded by the Hilti Foundation, set to work in 2003. Today, researchers and students of the venerable university are regular guests aboard Goddio's research ship and members of the scientific team.

Equally important results of the unique partnership between the foundation and science have been the countless films and reports produced on the subject of Goddio's research and, above all, two major international exhibition cycles featuring the sunken

treasures of the Egyptian kingdom, which to date have delighted millions of people all over the world.

This last objective is key to the Hilti Foundation's sponsorship, because the sustainability of this partnership can only be ensured if the cultural values and historical connections are made public. "That's why making the findings of the excavations accessible to the general public was part of our plan from the outset," Hilti explains. "We don't want to bring the history of Egypt to light only to let it gather dust in an archive." That is why the public relations agency salaction has been handling these projects since 1996. Hilti's dream? For a museum to stage a permanent exhibition of the research findings.

Over the past 20 years, Goddio and his team have enriched our knowledge of the Egyptian kingdom – a kingdom that is also one of the central points of reference for European culture – with hitherto wholly unknown facts and facets of its culture. In at times hazardous conditions and with the aid of state-of-the-art technologies, the divers and scientists on board the research ship, which is effectively a floating excavation house, discovered the Portus Magnus (the Great Harbour or Eastern Harbour) and the palace island of Alexandria as well as the sunken cities of Canopus and Thonis-Heracleion in Aboukir Bay. They uncovered the ruins of extensive temple complexes and the remains of ships that sank over 2,000 years ago. They disproved ancient historical writings and revised modern ones. And last but not least, they recovered cultural treasures of immeasurable value.

It is an adventure with as yet no foreseeable ending – an adventure such as only true science and passionate research can recount.

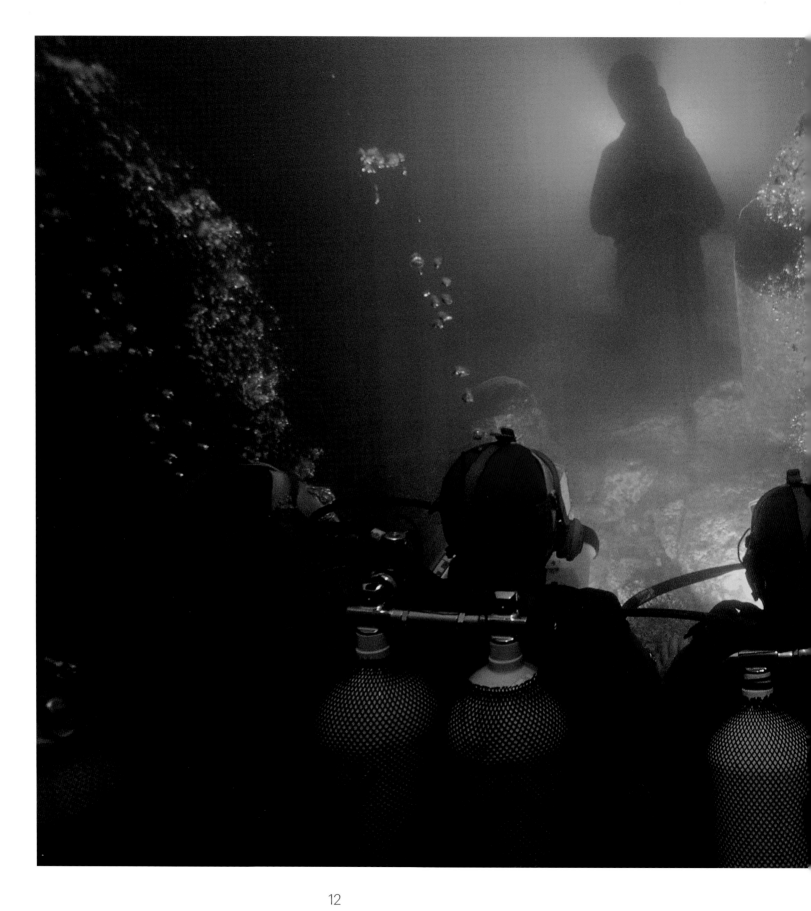

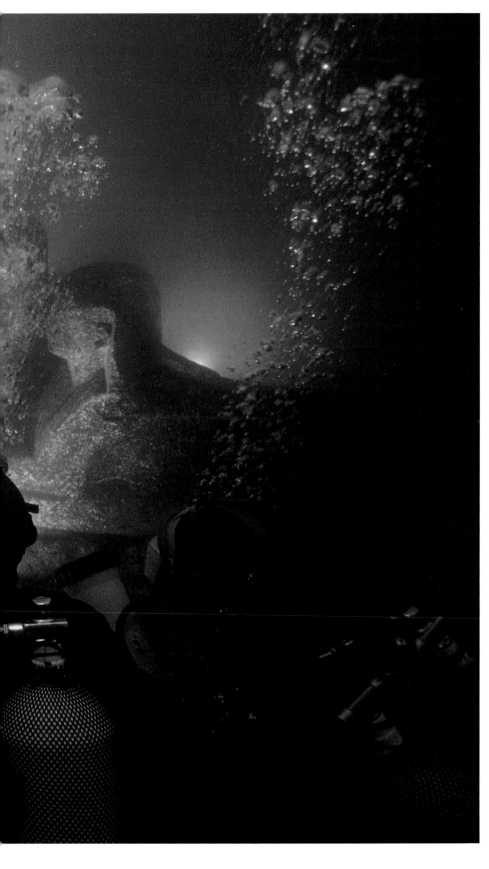

Resurrection of a world long past. In October 1997, archaeological divers discovered the statue of a priest of the goddess Isis on the submerged island of Antirhodos in the ancient harbour of Alexandria, and re-erected it as it would once have stood. "When the image blurred in the water, I felt as though I had seen a ghost," Goddio later wrote.

The priest, carrying the figure of the god Osiris in his arms, appears to be striding across the ancient paving stones towards the two sphinxes. The features of the sphinx on the left resemble those of Pharaoh Ptolemy XII, the father of Cleopatra, who was Caesar's and later Mark Antony's mistress.

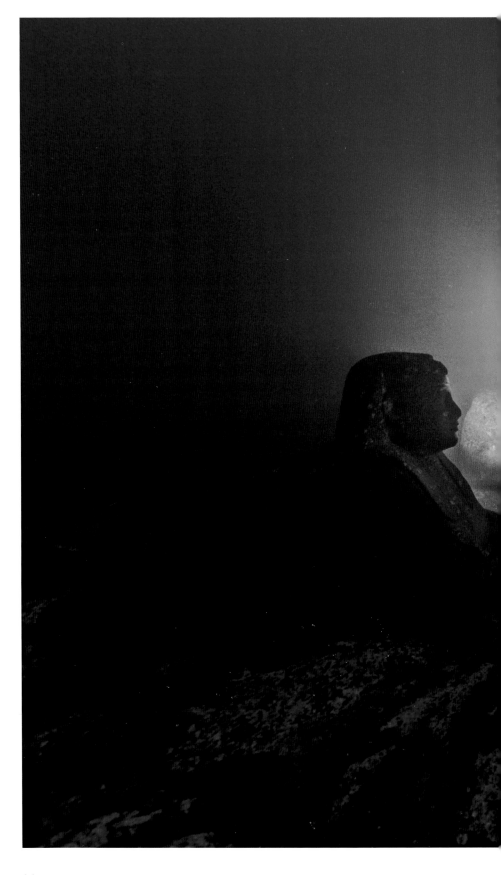

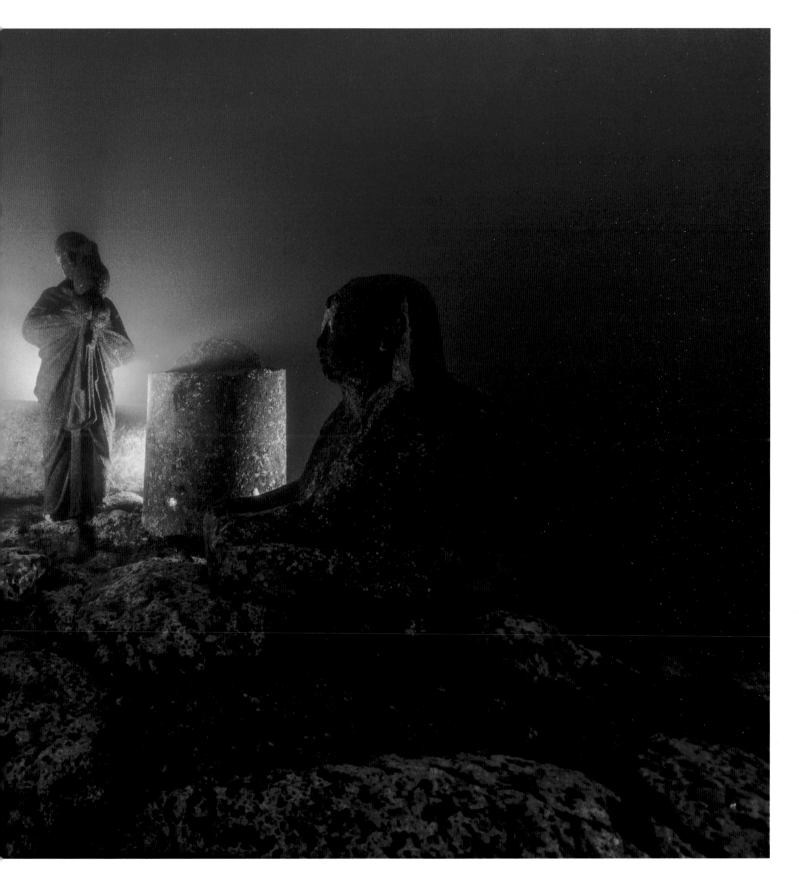

Since a stonemason first chiselled him from black granite and polished him till he gleamed, this priest of Isis spent nigh on 2,000 years in his watery grave. Despite the inroads made by the salt water, his features are clearly recognisable.

Goddio's team found this huge weathered sphinx on the palace island of Anti-rhodos in 1997 and decided it should not be moved. It is still in situ today.

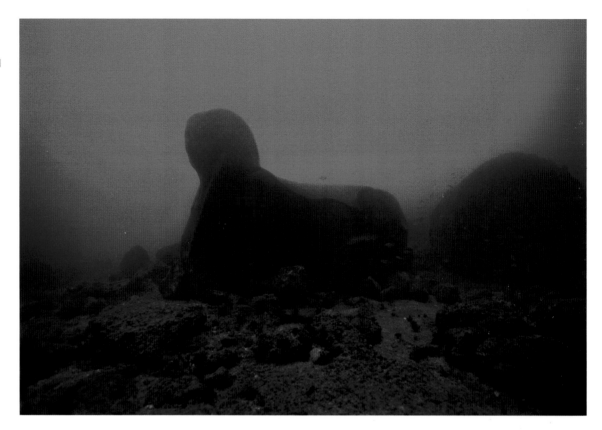

A stone bearing hieroglyphs in the Portus Magnus of ancient Alexandria poses a puzzle. The slanting beams of torchlight reveal that the inscription must have been made around 580 BCE – over 200 years before the city was founded.

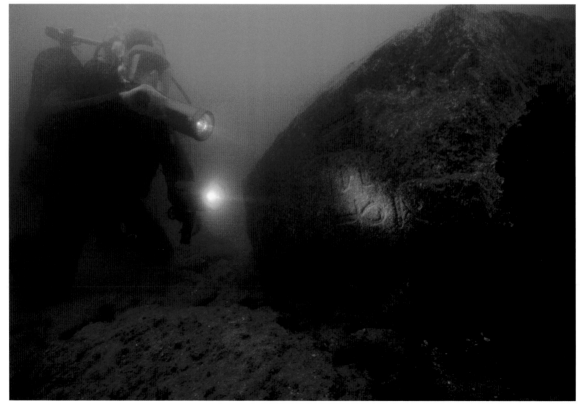

A prince's countenance. On the shore of ancient times, opposite the palace island of Antirhodos, the divers find a granite image of Caesarion, the son of Cleopatra and Julius Caesar, who was born in 47 BCE. He only lived to the age of 17, when he was murdered by order of the Roman Emperor Octavian.

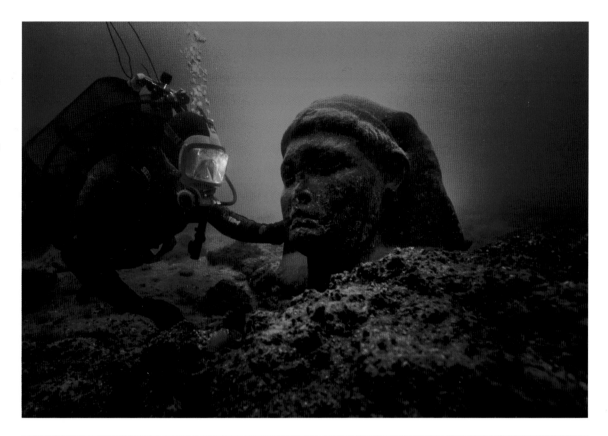

Large blocks of limestone formed the foundations of a small palace building on the island of Antirhodos, which is presumed to have been used by Cleopatra.

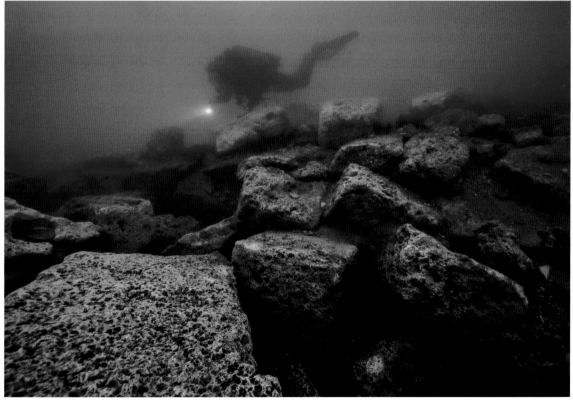

This white limestone ibis is missing its head. Goddio's team found it in the ancient harbour of Alexandria. The sacred bird dedicated to the god Thot is thought likely to have been part of a sanctuary.

Eye to eye with a deity. A diver holds the head of the god Serapis, to whom great temples were dedicated in Canopus and Alexandria. Serapis, who was the established "God of the Empire" under the Ptolemies, embodied the combined characteristics of a number of Egyptian and Greek deities.

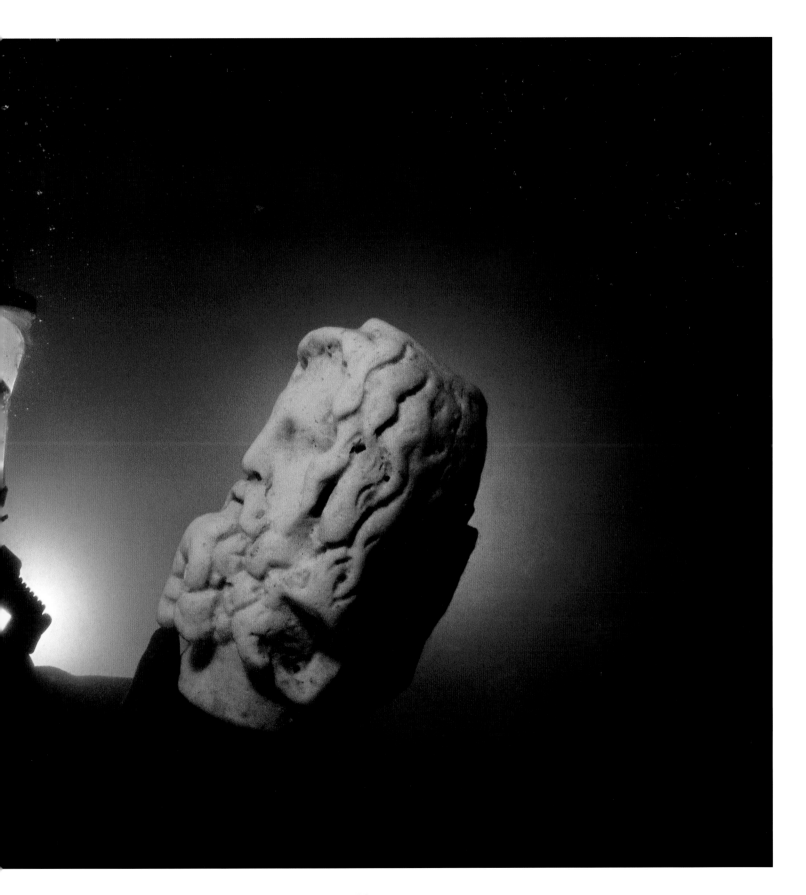

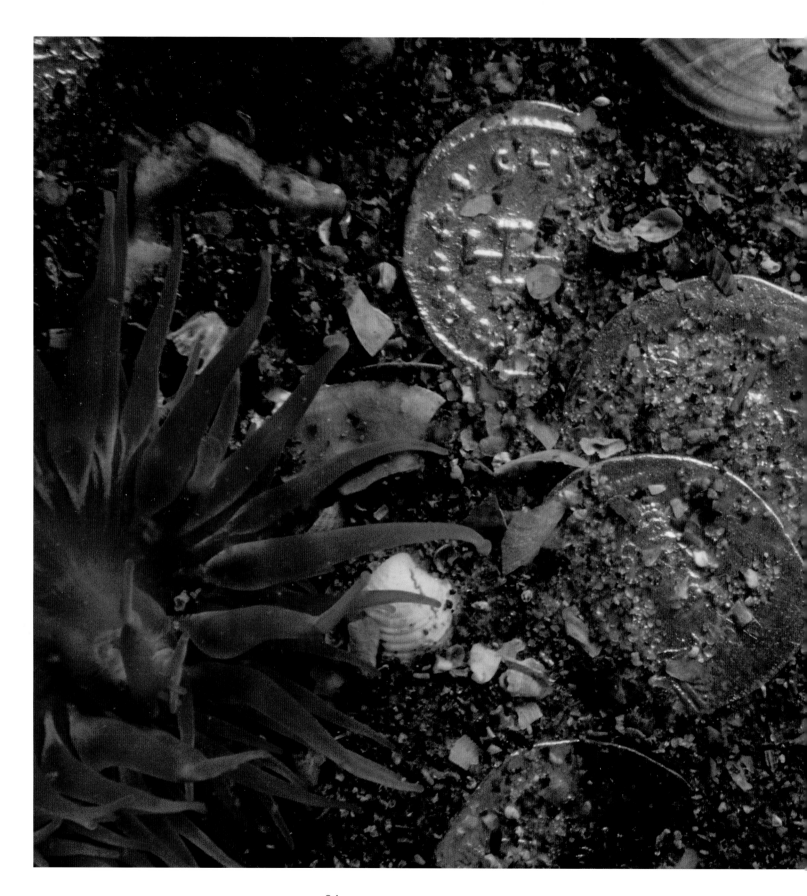

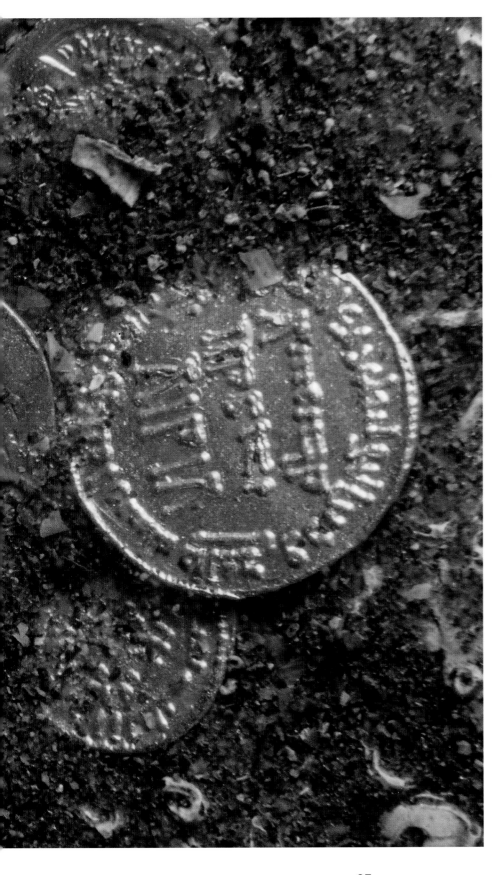

Treasures in the sand. Traces of almost every epoch can be found in the submerged cities. These gold coins date from the Byzantine and early Arab and Ottoman periods.

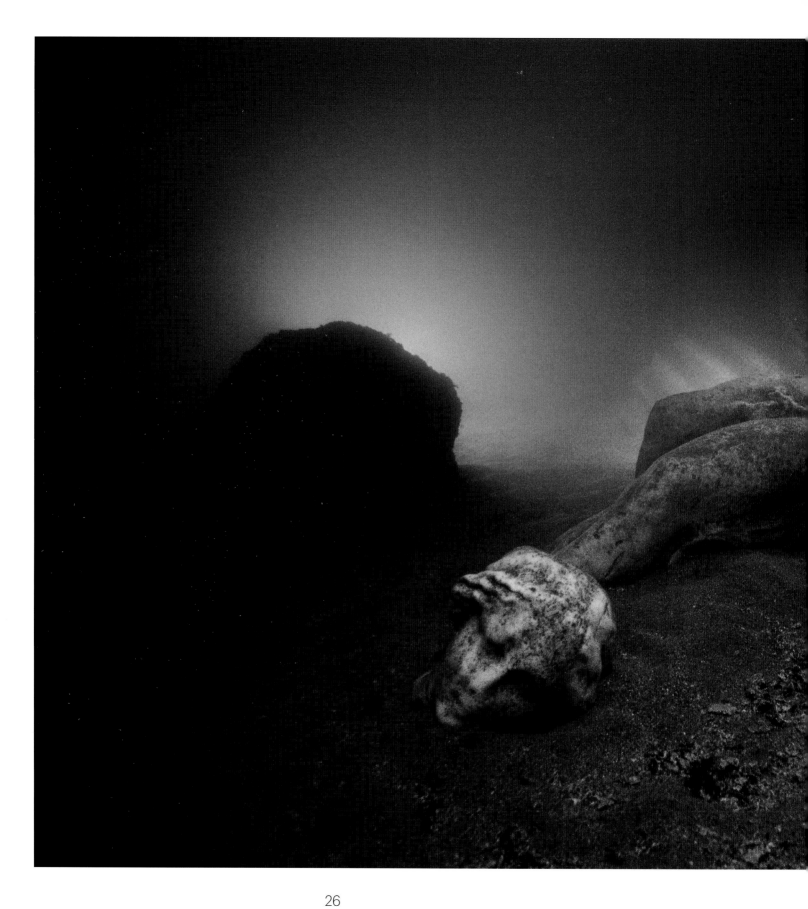

An allegory of destruction: in the foreground, a stone head, that of Antonia Minor, Mark Antony's youngest daughter, and behind her, in the light of the divers' torches, a torso of the god Hermes, who occupied an exceptional place in the pantheon of the Ptolemaic pharaohs

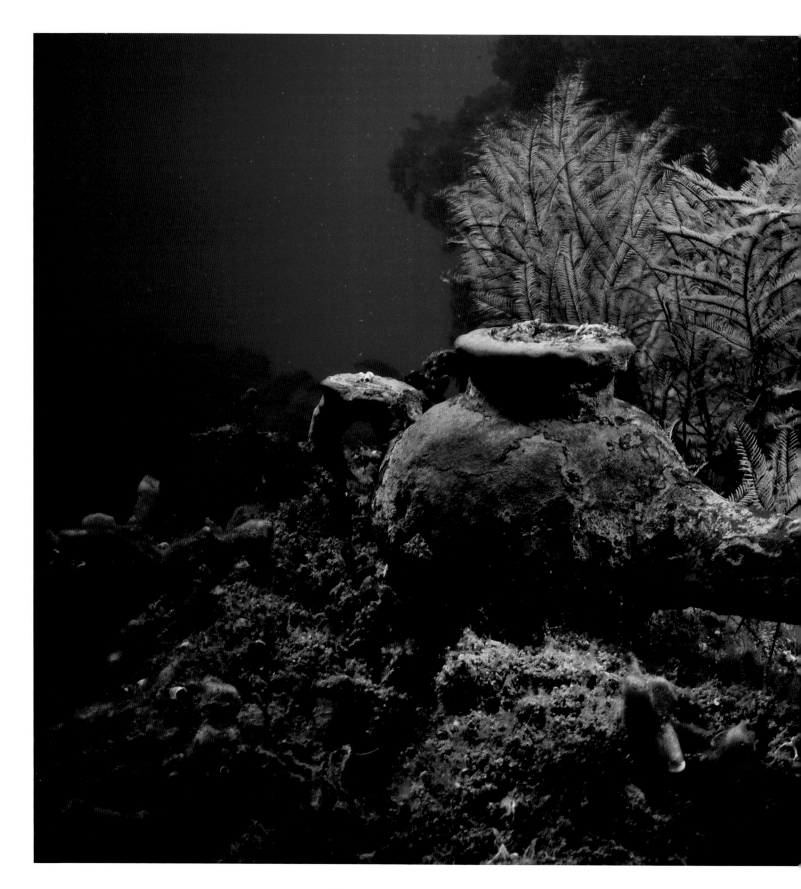

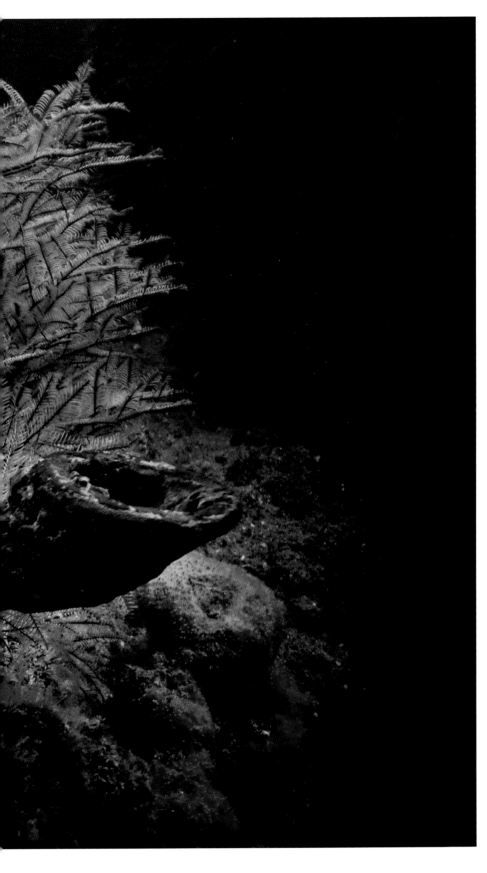

This oil lamp was cast in bronze 2,200 years ago. Tarnished after its long sojourn beneath the waves, it now shimmers in many colours. Goddio's divers found it close to the Temple of Amun in Heracleion.

The colossal statue of a
pharaoh, originally five
metres tall, lies shattered
on the sediment. It stood
on the square in front of
the monumental Temple of
Amun-Gereb in Heracleion,
probably around 200 BCE.

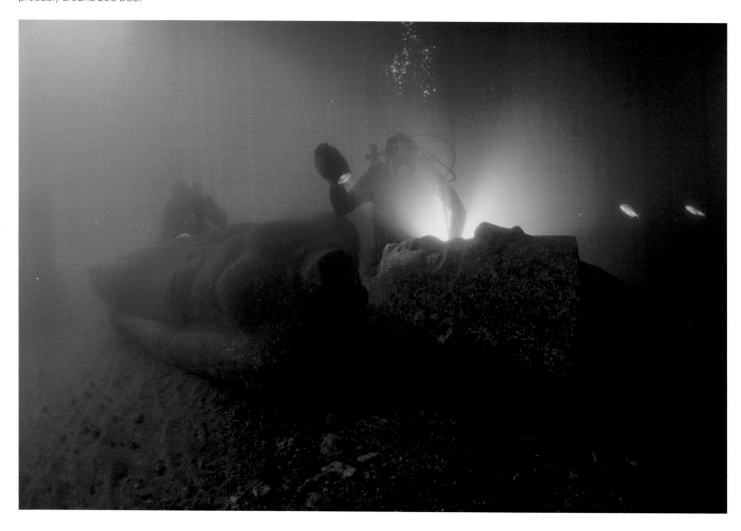

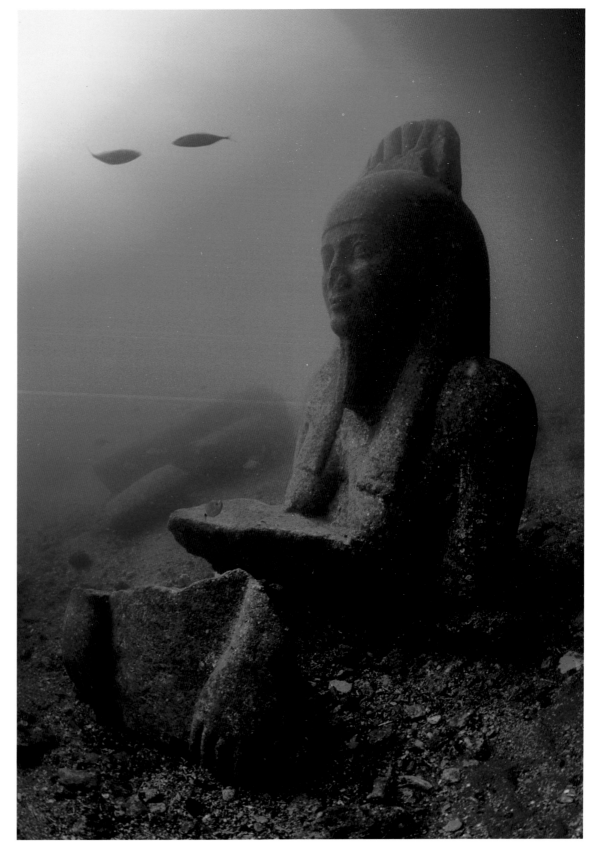

Head and chest of Hapi, god of the Nile flood, and in the foreground, a fragment of the sacrificial tablet he carries on his hands. Reassembled, the red granite figure measures 5.40 metres. It too once stood on the temple platform in Heracleion, next to the statue of the pharaoh.

As a sandstorm approaches, water lilies the Nile has washed into the sea drift through the Bay of Aboukir. In the background, the Princess Duda, the mother ship for Franck Goddio's team of scientists.

32

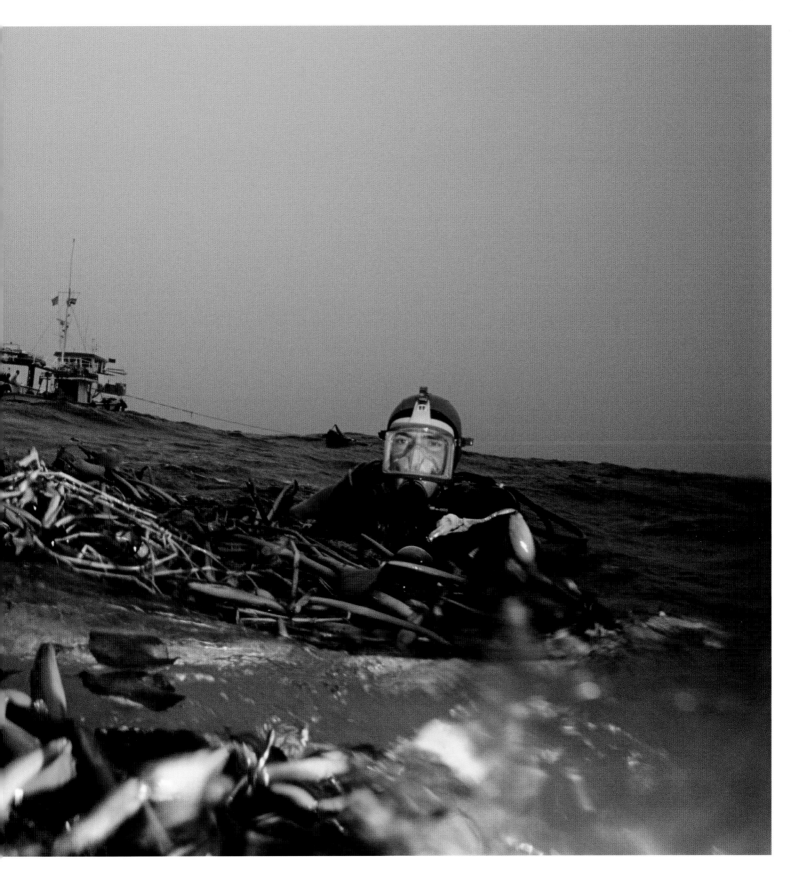

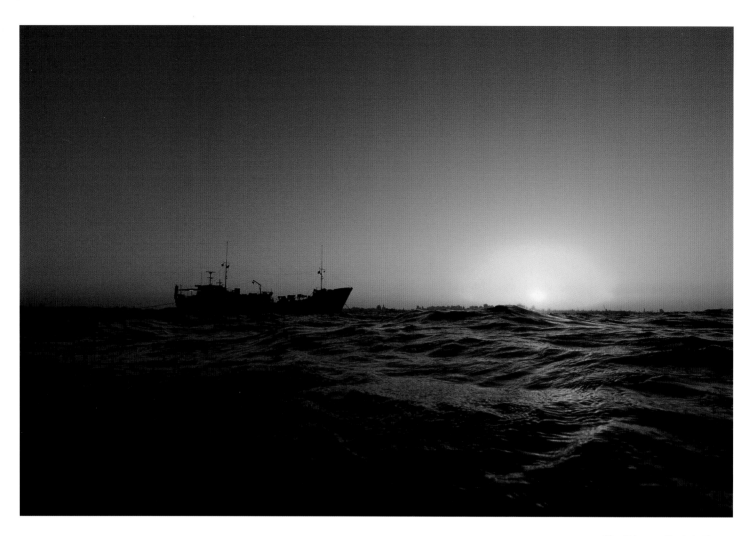

The Princess Duda in the
Bay of Aboukir at sunrise.
The city skyline is just
visible on the horizon.

The Adventure of Underwater Archaeology
The Floating Excavation House

~~~~~~~~~~~~~~~~~~~~

Blue fishing boats and rusty barges bob gently on the waters of Aboukir Bay. It's still morning, but already the heat has draped itself like an oppressive shroud over the city. Dust clouds rise from the track leading up to the quay wall and settle in a grey layer on the roofs of the huts, where the fishermen and their families live. The RIB (Rigid Inflatable Boat), a Zodiac belonging to the small fleet of the research vessel Princess Duda, is waiting by the quayside.

A soldier peels himself out of the shade of the guard house and checks the names of the passengers – the harbour is a security area, so anyone boarding a vessel here must register in advance. Catherine Grataloup, an expert on ancient ceramics, climbs on board followed by Philippe Rousseau, an archaeological diver, archaeologist Damian Robinson, a scholar of ancient trading routes and ships, and two graduate student archaeologists from the Centre for Maritime Archaeology at Oxford University. Their destination, the Princess Duda, is at anchor roughly six kilometres from the coast – directly above the city of Thonis-Heracleion, the ancient international port of the pharaohs, which sank beneath the Mediterranean waves almost 1,300 years ago.

The RIB gathers speed. Children are playing in the murky waters at the mouth of the harbour, while further out, fishermen have cast their round nets, and now and again tiny fish leap from the water, probably to escape predators.

After a good quarter of an hour, the little boat has reached its destination. The bright blue-and-white research boat is moored in calm waters. Up close, her old name is still discernible beneath the white paint on her stern: Kirsten, home port Hamburg. In October 1962, the present-day research ship was launched as a cargo vessel in the town of Oldenburg, North Germany. It was later taken over by a ship owner from Valletta, who renamed her after his daughter. She has sailed under the Maltese flag ever since.

The RIB ties up on the mother ship's port side, right beside the steel accommodation ladder. Waiting at the railing above is Franck Goddio, a man of lean, athletic build with laugh lines

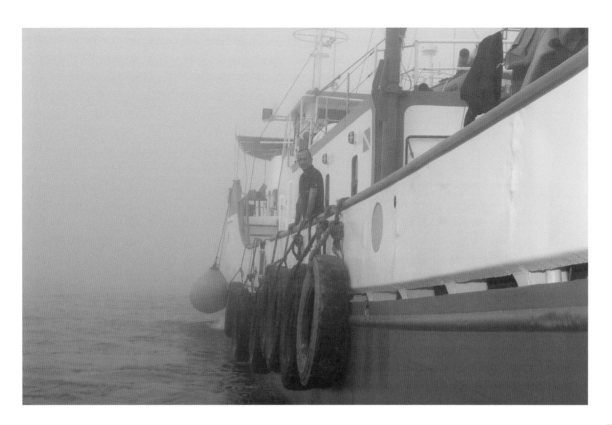

Franck Goddio in the early morning mist at the railing of his research ship; below, peering through an 18th-century spyglass that once belonged to an officer of the Napoleonic fleet destroyed by the English in the Bay of Aboukir.

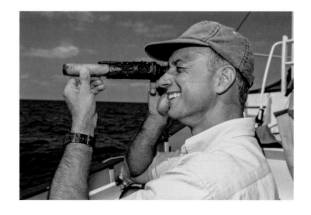

around his eyes, sporting a faded polo shirt, shorts and a light-blue cap. He's a disarmingly friendly, open guy whose every sentence betrays his boundless enthusiasm for what he has made his life's purpose – archaeology.

Today, Goddio is arguably the most famous, but quite definitely the most successful underwater archaeologist in the world; a man who has revolutionised the search for relics from the past in the depths of the ocean. Goddio has adapted technical devices, such as magnetometers, side-scan sonars and multi-beam echo sounders originally designed to locate raw materials among other things, for use in his marine surveys, and also further developed them to meet his purposes. With the aid of this technology, he and his team first located the Royal Port of the ancient city of Alexandria, with the palace island of Antirhodos then the city of Canopus, and finally Heracleion – three cities thousands of years old, which had previously been considered either lost to the waves forever or merely legends created by ancient historians. A German magazine even nicknamed Goddio "master of treasures".

Franck Goddio was born in Casablanca in 1947. He was five years old when his mother moved back to her native France, to the outskirts of Paris, taking him and his sister with her. It was at school that he discovered his interest in history and archaeology. Now and again, he would spend his holidays at real archaeological sites, where the children were allowed to dig in the sand with trowels in search of treasure. His early enthusiasm became a passion that has never left him – even though his life would first take a different course.

Not only did the young Goddio display a flair for history, he also had an obvious talent for figures, which is why, on leaving grammar school, he enrolled as a maths student at the prestigious École Nationale de la Statistique et de l'Administration Économique in Paris. In 1972, aged 25, he took up his first post, as a government adviser for the United Nations in Indochina. From an office in Vientiane, the capital of Laos, he instructed the administrations in Laos, Vietnam and Cambodia on the practical use of statistical methods – right in the middle of the Vietnam War. He stayed until the end of 1975 and was one of the last western government advisors in Laos at the end of the war. He went on to work as a financial advisor for the French Foreign Ministry in Saudi Arabia, where he helped establish the Saudi Fund for Development. He spent six years making the rounds of the international financial markets, constantly on the move between Riyadh, Paris, Frankfurt and Washington.

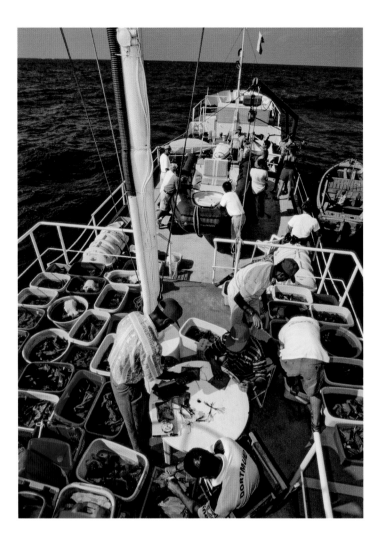

The archaeological finds from the ancient sites are immersed in fresh water to extract the salt they have absorbed. In the background, a camera team.

### New Technology for Maritime Archaeology

It used frequently to be the case that maritime archaeological discoveries were made in the wake of chance finds. For example, a fisherman might discover an amphora in his net, a diver unexpectedly find himself confronted with a shipwreck, or a pilot make out unusual rock structures beneath clear waters. Goddio, by contrast, searches systematically – and was the first to do so with the aid of cutting-edge technology. Here are the most important devices:

### Nuclear Magnetic Resonance Magnetometer

This instrument was developed by the state organisation French Atomic Energy Commission, CEA, (today's Alternative Energies and Atomic Energy Commission). Underwater, the magnetometer is drawn across the survey area as close to the seabed as possible. As it moves, it performs a high-precision measurement of the strength of the earth's magnetic field at a constant 5,000 times per

Then the job was done and Franck Goddio, in his mid-thirties, was already a highly successful man. There was no more for him to achieve in that field, nor did he wish to. He turned down an attractive offer from the World Bank and looked instead for a new and meaningful challenge – and discovered his old love anew: archaeology. Now, perhaps, was his chance to devote himself entirely to it. Reflecting on this, Goddio noticed a gap in research that surprised him: that hardly a university in the world, and practically no private institute, was searching systematically and scientifically for underwater antiquities. How could that be? And what would it take to fill that gap?

Goddio had learned to dive, but that, as he later said, was not his motivation. Nor was it a desire for adventure. It was another idea, one that seemed attractive enough to him to warrant more thorough investigation. Because the seabed was where testimonies to the history of human civilisation were said to be awaiting discovery in virtually the same condition as when they disappeared long ago – preserved by the sea, or at least undisturbed by plundering treasure hunters and subsequent construction work. Goddio then set about systematically exploring the blank spot. He spent one and a half years travelling the world, talking to scientists, divers and universities – and at once learned the reason for archaeology's neglect of the seabed: a scientist working on dry land can usually decide literally according to the lay of the land where an excavation would seem to make sense and where not. At sea, that is impossible. That is why, at that time, the search

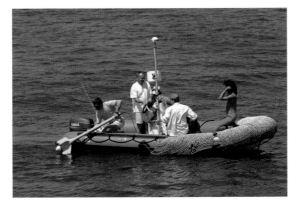

second. Since compacted structures, such as blocks of stone and wrecks, cause local anomalies in the magnetic field even when they are covered in sediment, they can be easily located with an NMR magnetometer.

### Side-Scan Sonar

The side-scan sonar provides a digital image of the seabed to the right and left of the ship up to a distance of between 50 and 150 metres. At the same time, it identifies objects that are lying on top of the sediment, but not beneath it. Like all sonars, it does this by generating sound waves, registering their echo and calculating the distance to the object by the echo delay time. Although the instrument scans a large area, it produces no precise images, so that it is not possible, for instance, to distinguish between rocks and anthropogenic structures.

for traces of the past in maritime archaeology mostly remained fruitless. And the universities simply did not have the funds to conduct random research.

Goddio drew three conclusions from this. Firstly, the element of chance in underwater archaeological research needed to be reduced to a minimum. Secondly, that that could only be achieved with meticulous preparation and the scientific use of technology. Thirdly, the necessary funding should not come solely from public coffers.

One of Goddio's trips took him to Egypt, where he met deep-sea research scientist Jacques Dumas. That was in 1984, when Dumas, heading a team of Egyptian and French scientists, had just discovered the remains of the L'Orient, the flagship of Napoleon's fleet, which was sunk in Aboukir Bay on 1 August, 1798 during a surprise British attack. Goddio accompanied Dumas on a number of dives and what he saw immediately made it clear to him that the shallow coastal waters to the west of the Nile Delta held some very different secrets, not just historical shipwrecks. Perhaps, he mused, he could make a contribution to the search for answers to some of the big open questions of Egyptian history? Where, for instance, did the legendary Canopus really lie? Where was Heracleion, the large seaport dating from the time prior to Alexander the Great's arrival? And did the mysterious Thonis ever exist?

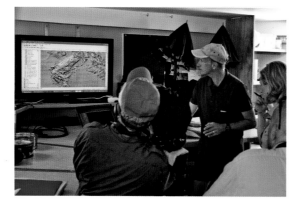

**Multi-Beam Echo Sounder**

The multi-beam echo sounder also works with acoustic waves and measures the delay time of their reflection. Here the signals are fanned out beneath the ship and deliver an accurate profile of the ground. The data gathered is then digitally processed to put together a 3D map of the seabed. This is how ancient harbours, ruined buildings and former dykes came to light in Alexandria.

**Sub-Bottom Profiler (Parametric Sediment Echo Sounder)**

This instrument is capable of identifying structures hidden deep in the sediment on the seabed. To do this, it uses sound waves with frequencies that can penetrate far into the ground. In the sub-bottom profiler, the signals have different frequencies: low-frequency waves penetrate further into the ground but produce less accurate images;

Sometimes a single thought can decide the course a life will take. Goddio decided to embark on a quest, the quest for history and the stories of generations long past – and that quest would take him to the bottom of the sea.

What he experienced in his first weeks in Egypt also brought Goddio a fourth realisation: that serious archaeological research underwater absolutely depends on close cooperation with state authorities and institutions. This also means that the state on whose sovereign territory researchers retrieve artifacts from the seabed is entitled to those finds. And that is precisely the premise that separates treasure hunters from archaeologists.

Three years later, Goddio founded the European Institute for Underwater Archaeology (IEASM) in Paris – to serve as the future centre and backbone of his activities.

Towards noon, the Princess Duda fills up as, one by one, the divers climb up the accommodation ladder and onto the ship. Some 50 men and women generally make up the excavation team, the ship's crew included. For six or seven weeks at a stretch, they have to get along with each other, most of them sharing two-bed cabins. Not everyone is suited to such living conditions. At present, there are 35 people from eight nations on board as well as a few on land taking care of logistics, plus a few more running practical tests on new survey technology in Alexandria harbour. Most of the Egyptians on the team go home to their families each evening.

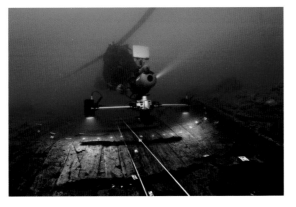

high-frequency waves do not penetrate as deeply, but provide a better image.

### Panoramic and 3D Photography

For panoramic photos of ancient shipwrecks, for example, hundreds of digital photos are taken underwater according to a set grid. Later, the computer pieces the digital images together to form a complete picture. A 3D picture is sometimes generated from many thousands of photos of one object, taken from different angles. Afterwards, special software is used to calculate from that information a 3D image that can be turned and observed from all sides. Used in conjunction with GPS data, this also creates a precise, photographic map.

Where the sediment-laden Nile flows into the Bay of Aboukir, it colours the upper layers of water a greenish-brown and robs the divers of the last vestiges of visibility.

Underwater border crossing. Above the large school of fish, the light clearly marks where the waters of the sea and the Nile converge.

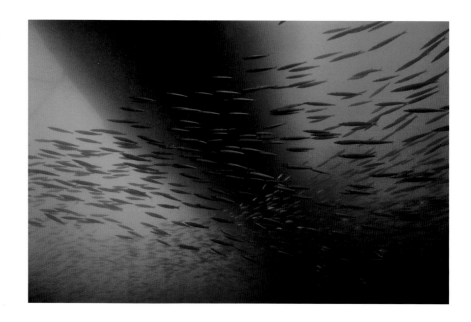

Small boats with the Hilti logo on their side are moored some distance away from the research ship, marking the spots where the divers are at work: one recently discovered temple in a state of collapse, an ancient shipwreck, a pile of large blocks of masonry that may one have been a pier or a quay wall. Below the Princess Duda herself lies Goddio's most significant site to date in ancient Egyptian Heracleion, the remains of the monumental temple erected to Amun-Gereb, the supreme god of the ancient Egyptian pantheon, and also those of a temple to his son Khonsu, whom the Greeks also honoured – as Herakles.

Dripping heavily, Jean-Claude Roubaud climbs the ladder, like Neptune emerging from his realm, a short man in his late fifties with a round head and laughing eyes. He has been diving since he was five, he later reveals. Peeling himself out of his neoprene suit, Roubaud, head archaeological diver on Goddio's team, complains of poor visibility that day. The sea off the coast of Aboukir and Alexandria not only has to cope with the two cities' filth but also with pollution from the oil industry and the oil-fired power stations whose smoking chimneys rise into the sky along the coast. The Nile also sheds its load along this stretch of coast: yellow mud, heavy metals and organic material that it has collected along the more than 1,000 kilometres of its course from the Aswan dam in Upper Egypt to the delta north of Cairo. From the bow of the Princess Duda, the yellow freshwater river carrying along the floating remnants of water lilies is clearly distinguishable from the grey-blue waters of the Mediterranean Sea. Normally, visibility in these waters is between one metre and a half, says Roubaud, who has been working with Goddio since 1992, and it's quite an event if it ever reaches four or six metres.

Roubaud has formed the habit of taking off his flippers when he reaches the seabed so that he can walk across the excavation site without kicking up too much sediment. Sometimes, when he has found something, he gets down on his knees and gropes his way forward, he says with a smile, like a pilgrim in Heracleion, moving almost weightlessly above the witnesses to the pharaohs' former glory.

All of the divers report more or less the same: how they sometimes run out of air because they are so engrossed in their work down in the depths that three or more hours have passed without their noticing and they then have to hurry to find the boat waiting to take them back; and that it is not rare to encounter problems getting there because of a drifting fishing net, say, or a strong current that gets in their way. They take all of this in their stride as

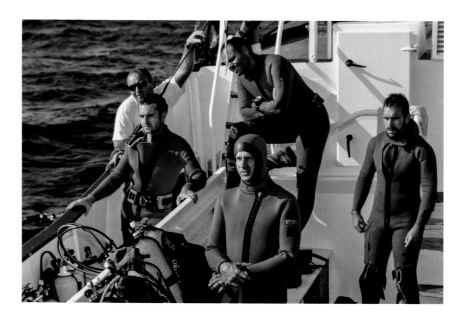

Preparing to dive once more into the history of Egypt. In the foreground: Franck Goddio in neoprene.

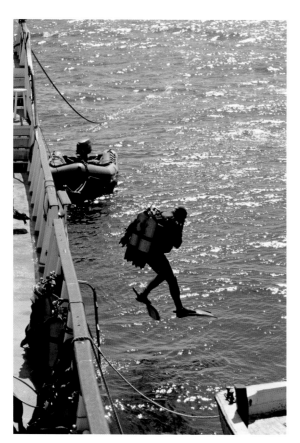

The divers' working day begins at eight every morning – with a leap overboard.

the price to be paid for having the most fascinating job they can imagine.

In the mess on board the research boat, the atmosphere is one of quiet activity. The divers have returned with a votive barque, an amulet and some bronze coins, and are now first of all entering their finds in the mission book – with a comprehensive description, a sketch and details of the exact spot where they were found. After that, each piece is assigned a number and registered in the database from which Goddio incorporates the artifacts into the electronic map depicting the world of the seabed on a large screen on the wall. It is overlaid with a digital system of coordinates that has its analogue counterpart underwater: to mark the position of each spot where a find is made, Goddio has a net with a mesh of precisely one metre by one metre stretched over the area. That way, he can plot on the electronic map the exact position of each fragment, each block of stone, each wooden post. This is how, over the years, this unique body of data has grown to become the digital brain of his excavation work.

By the end of this particular day, Goddio will have marked on the map the precisely 17,557 objects the divers have so far retrieved from the deep – and that is only from Heracleion. Goddio has created a similar map for Canopus and a third for Alexandria. However, not only the positions of ashlars and columns, jewellery and statuettes are plotted in these files; they really do contain all of the information the excavation team has gleaned from its exploration of the seabed: the data from the magnetometer prospections and also from the echo sounder and side-scan sonar surveys, each stored in separate records and clearly distinguishable from each other. This means that buildings are also saved in a different record from shipwrecks or ceramic or coin finds – in all, there are nearly 1,000 different layers of data. It is a real treasure because by combining the different layers, the archaeologists can correlate everything with everything else on all three excavation sites and thus gain insight into how things were interconnected that they could never have attained simply by surveying the landscape of ruins on the seabed.

Goddio moves the cursor over the map on the screen, selects the seabed terrain from the menu and zooms in. Clearly visible in the sediment are the contours of five vessels that probably sank thousands of years ago. The data from the high-tech surveys produce a kind of jigsaw puzzle that would ultimately only have to be pieced together, Goddio explains, his eyes fixed on the big screen. "And suddenly the picture is clear: here is where you have

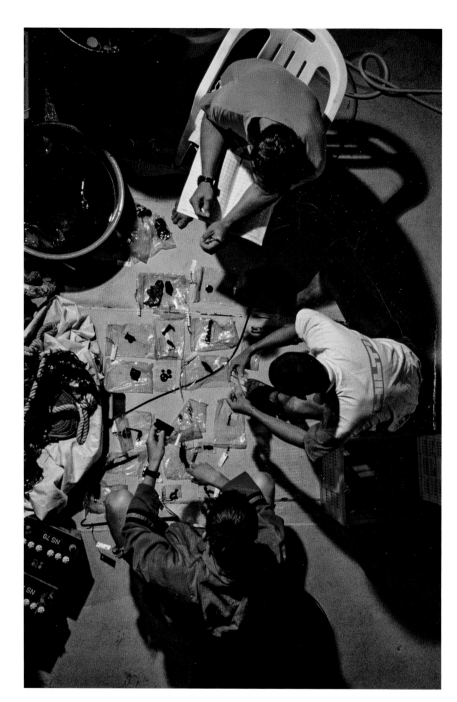

All finds are labelled
and securely packed
while still underwater.
Once on board, they are
registered and entered
in the mission book.

to start." If he wanted to, he could send the divers there right now, equipped with suction devices for the careful removal of sediment, knowing precisely to the centimetre where they would have to look.

That's because the best way to excavate is always to operate with maximum pin-point precision, he says, just like in medicine. The less interference, the better. After all, the artifacts are no longer the most important aspect of modern archaeology; the emphasis is now on the interconnections, on discovering the stories the objects have to tell us. And they can do that best where they are found.

His work done for the day, chief diver Jean-Claude Roubaud cleans his equipment. It is not unusual for him to spend eight hours of the day underwater.

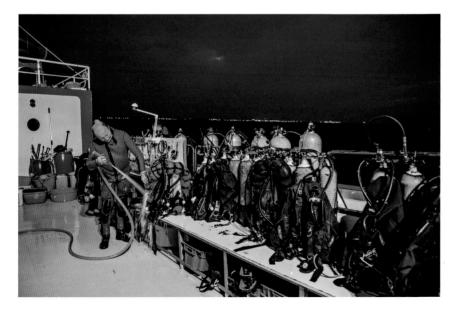

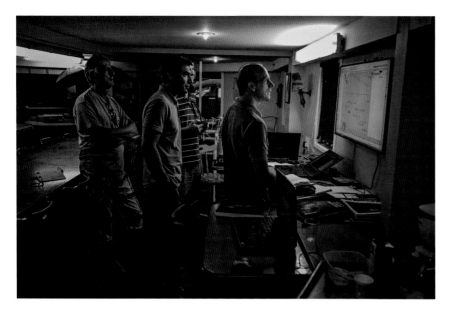

Goddio at the computer screen in the mess of the Princess Duda, studying the digital excavation map. With him are archaeologists Alexander Belov, Grégory Dalex and Patrice Sandrin.

A diver from the Underwater Archaeology Department of the Supreme Council of Antiquities enters the day's finds in its mission book.

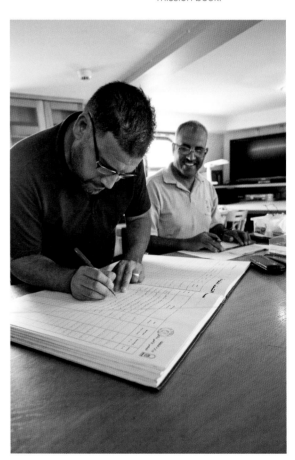

Two Egyptian inspectors examine a bronze object that has just been raised. As yet, it is not possible to identify it with certainty.

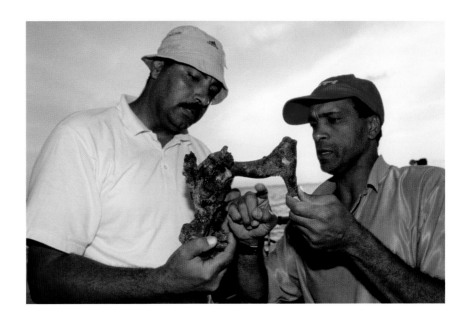

Goddio with a votive barque made of lead, a sacrifice made to the god Osiris thousands of years ago in Heracleion

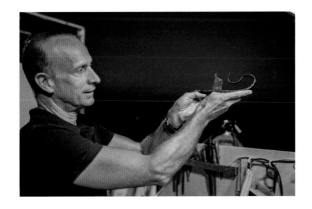

An Egyptian diver and his French colleague sort artifacts on deck.

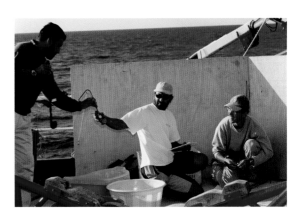

Ceramics specialist Catherine Grataloup uses a profile gauge to copy the contours of a ceramic object and transfer them to paper. This method simplifies the dating process.

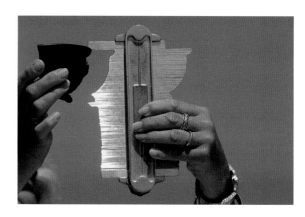

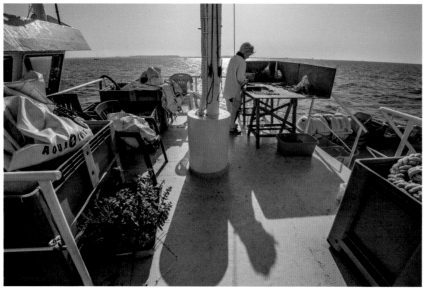

Catherine Grataloup at her workbench on the upper deck. In the foreground, herbs for the galley.

The finds are stored in plastic tubs filled with water; exposure to air would soon destroy them.

The most important man on board after the mission chief: Jirǐ, known as George, the ship's Maltese cook

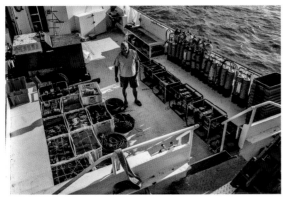

Everything has its place on board the ship: diver Philippe Rousseau surrounded by equipment.

One of the many boats without which the excavations on the extensive underwater site would not be possible. Some of these boats remain anchored right above excavation sites overnight, others go back to Aboukir in the evening and return early the following morning.

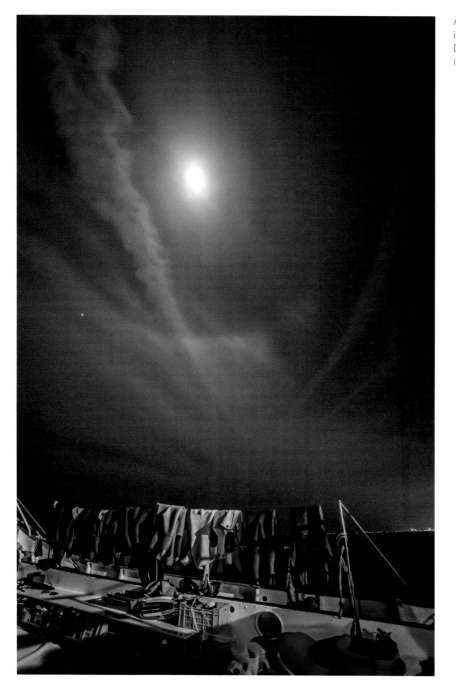

A quiet moonlit night
in the bay of Aboukir.
Diving suits on deck dry
in the balmy breeze.

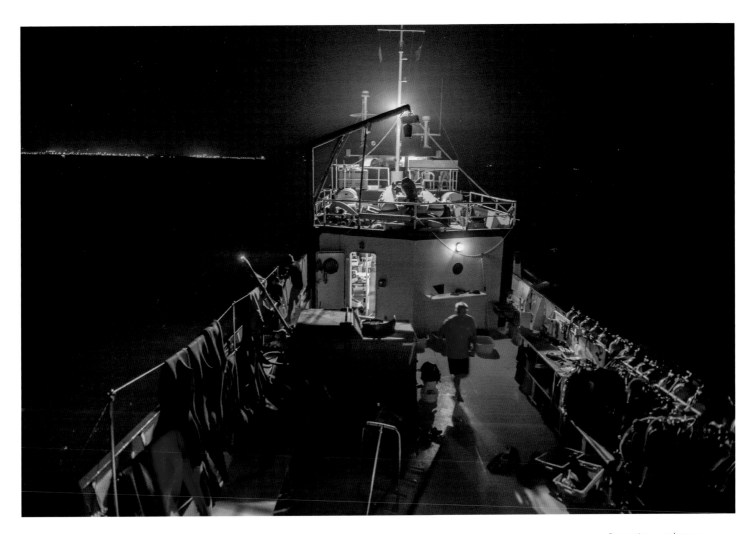

Sometimes, when a strong wind gets up and the sea turns choppy, the hawsers have to be rearranged and re-secured.

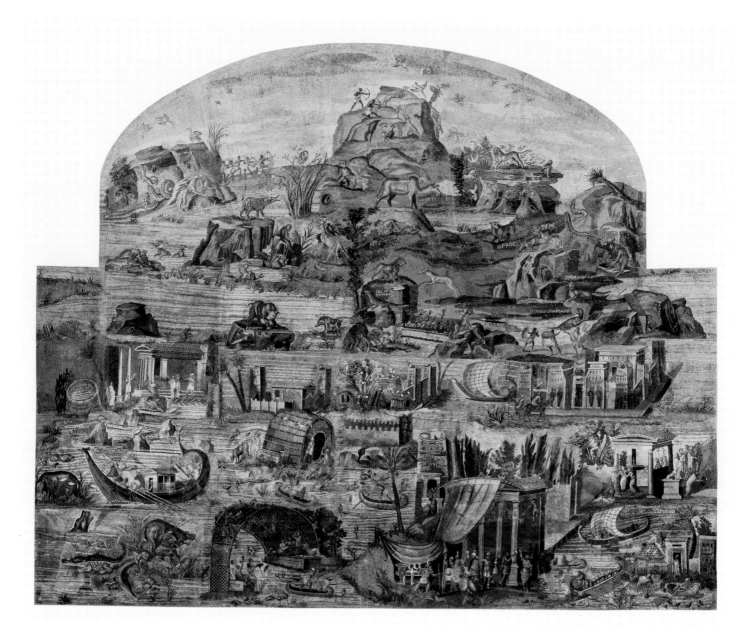

The Nile mosaic of Palestrina, the best-preserved depiction of an ancient Nile landscape, is almost six meters wide and dates from the 1st century BCE.

# How It All Began
## In Search of Sunken Egypt

~~~~~~~~~~~~

Visibility was virtually zero; the sea, cloudy with algae and effluents. Chief diver Jean-Claude Roubaud still remembers very well the dives he made in Alexandria harbour in late July 1992. "We were down there, looking around, and there was nothing to be seen." It was Roubaud's first summer on Goddio's team – and it was the first major survey in precisely that region, where, according to popular tradition, the Portus Magnus, the great eastern harbour of the Ptolemaic metropolis, once stood, its shores lined with palaces and temples.

Goddio had chartered a spacious catamaran and called it the Kaimiloa. The name pays tribute to his grandfather, Éric de Bisschop, whom Goddio never met, but who became world famous when he sailed from Honolulu to Cannes, in the late 1930s on board a catamaran of his own construction, which bore the same name. *Kaimiloa* is Hawaiian and loosely translated means "in search of distant horizons". De Bisschop's construction was the very first modern catamaran and, as such, caused quite a sensation.

"Unlike his grandfather, Goddio had his boat loaded up chiefly with equipment: magnetometers, side-scan sonars, and echo sounders for bathymetrical surveys, in other words for determining the topographical features of the seabed. With the aid of these instruments, he planned to chart as detailed a map as possible of the harbour bed. That is why he and his team spent weeks moving methodically through the Bay of Alexandria, precisely charting everything the instruments detected according to a grid system. And the images they generated appeared to prove that they were on the right track – with clues clearly pointing to the mysteries that lay hidden in the depths. An ancient harbour wall became visible as a level hump beneath the sediment, and a large, geometrically-shaped hollow indicated the presence of what may have been a harbour basin.

None of this was visible to the naked eye from the surface, which is why, time and time again, Goddio and his divers climbed into their neoprene suits, pulled on their goggles, strapped oxygen bottles to their backs and let themselves down into the murky waters to take a look for themselves.

Thonis, later Heracleion, Egypt's gateway to the world. This is how the port could have looked 2,400 years ago. The small islands in the estuary of the western branch of the Nile were built over and the structures reinforced with stakes, while in the east, a sandbank offers protection from the Mediterranean breakers. On the right the Temple of Amun-Gereb, the god of gods, and his son, the moon god Khonsu, stands majestically beside the Grand Canal. Khonsu was the god the Greeks worshipped as Herakles.

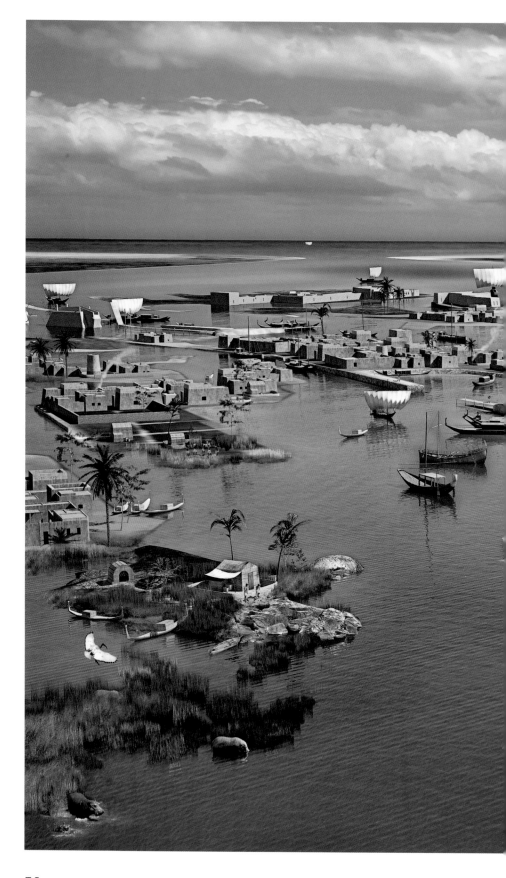

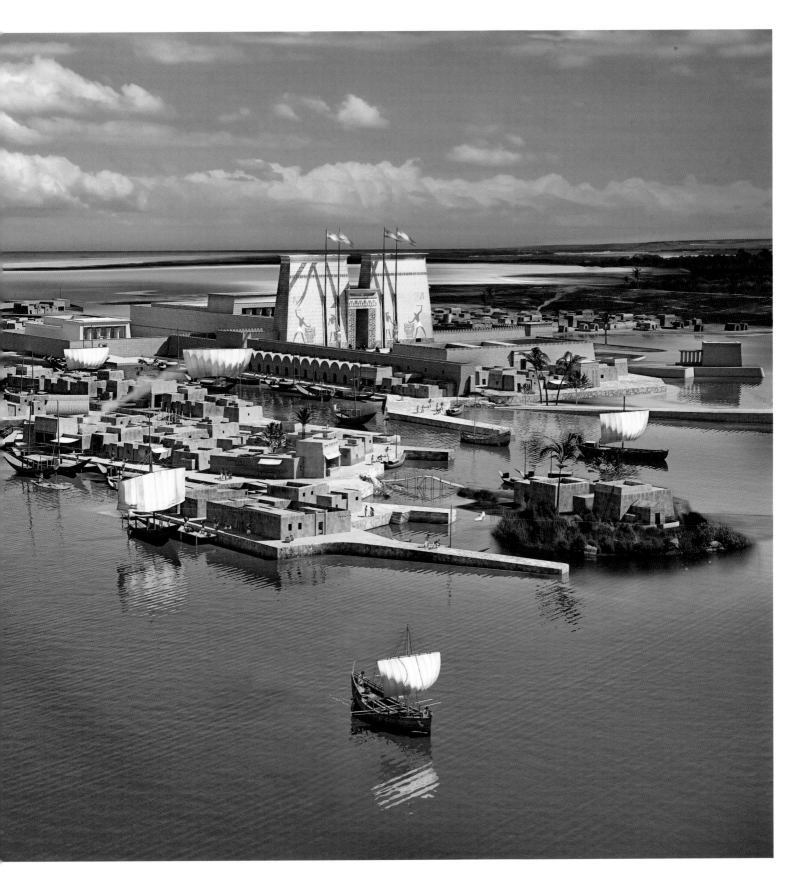

How alike these images are: below, the bust of Cleopatra VII from the Collection of Classical Antiquities in Berlin; above, the same portrait on a bronze coin found on the bed of the Portus Magnus of Alexandria.

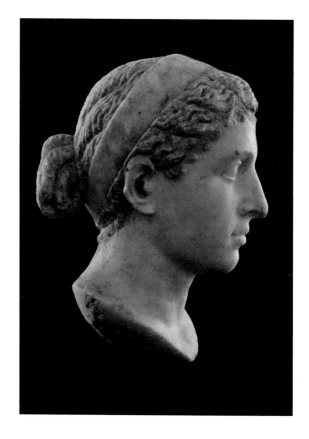

Up on the surface, white yachts lay at anchor in front of the 15th-century Quaitbay citadel at the eastern end of the former island of Pharos, open fishing boats bobbed on the waves and water taxis buzzed across the harbour. Underwater, the poor visibility made it very difficult for the men to get their bearings and maintain contact with each other. They began digging randomly in one spot – roughly where the magnetometer had indicated an indistinct structure in the sediment. Suddenly they came up against granite: a piece of statuary. "The head of a sphinx, over 2,000 years old," Roubaud recalls, still visibly delighted: "It was a fantastic feeling." They had made a find.

The previous year, Goddio had already contacted the Egyptian Supreme Council of Antiquities, then still within the mandate of the Minister of Culture. It hadn't been difficult to convince the country's authorities of the value of the planned mission in Alexandria, he says. Quite the contrary, in fact; archaeologist Mohammed Ibrahim Bakr, head of the Council of Antiquities at the time, had a proposition of his own for the underwater archaeologist. "He asked me to complete the project begun by Jacques Dumas," who in 1984 had discovered the flagship of Napoleon's vanished invading fleet in Aboukir Bay, but had died of a heart attack the following year in Morocco. Goddio agreed to do so. But it was not until 1998, 200 years after the British and the French fleets had fought their sea battle at the mouth of the Nile, that Goddio and his team were able to devote themselves to the relics of the L'Orient.

That was because their prime interest lay in ancient Alexandria, where, more than 2,000 years before, the Great Library of Alexandria had stood, where the white lighthouse, the seventh wonder of the ancient world, had watched over the harbour entrance, and where Cleopatra VII, the last pharaoh, had first become Julius Caesar's mistress and then, following Caesar's assassination, that of his second-in-command, Mark Antony, until both took their lives in 30 BCE. Their death signified the definitive end of the pharaonic kingdom after more than 3,000 years.

The partly sunken metropolis of the Ptolemies is a place, according to Goddio, where the heart of history beats. He has set himself the task of uncovering that heart with the aim of showing the world what can still be discovered of the city's glorious past. Except on his visits to Jacques Dumas, Goddio had never previously worked in Egypt. And so he quickly learnt that the real challenges only begin once the cooperation agreements with the Supreme Council of Antiquities in Cairo have been signed and sealed.

What qualities does someone wishing to search for antiquities in the waters at the mouth of the Nile need to have? "Patience," replies Goddio. "An infinite stock of patience." He came to that conclusion after discovering the need to obtain an official permit for simply everything – for importing technical equipment, for radio communications, even for the presence of every single member of the team. On top of this, each diver required a personal diving permit, and it was also necessary to clarify in advance how the finds would be dealt with, of course. Who would be permitted to touch them underwater? Was it acceptable to raise them? And who would monitor this work? After all, besides the Supreme Council of Antiquities, there were the local authorities, too, which wanted to be involved in the project in Alexandria. And the coast guard of the Egyptian navy as well as the naval commands responsible for the respective sections of coast were also on board while the ruins of Heracleion and Canopus were under excavation. Months had passed before every permit had finally been obtained.

At last, however, in the summer of 1992, the undertaking could begin. At that point, however, none of the people involved had an inkling that over the years this scientific adventure would gradually become the world's largest maritime archaeological research project ever. "It was a real stroke of luck for us to be able to explore such an extensive area as this," says Goddio, whose team by then also included a number of divers dispatched by the Egyptian

What the Authors of Antiquity Reported

The cities of Canopus and Heracleion were Egypt's gateways to the Mediterranean until 330 BCE. That role then fell to Alexandria, which had been founded a little further west in 331 BCE. Only few contemporary reports from these cities exist, making them all the more valuable to Goddio. "As soon as we had gathered the data with our technology and located the structures, we used the ancient author's reports to identify what we saw there," says Goddio, "because these people were there at that time – they saw the temples, the palaces and the ships in the harbours with their own eyes."

The most detailed descriptions came from Alexandria, which roughly 2,100 years ago was the second-largest city on the Mediterranean after Rome. The most detailed account comes from the Greco-Roman historian and geographer Strabo (right), who probably visited the city around 25 BCE. He begins with a description of the island of Pharos, just beyond the harbour entrance "with its mag-

Supreme Council of Antiquities – after all, the collaboration was not intended to take place only on paper. But only now did he gradually come to realise just how extensive this area really was. "Where on earth do you begin? What approach should we take? We lacked any kind of routine for coping with such a huge task."

The men were confronted with a good 400-hectare expanse of water between three and 15 metres deep. Goddio decided to take a mathematical approach. He laid an invisible grid of lengths and breadths over the bay. Then his people climbed into the Zodiac and followed those lines, towing behind them the NRM captor placed at their disposal by the French Atomic Energy Commission. But they had only a few weeks and it was impossible to chart the entire area in detail in so short a time.

While the technology did its job all the more reliably as the scientists got the hang of it, the divers soon realised that July was not necessarily the best month for maritime research in Alexandria, however. It is suffocatingly hot there at that time of year, with average daily temperatures easily rising to 30 degrees. As a result, algae clouds the harbour waters and the level of microbial pollution resulting from untreated sewage being released into the sea is unpleasantly high. In August, on the other hand, the divers' work is made difficult by a very strong north wind, which pushes water and sediment into the bay. So this first expedition showed that there are really only two narrow time slots in which archaeo-

nificent tower of white stone," because the ships "need a tall, bright beacon by which to locate the entrance to the Great Harbour." Alexandria itself, Strabo reports, is "the shape of a *chlamys,*" a type of military cloak.

The chlamys analogy was evidently originally coined by the Roman historian Diodorus Siculus, who lived in Alexandria circa 60 BCE. In his *Bibliotheca Historica,* he describes it as a city "certainly well ahead of all others in elegance, size, wealth and luxury." Strabo, too, admires its convenient streets built according to an orthogonal grid plan and its numerous royal palaces. They were "all connected with one another and with the harbour," he notes of the palace district on the Lochias peninsula. In the Great Harbour, on the other hand, lay Antirhodos, "a small island with a palace and a small harbour of its own." Close by was the theatre and next to that the Temple of Neptune; then to the right of that, the Caesareum (the temple Cleopatra built in Mark Antony's honour, which was later dedicated to

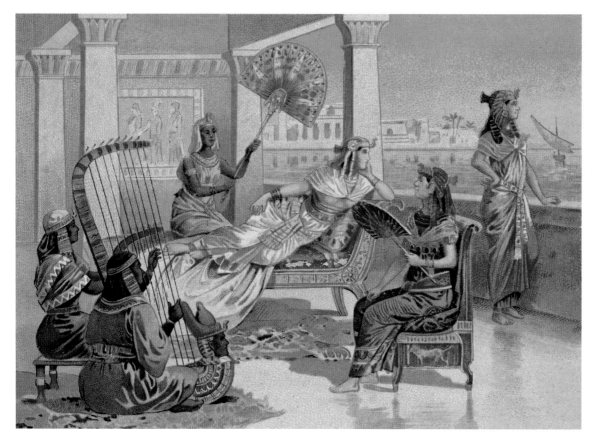

the cult of the deified Caesar), the Emporion (the market) and the magazines.

Less detailed accounts exist of the neighbouring cities of Canopus and Heracleion. The latter had entirely lost its significance as a port in the 1st century BCE, so that Strabo only deemed "a temple to Herakles" there worthy of mention. Some 400 years earlier, the Greek historian Herodotus had devoted a number of chapters to Herakles in the second volume of his narrative *Histories*. Heracleion, as Herodotus wrote, served as a temporary refuge for Paris, the Trojan prince, and Helen, wife of the King of Sparta, whose liaison, as legend has it, was the cause of the Trojan War. Of the Temple of Herakles, Herodotus writes that anyone who sought sanctuary there "and committed himself to God" would no longer be punished.

Something more contemporary has survived from the neighbouring city of Canopus, which made an ambivalent impression on Strabo. That was because while, on the one hand, he noted that it was the site of the temple of the Egyptian-Hellenic god Serapis, to whom healing powers and oracular miracles were attributed, Strabo found the more secular side of Canopus rather "peculiar", noting: "But remarkable above everything else is the multitude of persons who resort to the public festivals, and come from Alexandria by the canal. For day and night there are crowds of men and women in boats, singing and dancing without restraint and with the utmost licentiousness. Others, at Canopus itself, keep hostelries situated on the banks of the canal, which are well adapted for such kind of diversion and revelry."

logical dives can take place under acceptable conditions off the Mediterranean coast of Egypt: in the months of May and June, and in September and October.

"On top of that," Goddio recalls, "the historical information we had at our disposal for realising our project was very sparse." Certainly, there are the reports left by ancient contemporary witnesses – among them Strabo, Diodorus and Julius Caesar. Goddio had read them all and found them lacking, and mostly imprecise in their description of what they found before them. "You do have to base your research on historical sources, but you cannot trust contemporary observations implicitly," he emphasises, "You have to be very cautious there." The reason being that the writers of over 2,000 years ago were not so very different from their present-day counterparts in their manner of describing things: they only wrote about what seemed to them to be interesting and report-worthy. What did not, they left out.

Goddio had studied ancient Egypt, read what there was to read about it. "But I am no Egyptologist," he says. In the years following 1992, he obtained the necessary knowledge of this field from the best experts he could find. That's how he came to call on Jean Yoyotte in the mid-1990s. Yoyotte, a professor at the illustrious Collège de France in Paris, was considered one of the most knowledgeable Egyptologists in France. The two men spent weeks sitting at the big, dark-wood table in the living room of Goddio's apartment in Paris, discussing the pharaonic age. "I could not have had a better teacher," Goddio recalls, "the time with Yoyotte was wonderful."

When it came to interpreting Greek inscriptions from the Ptolemaic Period, which began with Alexander the Great's campaigns of conquest and the foundation of Alexandria in 331 BCE, he consulted the twins André and Etienne Bernand, both historians and acknowledged experts in their fields. This led to Goddio forming a decades-long and intensive connection with the two, from which emerged, among other things, a jointly written book on the sunken royal quarters in Alexandria. On a number of occasions up to their deaths – the two brothers died within just two days of each other in February 2013 – they spent time on the underwater archaeologist's ship contributing to the research.

Goddio also discussed with the Bernands some old maps of the lost city of Alexandria. Occasional attempts had repeatedly been made in recent centuries to draw a plan of this exceptional city on the basis of ancient descriptions and the observations of fishermen and swimmers, who claimed to have seen the shadow of a pillar here, masonry from submerged walls there. While

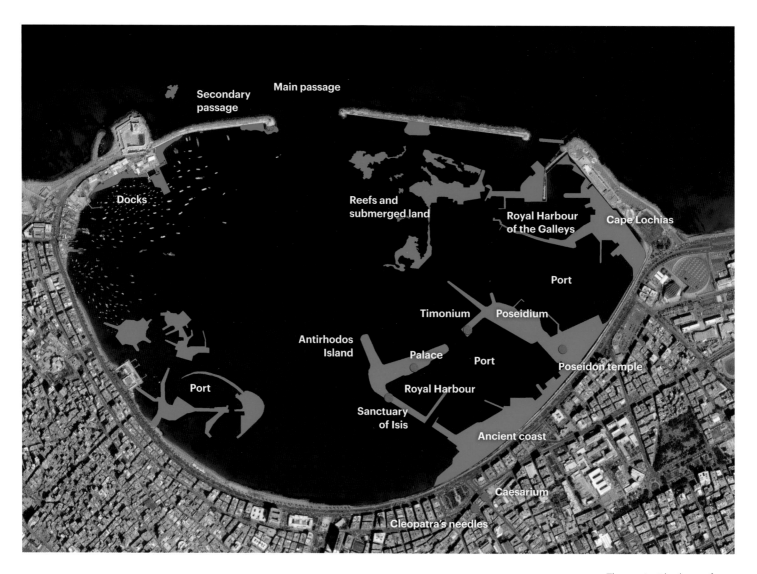

The ancient harbour of Alexandria. The sunken areas Franck Goddio has been able to identify over the course of the past 20 years are marked in blue.

delving in archives, Goddio came upon some maps of Alexandria dating from as far back as the 16th century, and others from the 18th century, when the world began to take an interest in the mysterious kingdom of the pharaohs. The best-known plan to date of the lost parts of the city, however, was created by Mahmoud el-Falaky, an Egyptian engineer and astronomer, who in 1866 drew a map of Alexandria for France's Emperor Napoleon III, based on information he had gleaned from ancient writings and his own observations. Even in the late 20th century, his map served many scientists studying the ancient city and the Ptolemies as the basis for their work.

Goddio analysed this 130-year-old map more thoroughly and was astonished: "What I saw there was more like a sheltered bay, the harbour of a small provincial town. It would not have withstood a single heavy winter storm." He decided to set aside all the existing information, including el-Falaky's plan of the city, and to apply his own methods, to use modern technology to decipher the topography of the Great Harbour of Antiquity. What ultimately emerged, after years of charting and prospection, was something entirely different from what the ancient plans showed. "Far, far bigger, far more intelligently planned – and far more practical," says Goddio.

This was the beginning of a research project that was to become his life's work. Every question he and his technicians, Egyptologists, underwater archaeologists, ceramics experts and specialists of ancient shipping raised immediately threw up a new one.

For example, the question of the rise and fall of Alexandria was immediately followed by the question of what preceded it? Where had Egypt's gateway to the Mediterranean Sea been before the Ptolemies built their city? How did the goods from the Hellenic world – the pottery, the jewellery, the wine amphorae – make their way to the kingdom of the pharaohs?

The ancient texts mentioned the city of Canopus and also another city by the name of Heracleion, while stele inscriptions named a place called Thonis. Now that they had located the lost city of Alexandria and begun charting it, Goddio and his team of scientists set out in 1997 in search of what to the pre-Ptolemaic pharaohs had been the "gateway to the world", some 35 kilometres to the north-east: in Aboukir Bay. And if exploring the submerged remains of Alexandria had seemed a mammoth undertaking – here they were confronted with an insurmountable task. Before them stretched 11,000 hectares of sea, 110 square kilometres to be scoured for witnesses to the past. Would there

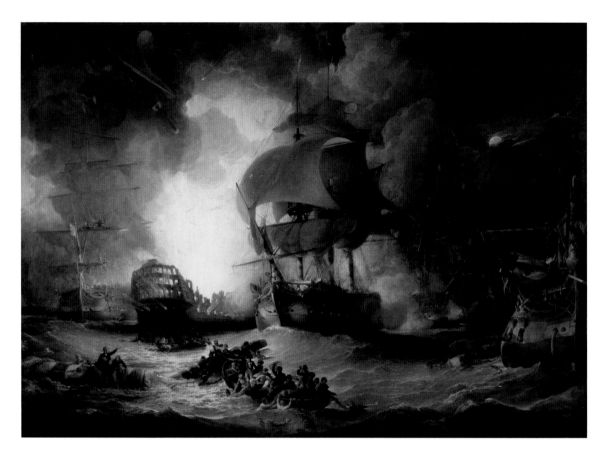

Admiral Nelson's triumph was traumatic for the French: L'Orient, the flagship of Napoleon's expedition fleet, sank in a tremendous explosion on August 1, 1798, during the Battle of the Nile. The picture below shows how the contemporary caricaturist James Gillray interpreted the drama: Nelson is seen cudgelling to death a horde of crocodiles sporting France's colours. In a reference to the Bible, the artist named his work *The Extirpation of the Plagues of Egypt*.

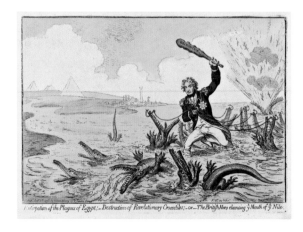

be visible evidence of ancient temples or port facilities, or at least a few fragments of ancient masonry to be found?

But Goddio first had a task to complete, the excavation of the L'Orient, which Jacques Dumas had discovered over ten years earlier in the mud off the coast of Nelson's Island. Goddio knew where the wreck lay. And he and the Supreme Council for Antiquities now set about raising what remained to be raised. Little was still recognisable of the original ship, the largest in the Corsican commander's fleet, which had once been 65 metres long, had been manned by a crew of 1,080 and had 120 cannon on board – the remains of the ship were now strewn across an area measuring half a square kilometre. There, the divers found cannon in the silt, everyday objects, navigation instruments, massive nails from the vessel's hull and steering gear – plus any number of gold and silver coins, which they brought to the surface. At the same time, Goddio gained the opportunity to rectify a misapprehension: "Judging by the positions of the artifacts and the remains of the hull, we established that Napoleon's ship had not been destroyed by one large explosion during the English attack, as previously assumed, but more likely by two. They must have taken place almost simultaneously." Another side-effect, as it were, of the remote survey of the seabed was that the researchers located another two, smaller, French Navy frigates, the Sérieuse and the Artémise. Its own crew had sunk the latter after running out of ammunition in the battle with the English.

The survey in Aboukir Bay thus proved once again something that runs like a red thread through Goddio's entire scientific work: that the more closely he studied the submerged parts of history, the more critical and distanced his perspective became. On the other hand, the more detailed his charting of the seabed's true nature, its actual topography, using the available technology, the more all that historians and archaeologists had hitherto considered certain knowledge was called into question – and the clearer became a new and rather different picture of the past, many details of which had hitherto been unknown.

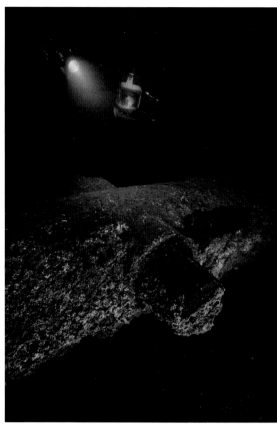

Franck Goddio inspects the remains of the pride of the Corsican general: a cannon of the L'Orient.

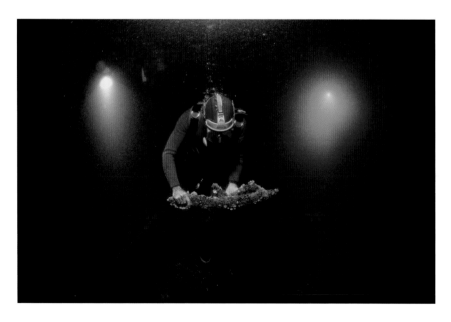

Goddio with an officer's sabre from the wreck of Napoleon's flagship

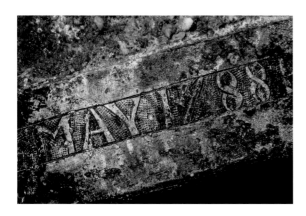

A mortar, cast in bronze in May 1788 – and in France, of course; in the 18th century, May was still spelt with a "Y" in French ...

... 210 years later, Goddio's divers found it on the seabed off Nelson Island in the Bay of Aboukir.

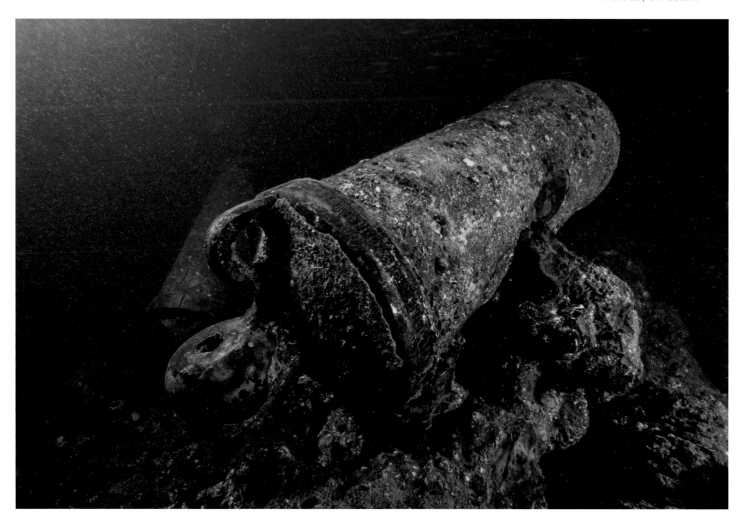

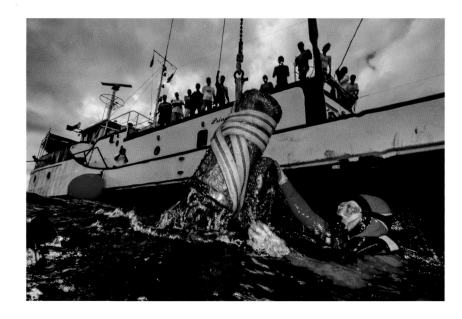

From the deck of the Princess Duda, the crew looks on with great anticipation as the old mortar is raised from its watery grave.

Little remains of the L'Orient itself. Most of what the divers discovered had been on board the ship when disaster struck: all that remains of the ship's medical supplies (top left), a muzzle loader (top right), an officer's sabre picturesquely protruding from the sand (bottom left), coins and musket balls (bottom right).

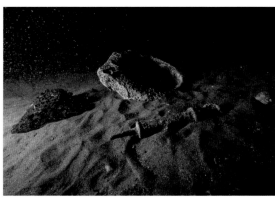

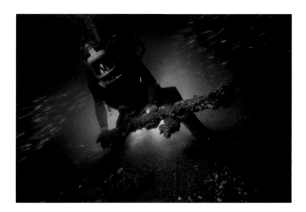

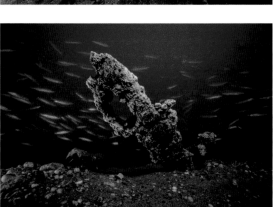

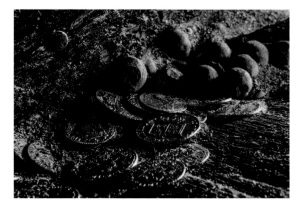

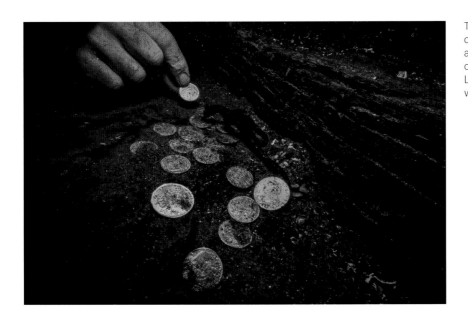

The crew of 1,080 went down with the L'Orient – and a tremendous hoard of gold. Here some golden Louis d'ors Goddio's divers were able to retrieve ...

... although first the coins had to be painstakingly uncovered with the aid of a special suction device.

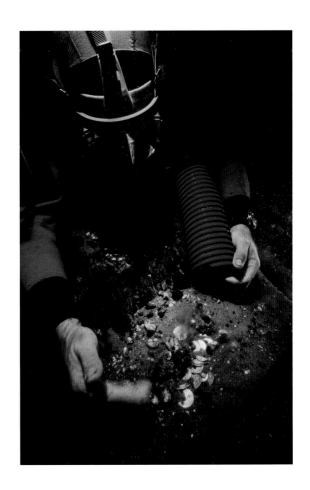

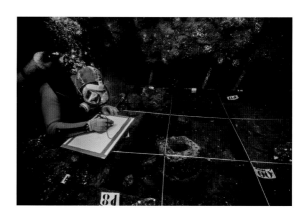

Underwater drawing: diver Patrice Sandrin makes a drawing of a bilge pump inside the remains of the L'Orient, precisely mapping the position of the find with the aid of a coordinate grid.

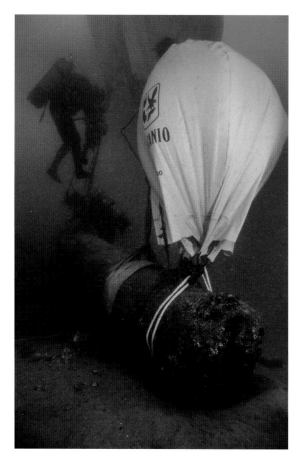

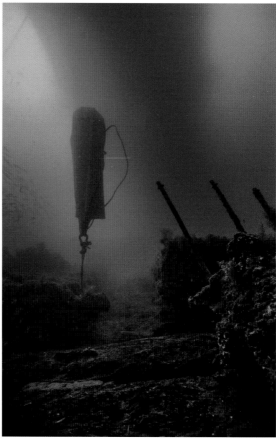

In the explosions on board the L'Orient, even multi-ton cannons were flung far from the ship. The archaeologists raise them with the aid of air-filled bags.

Copper nails the length of an arm still protrude from the surviving fragments of planking of what was once the largest ship in the French war fleet.

Once deadly, today surrounded by fish: the L'Orient's ammunition, fused together after being immersed in seawater for 200 years

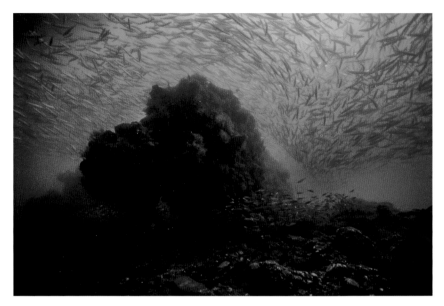

The divers of the IEASM find the relics of the French flagship strewn across half a square kilometre.

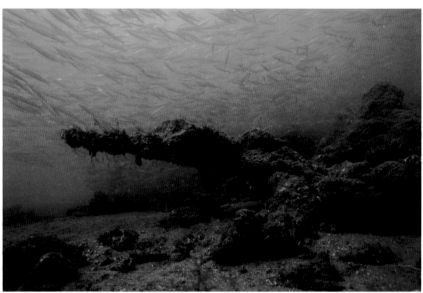

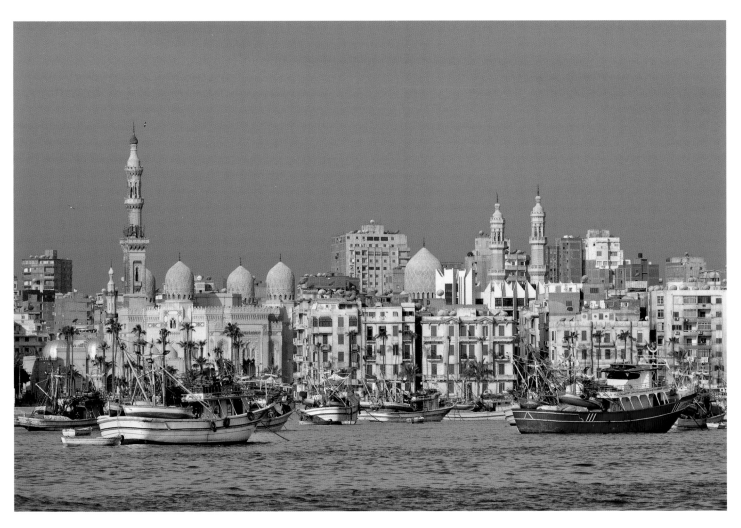

Alexandria's eastern
harbour. Once important
areas of the ancient
metropolis were located
here, where today
there is only water.

Alexandria
A Metropolis Re-emerges

~~~~~~~~~

The wave hit Alexandria wholly unprepared and with deadly force. It broke down walls, toppled columns, devoured the islands in the harbour and parts of the shore along with all of the buildings there. The Roman historian Ammianus Marcellinus, a contemporary witness, tells of ships torn from the harbour basin and flung far into the city by the sheer force of the water. And boats that lay tied up at the mouth of the Nile were later found three and a half kilometres inland.

The tsunami that devastated the ancient Mediterranean port on July 21, 365 CE had begun its course off the coast of Crete. On that day, the earth began to quake below the waves to the south of the island, discharging geological tension that had built up over centuries at the fault line between two tectonic plates, the point where the African Plate goes under the Aegean Microplate. It was not the first earthquake to occur in this subduction zone and it would not be the last. But with a likely force of 8.0 on the Richter scale, it was one of the most devastating in the history of the Eastern Mediterranean, and even in Sicily and the northern Adriatic people were surprised by the tidal wave's destructive force.

And in Alexandria, too, of course. Later chroniclers would tell of many buildings buried beneath the water, and of some 5,000 people who lost their lives in the disaster. "Civilisation," as the U.S. historian William James Durant once wrote, "exists only by geological consent, subject to change without notice."

That earthquake and the tsunami did not actually deal the city a mortal blow, but they did play an important role in a tortuously long process that culminated in the final destruction of the once so magnificent metropolis: nearly 200 years later, in the year 551 CE, the next earthquake hit the port, and in 796 or 797 another. In each of these natural disasters, further parts of the city collapsed, until finally, in 1303 it is conjectured, a quake of similar scale to that of the 4th century struck Alexandria and also caused the extensive collapse of the lighthouse on Pharos – that Wonder of the Ancient World, indestructible until that point and now no more than a ruin, a pile of rubble at the bottom of the sea.

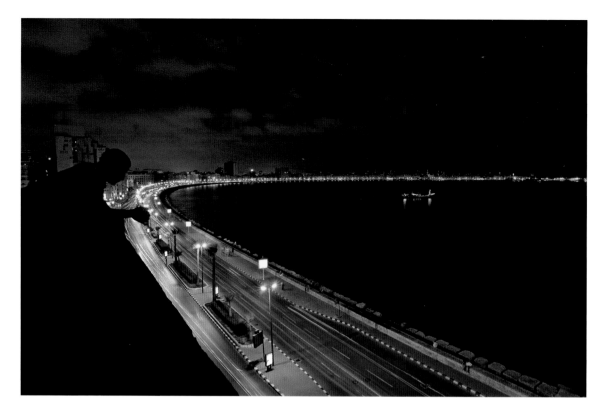

Alexandria's Corniche, the coast road, is probably the most famous thoroughfare in the entire Orient. In the middle of the bay, where the island of Antirhodos once lay, Goddio's research ship, the Princess Duda, lies at anchor.

An architectural work of art, the Bibliotheca Alexandrina opened its doors in 2002.

With the fall of the over 120-metre white stone beacon, the city's glory faded, its final splendour disappeared and its much-admired luxury was lost to oblivion.

"Alexandria sets you dreaming," as Goddio writes in his book *Sunken Treasures,* the reason being that the city named after its founder, Alexander the Great, was without parallel among the great cities of antiquity. From the beginning, it had been planned as a magnificent capital, and its location on the spit between the sea to the north and the ancient Lake Mareotis to the south provided good protection from invasion. A canal connected the lake and the city with the western branch of the Nile and the neighbouring cities of Canopus and Heracleion. The nearby island of Pharos afforded protection from attacks from the sea. A close companion of Alexander, Ptolemy I, who reigned Egypt from 306 to 282 BCE and founded the Ptolemaic dynasty, built a long dam from the mainland, rendering the island easily accessible.

Heptastadium (seven stadia) is the name ancient chroniclers gave to that structure – in reference to its length. However, no standard length existed for a "stadium" – it depended on which part of the Hellenic world you happened to be in. The Olympic stadium measured 176 metres, the Phoenician-Egyptian stadium, 209 metres; the Heptastadium will likely have been between 1.3 and 1.5 kilometres long. This massive mole dissected by two channels with bridges above them not only afforded easier access to the island, but divided Alexandria's natural harbour into the eastern Portus Magnus and the Portus Eunostos in the west. There was an organisational advantage to this, as the Portus Magnus thenceforth served as a splendid royal and military harbour, while the Portus Eunostos was mostly where merchant sailing ships tied up and transhipped their goods.

The Heptastadium was built by Dinocrates of Rhodes, an architect who at Alexander's behest probably also designed the city's layout: a network of roads intersecting each other at right angles, and divided into five districts. These were inhabited by Greeks, Egyptians, Syrians and Jews, Persians and Ethiopians. The newly founded Alexandria soon became a melting pot of nations and cultures. Some 400,000 people – other sources even estimate as many as a million – are said to have lived in the city during its heyday. Many of them were slaves. For centuries, though, Alexandria was also a place that inspired longing and attracted adventurers and explorers, merchants and artisans, priests and scholars.

The Temple of Isis and, most importantly, the hilltop Temple of Serapis, the imperial god established by Ptolemy I, which was erected in the Egyptian district of Rhakotis, were famous far be-

yond the borders of Egypt. It was in the royal district of Brucheion, though, on the eastern shore of the Portus Magnus, that Ptolemy I also built the Museion, a kind of early academy of science and research and cultural centre all in one. This institution made Alexandria a cradle of modern science.

Attached to the Museion was the Great Library – the "brain and heart of the ancient world", as it was once described by the American astrophysicist and author Carl Sagan. Its intended purpose was defined as being "if possible, to assemble all the books in the world," and it evidently took its mission literally. The library simply stole a considerable proportion of its inventory of allegedly more than 500,000 papyrus scrolls by borrowing them from Athens and later returning only copies, for example, or requisitioned scrolls from ships entering the port by order of the Ptolemaic pharaohs – which was then meticulously noted as an indication of their origin "from the ships".

But regardless of where the writings originated, the most important scholars of antiquity created the Museion and the Great Library, and the cosmopolitan atmosphere of Alexandria provided them with ideal conditions for their work. Euclid taught mathematics and music theory here; it was here that Eratosthenes of Cyrene first calculated the circumference of the earth (and correct to within just under 6,000 kilometres of today's accepted measurement), here that Aristarchos of Samos realised that the earth revolves around the sun, and also where the great mathematician Archimedes immersed himself in papyrus scrolls from the Great Library.

The city's glory was not to last, however. When, in the year 30 BCE, Cleopatra, the last pharaoh, took her own life and the Romans turned Egypt into a Roman province, it marked the beginning of the end of a glorious era. Although Alexandria remained the seat of the prefect Egypt, or Egyptian prefects, as Rome's governors in Egypt were known, and the city continued to be a centre for scholarly discourse and science, from now on political and religious conflicts would more and more often culminate in uprisings and massacres. Alexandria nonetheless continued to be the second most important and largest city in the Roman Empire. For the Roman emperors, it was a gold mine. They shipped the grain that fed their capital via the seaport of Alexandria, just as all income from their Egyptian province, Provincial Egypt, flowed straight into the imperial coffers in Rome.

Use of the Alexandrian harbour is documented until well into the 8th century – by which time the Arabs had long taken over both the city and the country on the Nile, says Goddio, even

though precious little of the Portus Magnus of yore likely remained – and up to the time of the next disaster, which came along towards the end of the 790s and finally submerged the islands, the harbour walls and the warehouses. Only the lighthouse survived for a few more centuries.

The sea did not swallow everything at that time, however, since most of the city was built on safe ground. But that area is where more than four million people live today, where a never-ending torrent of cars, motorcycles and buses flows along broad thoroughfares, and a phalanx of dilapidated concrete buildings rises into the sky. Whatever may have survived of the ancient Alexandria now lies beneath all of this, says Goddio – and is gone for ever. Little has been unearthed. The foundations of the Temple of Serapis, which the Christian Emperor Theodosius I had destroyed in the 4th century, a Roman amphitheatre, subterranean necropolises, here and there the relics of a Roman villa, fragments of statues and ceramic sherds. The two roughly 3,500-year-old obelisks brought here circa 20 BCE from the city of Heliopolis and erected outside the Caesareum, the temple Cleopatra built in honour of her lover, Mark Antony, have also survived, though not in Alexandria. One of these two stone needles today stands in New York's Central Park, the other in London by the River Thames.

Still there, however, are the temples and palaces, the statues and sphinxes that sank beneath the waves over 1,200 years ago. "To this day, that part of Alexandria has remained largely untouched," says Goddio, "so we have a good starting point." In May 1996, four years after the first surveys were conducted, he returned to the city west of the Nile Delta with a team from the European Institute for Underwater Archaeology, IEASM. Working hand in hand with the Egyptian Supreme Council of Antiquities and financially secure thanks to the patronage of the Hilti Foundation, Goddio this time intended to do more than explore and chart the area; he wanted to carry out some initial excavations on the seabed with, as he puts it, "surgical interventions" on those spots where the magnetometric and bathymetric measurements promised interesting results.

Franck Goddio is naturally not the first scientist to have thought of searching for ancient relics in Alexandria. Several excavations were undertaken in the 19th and 20th centuries; historians and archaeologists put forward a variety of hypotheses on the topology of the ancient port facilities. And Jean-Yves Empereur, also a Frenchman and five years Goddio's junior, set up a centre of archaeological study in the city as early as 1990, from which he organised a number of rescue excavations on land, mostly in ar-

The underwater archae-
ologists dig themselves
several metres into the
seabed in Alexandria's
harbour. Christoph Gerigk's
picture of this probe is
assembled from many
different photos – to form
a vertical panorama.

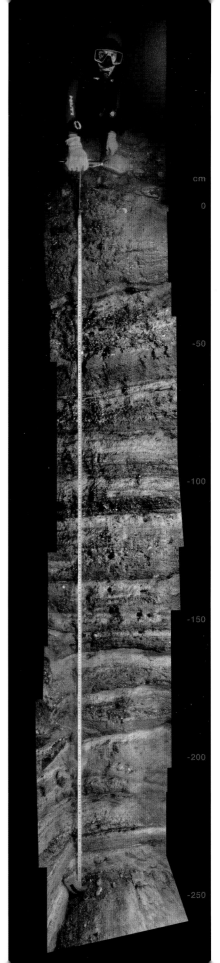

Exceptional conditions
underwater occasionally
demand full body input
from the divers.

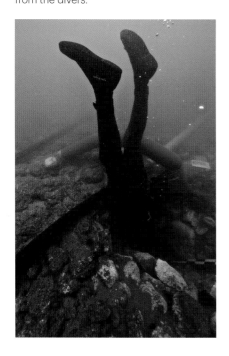

eas designated for development. In the course of that work, Empereur unearthed a necropolis, a subterranean cemetery. In 1994, the Egyptian authorities commissioned him to make an underwater search for ancient remains northeast of the Mamluk fort Quaitbay – the city administration was planning to build a breakwater there to protect the 500-year-old citadel from erosion by the sea. Over the course of the following two years, Empereur actually discovered more than 2,000, in some cases gigantic, blocks of stone, columns and capitals across a 2.25-hectare area of seabed, which he attributed to the long sought-after lighthouse destroyed in 1303, as well as sphinxes and fragments of shattered statuary. Some experts did voice their doubts as to whether Empereur was correct in attributing the rubble to the Pharos Lighthouse, however. The famous Egyptologist Jean Yoyotte, for one, who died in 2009, expressed his suspicion that the granite blocks, columns and statues could have been relics from the monumental Serapis Temple, which citizens of later centuries had tipped into the sea to form a breakwater.

In May 1996, Goddio sailed his catamaran, the Kaimiloa, into the Great Harbour and dropped anchor. Once again, the boat was crammed to the cabin ceiling with high-tech equipment – it served so many different purposes, after all: survey vessel, analysis lab, computer centre – and, of course, diving base. The IAESM had hired nearly 25 people for that first large-scale excavation mission in Alexandria. They set to work, taking the still incomplete map of the Portus Magnus from 1992 as their guide. Twice a day, the divers spent 100 minutes at depths of as much as 15 meters, wrapped up in thick neoprene suits to protect them from the sewage that flows untreated into the bay. By the end of the mission, there were more than 3,500 dives recorded in Goddio's logbook. And with every dive, the Ptolemaic metropolis came to life a little more.

Beneath the mud, which they carefully removed with a suction device designed especially for the purpose, the IAESM's research divers discovered architectural relics, amphorae and ceramics, fragments of statuary and ancient anchor stocks. "This time, visibility was also miserable," Goddio recalls, "barely more than 20 centimetres. Sometimes we couldn't see our own hands in front of our faces – even though the sun was blazing down from the sky." When there were no dives in progress, the Kaimiloa resumed its survey runs. That way, the scientists gained an increasingly detailed picture of the ancient topography and were able to chart sunken reefs that could once have been treacherous traps for incoming ships, as well as the ancient shoreline, the dykes and

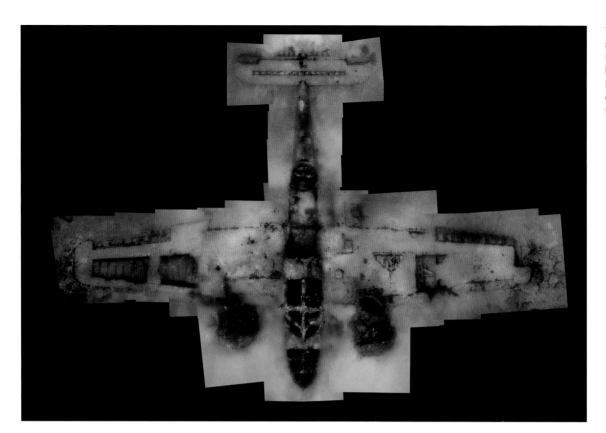

The scientists' echo sounder detected this British Bristol bomber half-covered in sediment in the eastern harbour of Alexandria; it dates from World War II.

## Change Through Trade

Soon after the city was founded in the 4th century BCE, Alexandria had become one of the largest international trading posts in the Mediterranean. To the east, relations extended far into Arabia and Mesopotamia and all the way to India via caravan routes, while in the west, shipping lanes connected the city with Greece, Sicily and even the Iberian Peninsula. According to Damian Robinson, Director of the Oxford Centre for Maritime Archaeology at Oxford University, in those days Egypt's greatest export was grain, alongside papyrus and linen. In exchange, the Greek traders paid, amongst other things, with gold, silver and lead, which the people of the Nile required for cultic and other purposes. Its many different trading contacts brought a wide variety of religions and cultures into the city so that over the centuries it became a melting pot, "a sort of interface between East and West," says Robinson, and also the most important intellectual and scientific centre of the Mediterranean region.

piers. The echo sounder even located a British Bristol bomber beneath the sediment that had crashed during World War II.

Soon the scientists' interest was directed towards a submerged peninsula, 350 metres long and 150 metres wide, which ends in two moles set at right angles to each other. Could this be where, according to the Roman chronicler Strabo's report, the Poseidon Temple once stood, along with the Timonium, a small palace Mark Antony had built and to which he withdrew after his former brother-in-law, Octavian, defeated him in the naval battle of Actium? Strabo had, however, clearly placed that peninsula much farther east, and there Goddio's people could find nothing that corresponded with the description. Goddio decided to take a look.

"After removing the sediment," the mission chief reports, "we could see an area of large stone slabs at the end of the western mole. Then we spotted the foundations of a small building." Radiocarbon analysis of timber piles dates the building to the end of the Ptolemaic Period – could this be Mark Antony's Timonium? The time, the place, the size – everything fits. So Strabo's account had been correct, but he had been mistaken in the location. Perhaps, though, the travelling geographer is not to blame; perhaps the long stream of copyists and translators, who constantly copied and rendered his text anew, simply confused west and east. If so, it was an error with consequences: all of the maps drawn up in an attempt to depict ancient Alexandria have positioned the Timonium wrongly.

While Egypt's maritime trading relations extended far back to pre-Ptolemaic times, contacts between Egypt and the Aegean region, especially Crete, can be traced to the Early and Middle Bronze Age, some 4,500 years ago. "Pioneers were evidently risk-loving sailors or merchants, who crossed the Libyan Sea less out of a sense of adventure than because they were driven by economic interests," says Diamantis Panagiotopoulos, Professor of Classical Archaeology at Heidelberg University. In the days of Egypt's Old and Middle Kingdoms, the pharaohs' chief exports to the Aegean were costly commodities, such as gold, alabaster, ivory and ostrich eggs, but they also included ceramic vessels, as well as scarabs, which were a popular amulet and symbol of the sun god Re in Egypt. This is an early indication that not only necessities but also cultural artifacts and probably also underlying spiritual and religious practices spread along the trading routes. On Crete, for instance, scarabs from the Nile "set

Working in the busy harbour is not without its dangers. One day, when a storm was churning up the sea, Goddio saw an anchor that must have weighed tons lurching through the seething waters just metres from where he was diving and then crashing into the Timonium with massive force, splitting the ground. A ship that had sought refuge in the harbour had been caught by a wave and driven out towards the open sea.

Although Goddio had initially resolved to leave most of his team's finds in situ, this experience prompted his decision – in consultation with the Egyptian authorities – to bring the artifacts not protected by sediment to the surface since only there would their long-term safety be assured. They would indeed be safer in museums than on the bed of a busy harbour.

It was a wise decision, although one that brought with it a drawback: from now on, it would have to be decided every single time whether something was important enough to be raised or could stay on the seabed, where it would be permanently out of the public eye and out of the reach of science. Not an easy task, since in each individual case a decision must be made on the scientific and historical interest of raising a find.

After the Timonium, Goddio turned his attention to Antirhodos. As early as 1992, he had already located the island on which, according to ancient accounts, a temple to Isis and a royal palace had stood.

Antirhodos is small, only 350 metres long and no more than 70 metres wide. "When we dived down," Goddio recalls, "all we could

serial production of local imitations in motion," writes Panagiotopoulos. Conversely, from Egypt's Middle Kingdom onwards, circa 2000 BCE, witnesses to Minoan culture, in particular ceramic imitations, are found in Egypt.

As international trade became more and more complex, new job descriptions came into being in Egypt. For example, in inscriptions dating from the New Kingdom (1550–1070 BCE) the *šwty*, a kind of commercial agent who established the contact between provider/producer on the one hand and intermediary/consumer on the other, is mentioned for the first time.

Trade-related cultural exchange gained new momentum in the 7th century BCE, when the Phoenicians and Greeks established their trading posts around the Mediterranean. The largest settlement on Egyptian territory was the port of Naukratis, a little upriver on the eastern bank of the Canopic arm of the Nile, where Pharaoh granted the Greeks leave to settle. In the light of new research, Naukra-

see to begin with beneath a layer of sediment 80 centimetres deep, were two large, shapeless blocks that looked like rocks covered in sediment." Visibility was at most 30 centimetres. Goddio examined the blocks more closely and, with the aid of a spatula, managed to jettison some of the sediment. Stone came into view below it. Now the divers began systematically removing the deposits – and were surprised at what they found: blocks of pink granite, meticulously hewn, some inscribed with hieroglyphs! On one of the stones they could make out the cartouche of Apries, a pharaoh of the 26th dynasty of Egypt. Apries ruled Egypt from 598 until 570 BCE and went down in history for a series of unsuccessful military adventures. But since he could not havè had anything to do with Alexandria, the stones must have come from another site and only been recycled as building material – a perfectly common practice in ancient Egypt. "The stone with the hieroglyphs was the first artifact with an inscription that we recovered from the harbour," Goddio remembers.

Antirhodos was to hold even more surprises for the archaeologists, however. The island revealed itself to be entirely covered with stone paving and slabs, and on subsequent dives the team found the remains of timber piles beneath a carefully paved area. Their dating furnishes the proof that buildings stood on this spot as long ago as the 5th century BCE. Alexander the Great was therefore not the first to establish a settlement in this sheltered bay. Returning to the paved area, the divers discovered the foundations of a palace dating from the 3rd century BCE as well

---

tis came into being in the late 7th century BCE, roughly at the same time as the border post that would soon after grow to become the port of Heracleion. To begin with, however, Naukratis was still the hub of the Egyptian trading network in the Mediterranean region. In the 6th century BCE, Pharaoh Amasis (570–526), whose wife was a Greek from Cyrene, gave the Greeks permission to build their own shrines there.

The coexistence of different faiths led to a religious practice that was not unusual: the common worship of deities. The Greeks identified the fertility god Dionysos with the Egyptian god of the dead, Osiris; the god Herakles, protector of sports stadia and palaces, was associated with the Egyptian god of the moon, Khonsu, who was the son of Amun, the supreme deity. The Greeks equated Isis, sister and spouse of Osiris, with the goddess of motherhood, Demeter; and the god Serapis, to whom great temples were dedicated in Canopus and in Alexandria,

embodied the combined characteristics of a number of Egyptian and Greek deities, bore the features of Zeus and, from the time of Ptolemy I (306–282 BCE), the self-proclaimed *Soter* (saviour), was even worshipped as the "God of the Empire".

Then again, Egyptian deities and cults also came into fashion. The Egyptian dwarf god Bes, who was the patron of childbirth and more besides, had been widely revered in Cyprus, Syria and Phoenicia, and it was probably Phoenician merchants who even carried the cult of Bes as far as Ibiza. Later, the cult of Isis attracted a great following, also in the Roman Empire, and evidence of its existence during the Roman imperial period has even been found north of the Alps. The cult of the Egyptian mother goddess survived in Europe until the early 6th century CE, when it was already all but forgotten in Egypt.

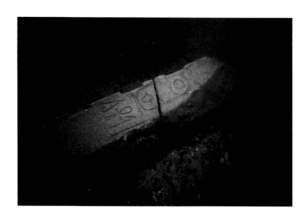

Part of a doorpost covered with hieroglyphs that was discovered in 1998 ...

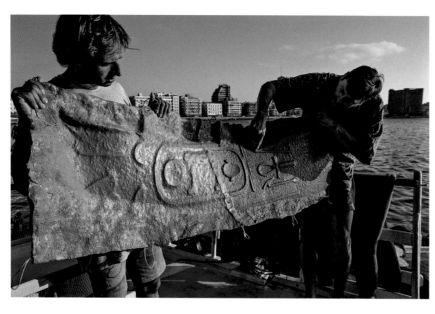

... and a silicone cast of the doorpost Goddio made underwater. Left, the late underwater photographer Fernando Pereira, who died in 2005; right, diver and artist Patrice Sandrin, who records the finds.

More than 2,000 years ago, the feet of pharaohs and scholars crossed these paving stones in the palace quarter of Alexandria.

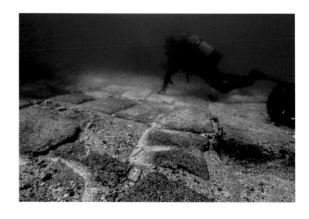

as the rubble of a pink granite column, amphorae, vessels, oil lamps, jewellery, coins, statuary fragments – a veritable cornucopia of history – and once again confirmation of the more than 2,000-year-old reports of contemporary witnesses.

As they neither could have nor wished to recover all of the artifacts, the researchers used technology to ensure the scientific evaluation of the discoveries at a later date. The position of each find was precisely plotted with the aid of GPS antennae, which received both satellite signals and those of a reference station on the shore, and then charted and saved on the digital map. This meant that, if required, the position of every single object could be determined precisely to within less than 50 centimetres. On the seabed, the men wrote on special plastic film, typed data into a waterproof laptop, and, using a specially developed mould, took silicone casts in situ of some of the inscriptions, so that they could be deciphered on land later on.

It was a Tuesday, 7 October 1997, "and a date I will never forget," Goddio still says today. Oceanex was the name of that trip's white research vessel, which he had moored opposite to the Corniche, Alexandria's waterfront promenade, and close to the submerged Antirhodos. The sea was choppy, and there was a cold north wind blowing, making work laborious. The waves were higher in the afternoon, and clouds were gathering in the sky. It did not look like being a good day. It would turn out to be the best of the entire mission, however.

"On the very first dive," Goddio reports, "the team unearthed a sphinx of grey granite!" A little later, the divers found another sphinx, immaculately preserved and made of black diorite. As would later become clear, it bore the features of Ptolemy XII, Cleopatra's father. Two such magnificent finds in a single day; that was a first!

But the run of luck was not yet over. Two days later, on 9 October, Mostafa El-Dessouki Abbas dived down to a statue he had discovered on Antirhodos that morning, just a few metres from the two sphinxes. Abbas, an archaeologist, had previously been involved in a number of excavations on land. Now he headed the Egyptian diving team for the Department of Underwater Archaeology at the Supreme Council of Antiquities. Very gently, he touched the figure, ran his fingers over its head, examined its form. "A woman," he thought, "with a child in her arms." Abbas swam back and reported to Goddio. Then several divers set to work cleaning the statue underwater, while a digital camera transmitted the images to the team on board the research vessel. And that is how, little by little, the true figure came to light: it

A golden ring with an engraved stone, fashioned sometime around the year 0. The divers found it in a shipwreck in the harbour of the submerged palace island of Anti-rhodos.

Ancient paving stones and the stumps of wooden stakes were found in many spots around the submerged eastern harbour of the ancient Egyptian capital.

was a man, not a woman. But visibility was poor, floating particles clouded the water like fog. "Then, suddenly, like a puff of wind, a current carried off the particles."

Now everyone could see what it was, even the crew on board the Oceanex. Before them stood a priest of the goddess Isis, 122 cm tall, with a smooth-shaven head, and dressed in a tunic. He had an air of dignity; an expression of almost total serenity. In his arms, he was holding a vessel from which the head of the god Osiris protruded. The team gazed in wonder at this unique phenomenon until there was too little light to make anything out. "When the image blurred in the water, I felt as though I had seen a ghost," Goddio would later note in his book *Sunken Treasures*.

And so here, once again, everything came together to form a coherent picture: the two sphinxes, the statue of the priest – they could be proof that, as handed down by Strabo, Antirhodos was the site of a shrine to the goddess Isis, who in Egyptian mythology was both the sister and spouse of Osiris, goddess of the dead and protector of the living.

Since then, Goddio has returned year after year with the IEASM team to the Portus Magnus, latterly with the Oceanex's successor, the large research vessel the Princess Duda. They measure the old coastline precisely to the centimetre, survey the area where the royal palaces stood on the submerged sections of Cape Lochias, and chart former docks and the royal harbour, in which the galleys lay moored.

The divers work tirelessly in the water, from six o'clock in the morning until sunset. On Antirhodos they found a granite pedestal with inscriptions from the time of the Roman emperor Caracalla, who subjected the Roman Empire to a bloody reign of terror between 211 and 217 CE, and in 215 also visited a terrible bloodbath upon the inhabitants of Alexandria. Not far from there, quite close to the old shoreline, they discovered a large bust hewn in black stone – a granite portrait of Caesarion, son of Julius Caesar and Cleopatra. And they also found a small, royal harbour in the south of Antirhodos – and hidden beneath the sediment, the wreck of an ancient ship.

Every year, they make new finds, penetrate deeper into the past life of Ptolemaic Alexandria. And there's no end in sight because so much still remains undiscovered. Where, for example, are the remains of the great warships, which were moored in the harbour basin when Julius Caesar commanded the scuttling of the entire fleet during the battle against Cleopatra's brother, Ptolemy XIII?

"One might have expected to find at least 200 ships in this large harbour," says Goddio, "but so far, we have only two." Where

Diver Bernard Camier carefully cleans a grey granite portrait that was discovered opposite Antirhodos in May 1998. It is presumed to depict Ptolemy XV, also known as Caesarion, the only son of Cleopatra and Julius Caesar.

The foot of a statue that once stood in Alexandria. IEASM divers took a silicone cast of it in order to decipher the engraved inscriptions on board the ship.

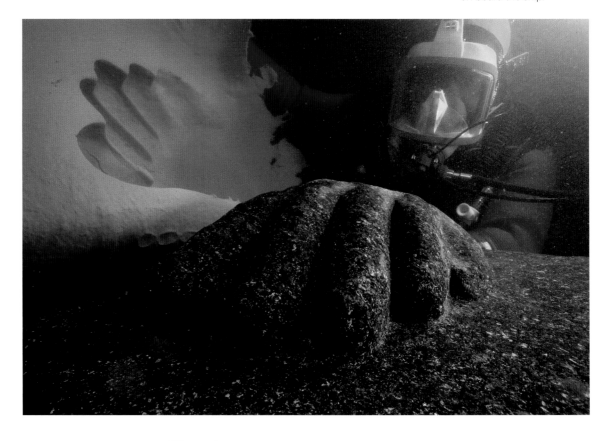

are the others? Buried metres deep below the sediment, waiting to be discovered? "The submerged city of Alexandria holds many open questions for us," says Goddio. "And to tell the truth, we are still right at the beginning of our search for the answers."

A block of granite with an inscription found in the Portus Magnus of Alexandria

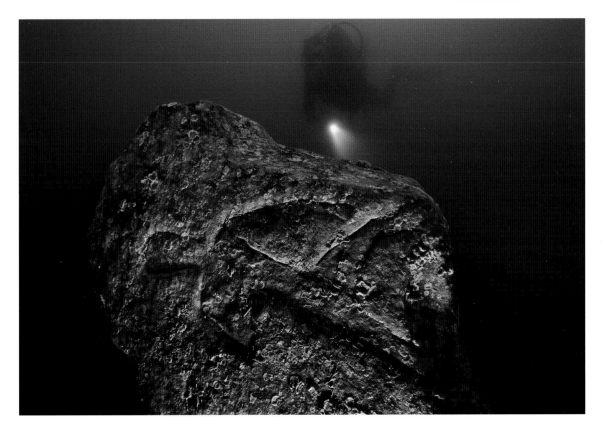

A curious sea bream eyes the barnacle-infested head of a priest dating from the Ptolemaic period. This is how Goddio's divers found it on the submerged Poseidium Peninsula in Alexandria in 2008.

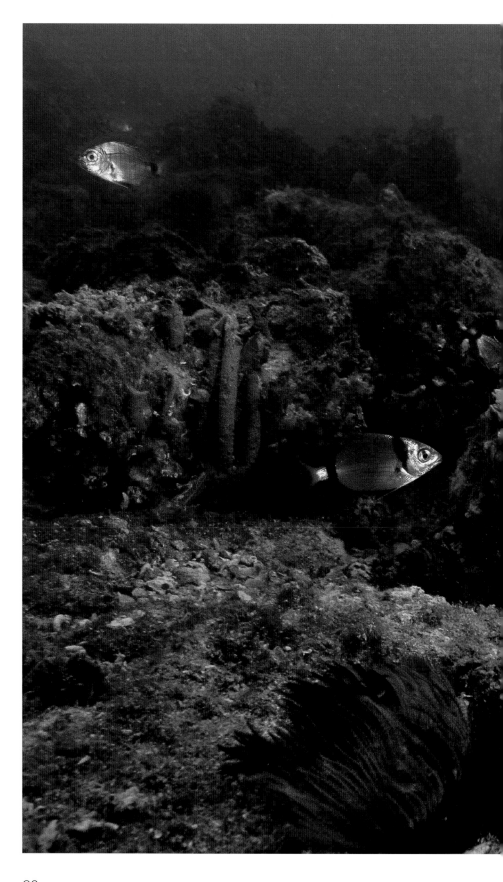

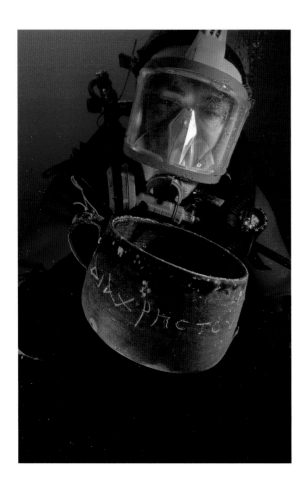

A fine-walled clay dish with a mysterious inscription, dating between 100 BCE and 100 CE, which archaeologists found in the water close to the waterfront promenade in Alexandria in 2008. The Greek text reads "DIA CHRESTOU OGOISTAIS". Is it a reference to Jesus Christ or was it a sacrifice to the god Ogoa? Ogoa was the name given to Zeus, the father of the Greek gods, by the Carians of Asia Minor who settled in Egypt and remained there for centuries.

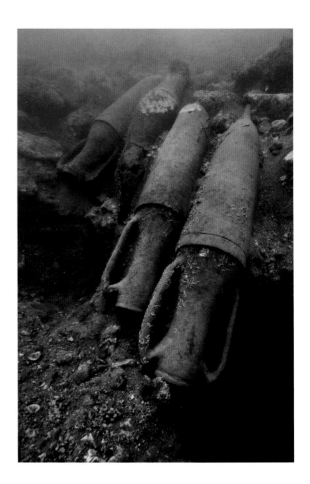

Well-preserved amphorae discovered in the Portus Magnus in 2010

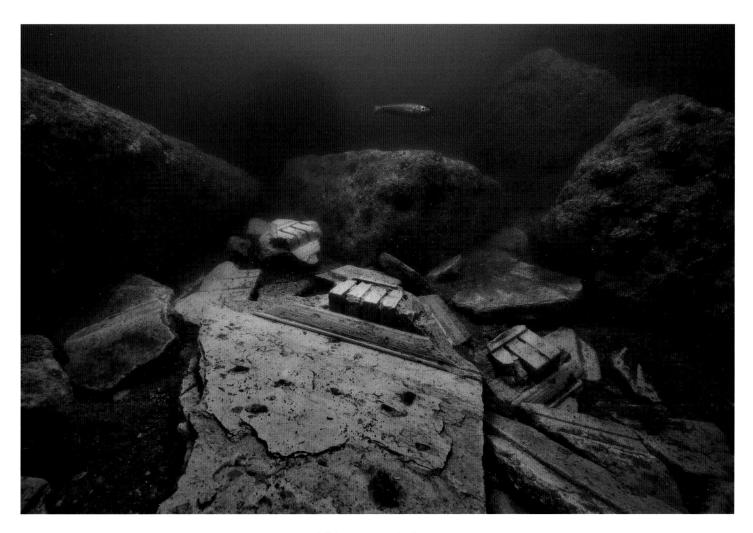

A fish appears to be the
only visitor among the
ruins of the Temple of Isis
on Antirhodos. Vestiges
of fine architecture today
lie shattered between
huge limestone blocks
from which the temple
walls were once built.

In the evening, Alexandria's waterfront promenade, fringed by a long line of concrete buildings, morphs into a glittering string of fairy lights. In ancient times, the spot where the Princess Duda now lies at anchor also buzzed with life.

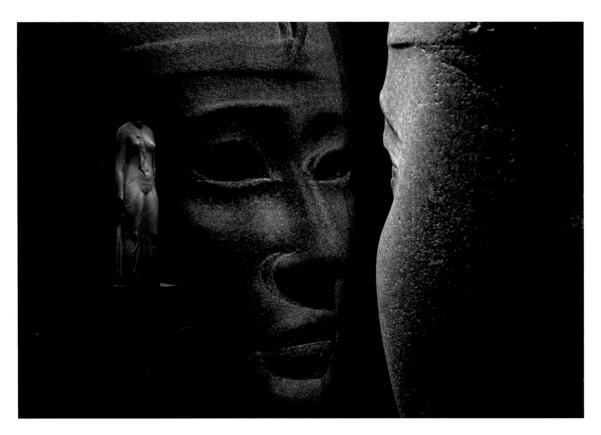

Madrid 2008. Queen meets king in the exhibition hall of the Matadero in Plaza de Legazpi square: the statue in the background dates from the 3rd century BCE and is thought to be of Arsinoë II; in the foreground, a pharaoh from the Saitic dynasty, which ruled Egypt from 664 to 525 BCE.

# Finds from the Deep
# A Challenge for Science

When the RIB ties up beside the Princess Duda after a good 20-minute ride across the waves in the Bay of Aboukir, Damian Robinson is the first passenger to climb up the ladder and over the railing. Franck Goddio welcomes him with a smile – a brief, but warm reception – and comes straight to the point: "We have made some fantastic finds, come on in and take a look." Taking his visitor from Oxford by the arm, he opens the mess door and walks over to the large screen on the left-hand wall of the cabin. The screen shows the topography of Heracleion.

"Here, a small Greek temple." Goddio points to a group of blocks marked on the map. A Greek temple in the pharaonic seaport? Before the arrival of Alexander the Great? Robinson looks astonished. "We don't know who the temple was dedicated to," Goddio continues, "Dionysos perhaps?" Dionysos was the Greek god of fertility and ecstasy. In pharaonic Egypt, the Greeks associated him with Osiris, the god of the dead, who was also worshipped as the god of fertility. According to their respective legends, both deities, although at home in completely different cultures, were murdered and torn apart because of family feuds among the gods. However, both were also restored to life afterwards. According to Herodotus, there were even resemblances between the feasts held in their respective honour. This, too, could be the answer: the annual festivities held in honour of the god Osiris also took place in Heracleion, not far from the remains of the Hellenic temple. "Could it be that we have discovered a Greek quarter to the city?" asks Robinson, audibly excited. It would be a first for the pharaonic gateway to the world. "Quite possible," replies Goddio, "we will have to investigate."

Robinson joins the excavation team of the Princess Duda on almost every one of its missions in the Bay of Aboukir. The youthful-looking scientist with a PhD in classical archaeology is head of the team excavating an ancient Egyptian cargo vessel the IEASM divers found in what was once the harbour of Heracleion. First and foremost, however, he is the Director of the Oxford Centre for Maritime Archaeology (OCMA), which was founded in 2003 as part of the School of Archaeology of Oxford University. The

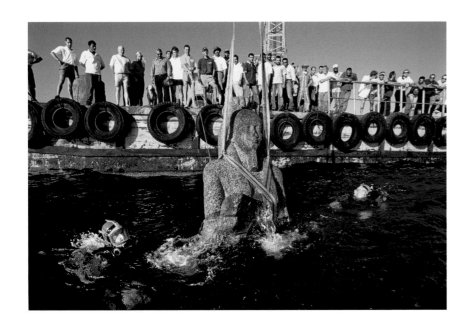

Hapi, god of the Nile flood, rises from the sea as Goddio's expedition team looks on. In the 4th century BCE, the statue stood in front of the Temple of Amun-Gereb in Heracleion alongside those of a pharaoh and his queen. Close to these, the divers also found a stele over six metres high erected by Pharaoh Ptolemy VIII. In spring 2001, the four monumental finds lie alongside one another on top of a 500-square-metre pontoon.

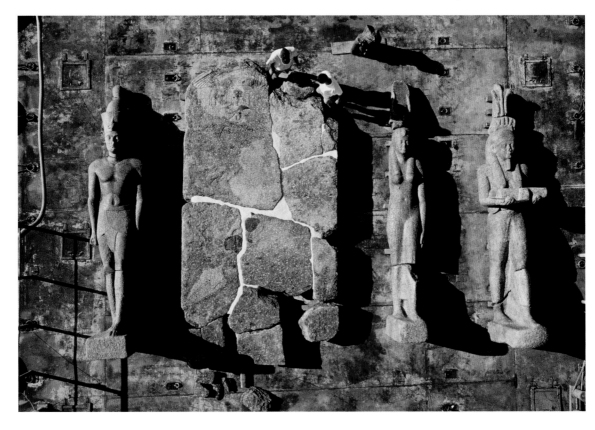

OCMA is the scientific backbone, at it were, of Goddio's research off the Egyptian coast. Here, too, the lion's share of the funding for staff, operations and postgraduate scholarships comes from the Hilti Foundation.

The fertile three-way connection between Goddio's European Institute for Underwater Archaeology, the Hilti Foundation and the venerable University of Oxford is founded on a British peculiarity; since its foundation more than 800 years ago, the university and its colleges have always relied upon the philanthropy of its benefactors to support it as a seat of learning, especially since even in Great Britain respected academic institutions such as Oxford University are increasingly beset by dwindling government funding.

The collaboration between the French archaeologists and the ancient English university was in no way a foregone conclusion, however. Rather, it came about due to the sheer volume of information Goddio had gathered in Alexandria and, in the ensuing years, also from the ruins of Canopus and Heracleion, which urgently called for scientific analysis, classification and discussion. Another important factor was that many archaeologists, Egyptologists and historians often reacted with irritation and even hostility when the man from Paris whose academic background was very different from their own presented his archaeological finds at symposia and in exhibitions. What Goddio had to show for his work, what he presented to academia and to the non-academic public alike in many cases simply did not accord with the established school of thought. He was met with hostility, doubt and scorn. Germany's *Der Spiegel* magazine decried him as a "treasure hunter" and a "snorkeler" – even after he had presented his first finds from the sunken palace quarter of Alexandria's Portus Magnus and set the world at large marvelling. The Trier-based archaeologist and doyen of Alexandrian research in Germany, Günter Grimm, who died in 2010, only later reconciled himself to the results of Goddio's research – having previously relied for his work on a plan of Alexandria based on his own findings, which in the light of Goddio's measured data proved to be incorrect. No scientist is happy to have another call his life's work into question.

Around the turn of the last century, Goddio and the Hilti Foundation were gradually coming to realise that the IEASM needed a university partner if it was not only to continue its successful research, but also to publish and throw its findings open to discussion in the scientific community. An academic structure was needed, says Goddio, "one we could hand our data

Feet first, head to head with his queen, the pharaoh from Heracleion travels on a flatbed truck from Aboukir to Alexandria.

Hapi in Paris. In 2015, the god's statue waits between the glass fronts of the Arab World Institute to be brought into position. It takes three days for the colossus to be erected for the much-visited Osiris exhibition.

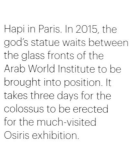

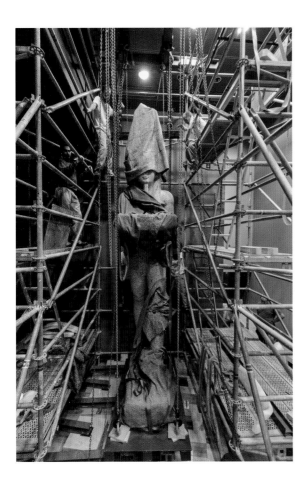

Two complete sets of scaffolding were required to bring the monumental statue of the god into position …

… and the technology used to erect such colossal statues has hardly changed over millennia.

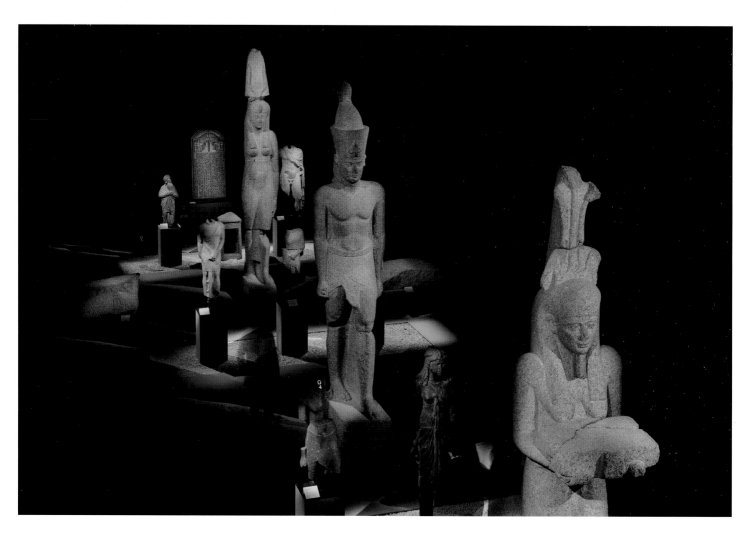

Hapi, pharaoh and his
queen in Turin in 2009.
The exhibition of Egypt's
sunken treasures has
delighted millions around
the world.

and finds over to for analysis and with which we could collaborate indefinitely."

But how do you go about finding a university that can offer the necessary expertise, on the one hand, and is willing, on the other, to make a long-term commitment?

Georg Rosenbauer of the Hilti Foundation, who was involved in the search for just such a university partner at the time, recalls that it was a long process and a not entirely easy one. They began trying in Germany and certainly met with interest at the universities they approached. The only reasons for their lack of success there were bureaucracy and the federal system – in other words, the fact that decisions about setting up and running study courses and university research institutes, and also about their funding, are ultimately the responsibility of the ministries of the individual federal states. Such processes not only take time; they are quite often also subject to political premises – and political premises can change.

So Rosenbauer fell back on some old connections and asked around in the USA. There, however, he was met with no particular interest. In the end, the foundation's emissaries owed its contact in Great Britain to a German archaeologist, Cornelia Ewigleben, who had studied classical archaeology in Oxford in the 1980s and headed the Antiquities Department of Hamburg's Museum for Arts and Crafts in the 1990s. She had shown the *Treasures from the Deep* exhibition there in the summer of 1999 – which featured some ancient Chinese ceramics that Goddio had brought up from the wrecks of five Chinese junks sunk off the coast of the Philippines. "That's how I came into contact with Georg Rosenbauer, Goddio and Dieter A. Irion, his media consultant in Hamburg," says Ewigleben, Director of the Württemberg State Museum in Stuttgart. "I was fascinated by Goddio's work in Egypt," she says, "and it was clear that he urgently needed a good academic partner."

Ewigleben thought of her old alma mater. Oxford is one of the most prestigious academic seats of learning in the world, as well as being one of the oldest. No one knows the exact year in which it was established, but Oxford, which was founded in the early 13th century, is probably the third-oldest academy in Europe after the universities in Bologna and Paris.

Ewigleben put the researchers in touch with Professor Roland R. Smith, a Scot and also an expert on Hellenic history and the Eastern Roman Empire, at the Institute of Archaeology in Oxford; and also with Barry Cunliffe, Professor of European Archaeology. "There, they realised what an opportunity they were being offered," she recalls. And Rosenbauer adds, "Oxford was thrilled

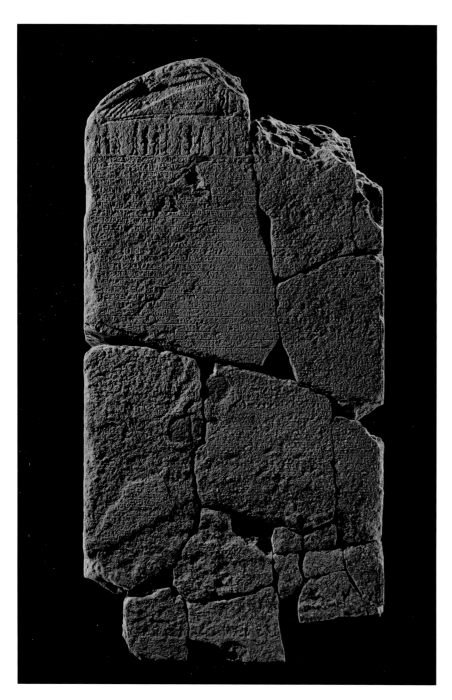

The monumental stele dating from the 2nd century BCE is covered with hieroglyphs and Greek texts, although many of the inscriptions are no longer legible. The texts are mainly in praise of Ptolemy VIII's regency.

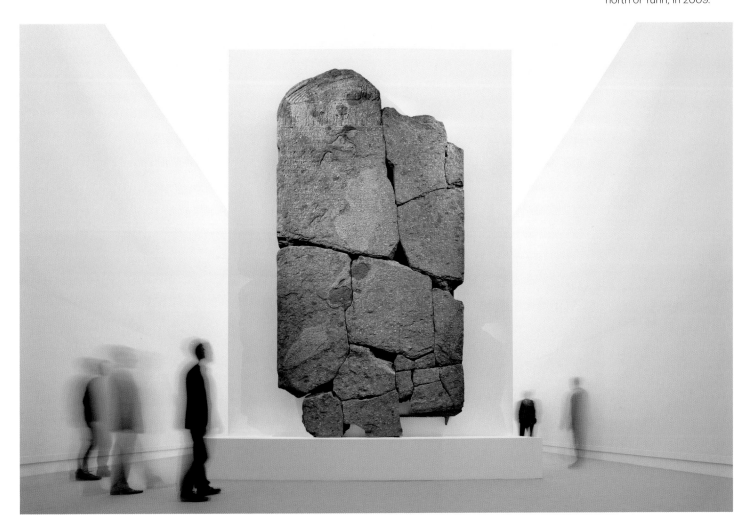

The red granite stele, broken into 17 pieces, weighs a total of 15 tons. Here, its presentation at the exhibition in the palace of Venaria Reale, north of Turin, in 2009.

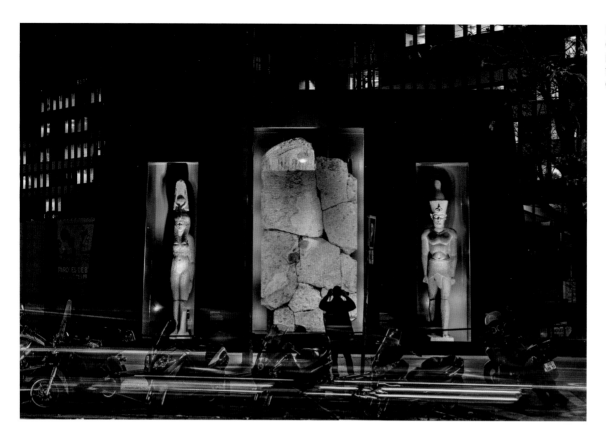

Paris 2015. The large stele of Heracleion, framed by pharaoh and his queen, at the Osiris exhibition in Paris curated by Franck Goddio.

The Arab World Institute, Paris 2015. Left, images of Osiris; right, a 1:1 panoramic photo, taken by Christoph Gerigk, of the processional barque found in Heracleion.

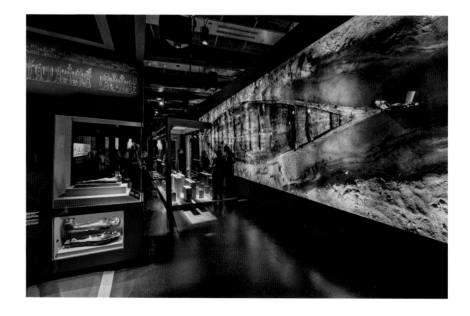

with the idea. We were immediately invited to tell them what we had in mind." Rosenbauer headed straight to Oxford with Goddio and Irion, where their proposals were soon outlined. The Hilti Foundation wanted to cover the costs of personnel and the work of the institute, as well as postgraduate scholarships; the university would select the academic staff and guarantee full integration of the institute into its teaching activities. Awaiting the delegation in Oxford were not only Cunliffe and Smith, but also Andrew Wilson, then head of the newly restructured School of Archaeology. "Before that, not many of us had heard about any sunken cities," remembers Cunliffe – "Sir Barry Cunliffe" since he was knighted in 2006. And so they were bowled over by what Goddio had to show them. "It was hard to credit. We had no idea that there were so many first-class finds under the sea."

Following a series of negotiations, the idea was ultimately submitted to Vice-Chancellor Sir Colin Lucas. At that time, he was engaged in dusting off and reorganising the structures of the venerable university; so there was room for new departures. Why, after all, should a university situated over 100 kilometres from any sea not run a centre for underwater archaeology? Especially since Goddio's presentation opened up exceptionally good prospects of acquiring further academic merit. Lucas did not have to be asked twice – and the Oxford Centre for Maritime Archaeology opened its doors in 2003.

The centre started in a small way with an undergraduate course in underwater archaeology, says Robinson, alongside the supervision of students working on their doctorates. More recently, the centre has developed a postgraduate masters course to help bridge the gap between undergraduate classes and doctoral research. Goddio also lectures there these days. He is a fascinating speaker and says he really enjoys giving the lectures. What's more, since 2015, the OCMA has been an associate member of the international UNESCO Network for Underwater Archaeology (UNITWIN).

Robinson has just moved into a new office with the OCMA – the School of Archaeology is spread across three different locations in Oxford. On his desk, an underwater camera, a flat-screen computer with a keyboard and a large quantity of papers and books vie for pride of place.

The bookshelf on the long wall, on the other hand, is already the very picture of order – with a row of volumes in blue and black with the letters OCMA on the spine. "The blue ones usually contain a collection of papers on specific topics," says Robinson – publications about trade in the Mediterranean region in

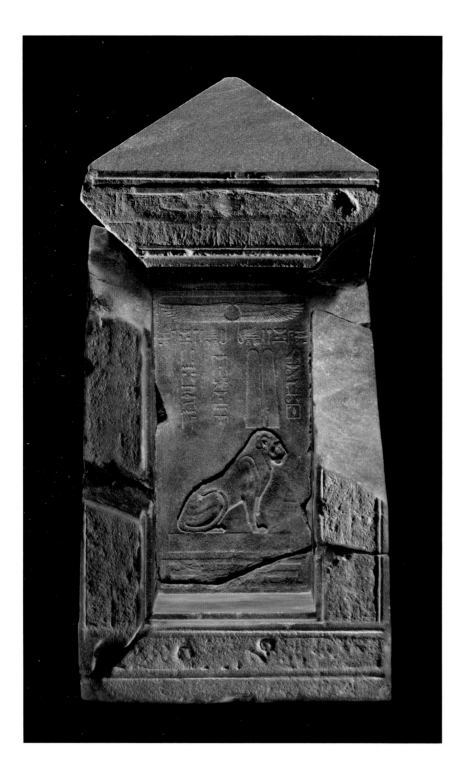

The Naos of the Decades
discovered in Canopus,
a shrine as tall as a man
with what is presumed to
be the oldest astrological
calendar in the world.

The Naos of the Decades was presented to the public in Paris in 2007. The exhibit united the fragments recovered from the Bay of Aboukir with the pyramid block that originally formed the top of the naos, which is housed in the Louvre, Paris.

Berlin 2006. The world premiere of the *Egypt's Sunken Treasures* exhibition in the Martin-Gropius-Bau presents this fragment of a larger-than-life-size statue of Caesarion. In the background, the figure of a queen excavated in Heracleion.

Caesarion was the son of Julius Caesar and Cleopatra VII. Goddio's divers found this bust (here at the exhibition in Madrid in 2008) in Alexandria's harbour.

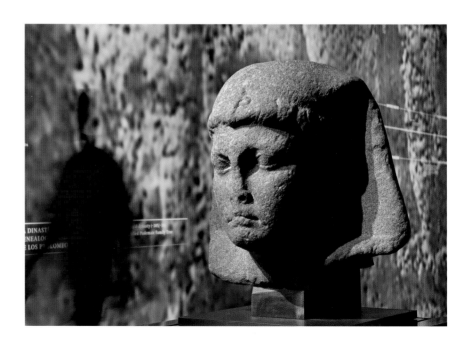

antiquity, for instance, or about Alexandria and the north-western Nile Delta. The black ones, on the other hand, are "detailed scholarly publications on the archaeology of the submerged Egyptian cities. People will still be quoting from them in 200 years' time" – that is the kind of time frame in which scientists in Oxford are accustomed to thinking.

The institute's own publications, however, take up only a small amount of space on the shelves, most being occupied by works on classical archaeology, and above all on Pompeii. Before taking on the directorship of the OCMA in 2007, Robinson spent several years studying the Roman port at the foot of Vesuvius, focusing especially on the role of wealth and the development of social inequality. Lost ports are rewarding objects for study, although these two characteristics do, in fact, exhaust the similarities between Pompeii and Heracleion and Alexandria because only certain aspects of archaeological work on the seabed are comparable to that on land.

"I was able to spend days gazing at a wall, waiting for enlightenment in Pompeii," says Robinson, comparing then to now. "Underwater, that's impossible," – and not just due to poor visibility.

Everything takes longer beneath the waves. For example, you might just have finished laboriously unearthing a find, the capital of a column perhaps, or a statuette, and then along comes a storm and everything vanishes: then "there's nothing for it the following day but to start again from scratch." Technically speaking, drawing a plan of the site underwater is no different from doing so on land, it just takes more time. Also, in the waters off the Egyptian coast, it is not possible to gain a clear picture of the excavation site from an elevated position. At least the 3D images of the uncovered finds that Christoph Gerigk takes great pains to produce provide a substitute. Gerigk, one of the most experienced underwater photographers in the world, has been a member of Goddio's team for many years.

Graduate study here is also different from the usual type of archaeology course, particularly for the students doing research on the artifacts found in Heracleion. "In order to understand what it's like working underwater, we encourage all of our students to learn to dive; after all, I had to," says Robinson. "Even if they are only studying small statuettes of Egyptian gods or lead objects, diving and understanding the technology that we use underwater is of great use in their studies as it helps them appreciate the opportunities, as well as the limitations, of working on the seabed."

Study trips on board the Princess Duda are part of the curriculum at the OCMA. For the Hilti Foundation students, trips out to

Quite a crush at the improvised press conferences in Aboukir harbour, where Franck Goddio and representatives of the Egyptian Ministry of Antiquities present their monumental finds from Canopus and Heracleion

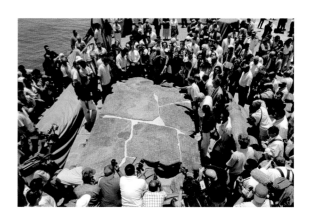

Aboukir, 2000. Franck Goddio (foreground) and Gaballa Ali Gaballa, then Secretary General of the Egyptian Supreme Council of Antiquities, give interviews on deck after the discovery of the Arsinoë statue in Canopus.

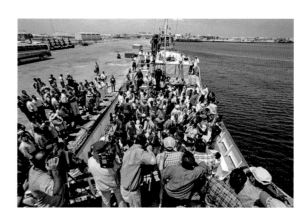

Presenting the Findings

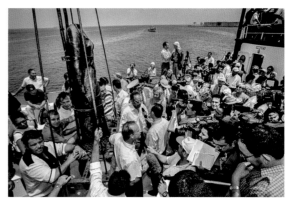

the Princess Duda are also a must. "We place great emphasis on this close cooperation and communication between the teams on land and at sea," Robinson explains, "after all, we have a great deal to learn from each other."

Underwater archaeology is not a matter of "finding as many statues as possible," but of recognising "how things correlate," what the finds can tell us about relationships, about trading contacts, religions, events and, in essence, the lives of ancient people.

The aim of the centre in Oxford is therefore not to produce narrow specialists on subjects such as ancient port facilities or shipbuilding techniques, but well-rounded, open-minded researchers." They need to know the detail, of course, but we also want our students to be capable of combining this with the ability to use cutting-edge technology and also to discern the "big picture," even under extremely difficult working conditions.

"Franck Goddio sees land where there's water," says Robinson. And that is precisely what it takes to be a good underwater archaeologist. Without that ability, it is as impossible to answer the big questions that arise during work on underwater ruins as it is the smaller ones, such as what was the significance of the Greeks' having been able to erect their own temple in the religious centre of a pharaonic seaport 2,500 years ago.

It is the job of archaeology to unearth the – literally – buried history of humankind, the history of entire peoples and societies and that of regional and local communities alike. "That's why our main objective in sponsoring the work of Franck Goddio and the European Institute for Underwater Archaeology was always to give back to society the knowledge gained from the excavations," explains Michael Hilti, cofounder of the Hilti Foundation. An important means to achieve this is to maintain a public presence.

Since the scientists alone cannot achieve this, the Hilti Foundation entrusted that task to the salaction public relations agency in Hamburg. "First of all, our job was to present the work of the underwater archaeologists and their unique finds from the Portus Magnus of Alexandria to the public, which had previously known nothing of them," says salaction cofounder Dieter A. Irion. In the mid-1990s, large sections of the public as well as classical archae-ologists still regarded maritime archaeology as a special field of treasure hunting. "That's why we organised a press conference right where the excavations were in progress." It was held on Sunday, 3 November 1996. The agency had booked the large function room at the Helnan Palestine, a luxury hotel in the grounds of the Montaza Palace in Alexandria, right beside the Mediterranean.

Even in the weeks before the press conference, the various media in Europe and the USA had reported on Goddio's discoveries. Speculation had focused chiefly on the sunken palace island of Antirhodos that Goddio's team had discovered, where Cleopatra is presumed to have once resided. That was why the communication strategists at salaction had expected intense interest from the media, "but what actually happened surpassed all our expectations," says Irion. Nearly 200 reporters from all over the world came along – "and all of them had paid the travel expenses for their own trip," Irion points out.

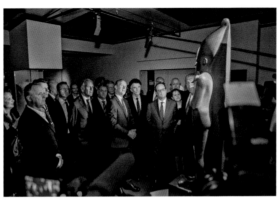

The first exhibition at the Grand Palais in Paris was opened in 2006 by then French President Jacques Chirac. At the second, nine years later, President François Hollande gave a speech at the Arab World Institute.

Rather unusual for a press conference, however, were the guests occupying the two front rows: the then Egyptian Minister of Culture, Farouk Hosny, was not about to miss the event any more than Abdel Halim Nur el-Din, at the time Director of the Supreme Council of Antiquities. They were joined by some 50 officers of the Egyptian army and their wives. After all, from the outset Egypt had sent its own divers and scientific personnel to participate in Goddio's underwater missions – and the excavation site was in a military zone.

The press conference, at which Goddio first presented photos and films of his finds, was the breakthrough that brought his research worldwide fame overnight. Regular reports and a number of documentary films about the progress of his work and the scientific classification of the finds followed in the next few years. The Franco-German television channel ARTE, for example, sent a team to the Egyptian Mediterranean coast, as did Germany's

Spiegel TV, the UK's BBC and the United States' Discovery Channel.

And the more the international media audience began to show serious interest in the scientific work of the IEASM, the more another idea took shape for Goddio and his media advisers. Why not take the spectacular finds from Alexandria and Heracleion straight to the public? Why not organise an exhibition quite different from those mounted by museums?

Goddio tells how persuading the Egyptians to agree to the project was not exactly easy. Their reservations were understandable considering that the artifacts the IEASM's archaeological divers had raised would not be the only ones to leave the country for a long time; they would be accompanied by objects from Egyptian museums that were necessary to give meaning to the exhibition. Furthermore, it was also difficult to find a museum willing to stage such a presentation on its premises for a period of more

than just a few weeks. After a lengthy search, an agreement was reached with the Martin-Gropius-Bau in Berlin, one of the most attractive exhibition venues in Germany.

But there was one drawback: the organisers had only about seven months to prepare the exhibition – "others have years," says Irion. "But we were fortunate in that we had no idea what we were letting ourselves in for. Otherwise we would probably not have taken it on." It was like jumping in at the deep end and took an incredible amount of effort – and it all paid off. The famous exhibition designer Philippe Delis (1951–2014) created the scenography, while the aircraft manufacturer Airbus took on the task of transporting the three monumental statues from the ruins of Heracleion – normally an undertaking that would take several weeks. The company sent its own Beluga Super Transporter to Egypt for the purpose – the aircraft is normally used to carry aircraft parts; an ordinary cargo plane could not have taken the colossal granite statues on board.

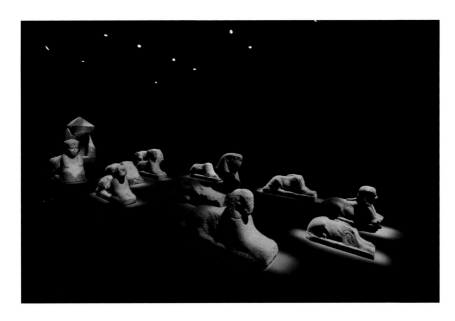

A procession of sphinxes receives visitors in a mystic light – an impression of the Turin exhibition of 2009. Facing page: a view of the first presentation of the finds in the Martin-Gropius-Bau in Berlin in 2006. Visitor numbers broke all records at the time.

On May 11, 2006, the exhibition *Egypt's Sunken Treasures* celebrated its world premiere in Berlin against a scenic backdrop the like of which had never been seen before in an archaeological exhibition. It proved so popular that the staff of the Gropius building even extended their daily working hours. Some 450,000 people visited the presentation over its five months in Berlin before it moved to Paris, Bonn, Madrid, Turin and finally Yokohama. Some of the objects were also shown in several cities around the USA under the title of *Cleopatra – The Search for Egypt's Last Queen.* In the end, Egypt's lost history had cast its spell over several million people around the world, and countless media had reported on it – a unique success.

For the return transport of the monumental statues from Japan to Egypt, the German shipping line Hamburg Süd provided one of its cargo ships. It carried the irreplaceable objects across the Pacific, through the Panama Canal and across the Atlantic back to the Mediterranean.

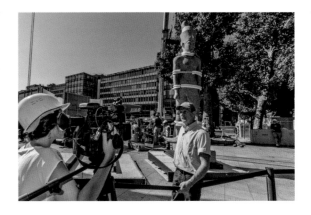

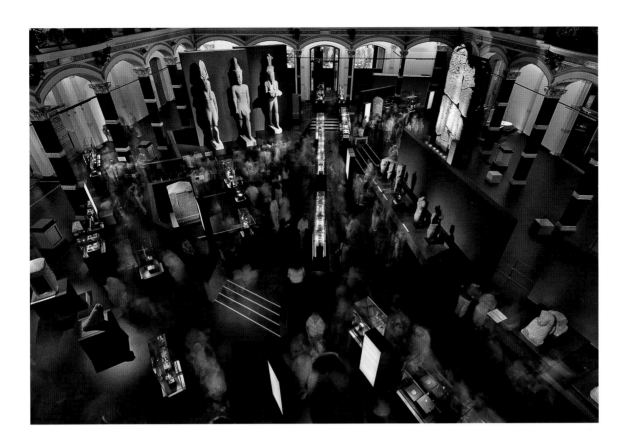

The reason for taking the long way round was to prevent the pharaoh, his spouse and the god from falling into the hands of pirates near the Horn of Africa.

The concept of the mobile exhibition had proved to be extremely successful – this much was by now clear. So Goddio could start organising the follow-up exhibition, *Osiris, Egypt's Sunken Mysteries,* which opened in September 2015 and occupied 1,100 square metres of space at the Arab World Institute in Paris.

While the first exhibition series had chiefly been concerned with bringing places that had vanished beneath the waves back into the collective consciousness, "the second exhibition focused mainly on correlations," Goddio explains. "The god Osiris's triumph over chaos and death is one of the central Egyptian myths." The evidence that Goddio found in both Heracleion and Canopus renders that myth tangible because the Mysteries of Osiris were held in the great Temple of Amun-Gereb in Heracleion

every year. They culminated in a procession, a ritual voyage along the river from Heracleion to the Temple of Osiris in Canopus, where the god made his symbolic descent into the underworld of which he was lord.

The stated aim of these exhibitions was to foster a more profound understanding of the ancient Egyptians' world view and system of values, says Goddio, but without in any way patronising visitors; instead the intention was to arouse their enthusiasm for the deciphering of ancient Egypt's mysteries.

The field of columns in
Canopus. The first time
the divers explored here,
they had to be exceedingly
careful not to lose their way
in the confusion of ruins.

# Canopus
# City of Temples and Taverns

~~~~~

In science, and especially in archaeology, great discoveries are frequently preceded by chance. So it was the day Group-Captain John T. Cull, commanding officer of the Royal Air Force aircraft depot in Aboukir, set out in his single-engined biplane for Nelson Island in the spring of 1933. An unremarkable islet, it is named after the British admiral, Horatio Nelson, who led his warships in a surprise attack and dealt a crushing defeat to Napoleon Bonaparte's expedition fleet on 1 August, 1798.

Looking out of the cockpit, Cull saw the desert, which extends almost to the sea at that point, and here and there a few lowly fishermen's huts and small boats that had been hauled up onto the beach. It was a peaceful day and before long the Mediterranean lay spread out beneath him, blue and clear. In springtime, the waters of the Nile reach their lowest level so that only a little silt and sediment washes into Aboukir Bay from the delta.

Yet were he flying today, however calm the sea might be, Cull would likely see no more than a grey-green expanse of water because now the Mediterranean is clouded all year round by pollution from Cairo and Aboukir, and most especially the effluent plumes from refineries and power plants as well as the algae growth they favour. But in 1933, flying out to Nelson Island, the pilot could still make out the sandy seabed below the calm surface of the water.

Cull loved gazing into the crystal depths of the Mediterranean, a view he had often enjoyed. But this time – he was by now almost two kilometres from the coast – he sighted something at the bottom of the sea that he had never noticed on previous flights: clearly visible in the water, a large, dark structure "in the shape of a horseshoe", as he later described it. Captain Cull had no explanation for it and so at that moment could not imagine that the news of his sighting would soon travel as far as distant Australia.

Back at the military airfield in Aboukir, the officer reported his observation to Prince Omar Toussoun. Toussoun, a scion of the Egyptian royal family, was an educated man, an intellectual, in his sixties, and had dark, bushy eyebrows that contrasted sharply

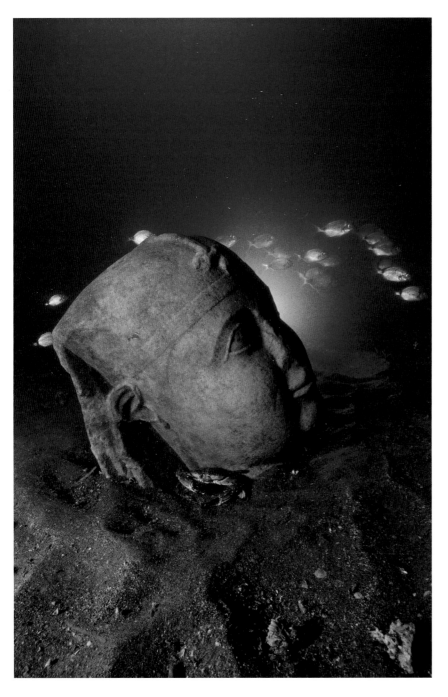

The underwater archae-
ologists discovered this
portrait of a pharaoh in
the ruin site of Canopus
as early as 1999. It was
hewn in quartzite in the 7th
century BCE and was prob-
ably the head of a sphinx.

with the grey of his hair and moustache. Toussoun owned large swathes of land in the Bay of Aboukir, and the site on which the Royal Air Force had built its airfield also belonged to him. Most importantly, however, Toussoun was a researcher of some repute, a member of the Royal Archaeological Society of Alexandria, and passionately interested in the history and archaeology of the region. The prince had already been searching for quite some time for signs of the vanished cities of Canopus, Menouthis and Heracleion, which must once have been situated somewhere hereabouts. Over and over again, ruins and archaeological finds had been discovered on the peninsula to the west of Aboukir and along the coast. Even the remains of a small temple had been found, as well as cisterns and fish farming tanks. Had they once been part of Canopus?

Sources from antiquity and late antiquity mention that Canopus lay on the coast, roughly 18 kilometres east of Alexandria; Menouthis was said to be situated another three kilometres further away, and yet another three kilometres further east lay Heracleion, which in the pre-Ptolemaic Period was the pharaohs' most important trading port. All three cities were sites of important temples: in Canopus it was the monumental Serapeum in honour of the god Serapis; in Menouthis, an Isis temple; and in Heracleion, an extensive temple complex where the god Amun-Gereb was worshipped and where the Greeks who lived there also worshipped their own god Herakles.

From today's perspective, in the light of Goddio's prospections, it would appear that Canopus consisted of a number of settlements dispersed across a wide area, whereas Menouthis seems to have been more of an eastern suburb than a town or city in its own right. But that knowledge was not yet available to Prince Toussoun. The distances reported by ancient witnesses also proved inaccurate in the light of modern surveys because the eastern part of Canopus was only four kilometres away from Heracleion.

Toussoun was electrified, at any rate, when the British Air Force pilot reported his observations to him. And so the prince himself went to talk to the fishermen who took their boats out into the bay and asked them whether they had ever noticed any ruins on the seabed. Indeed they had. They even gave him accurate descriptions of two spots out at sea, where their nets frequently became entangled and where pillars and the remains of large buildings could be made out in the depths.

On 5 May, 1933, a Friday, Toussoun sailed out to take a look for himself. He had hired an experienced diver; also with him on

Traces of the great disaster. After removing several metres of sediment layers, the divers discover deep cracks in the seabed caused by earthquakes and movements.

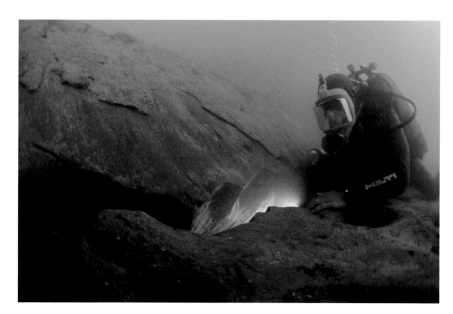

The remains of a building from the Byzantine period, unearthed on the excavation site in East Canopus in 2005

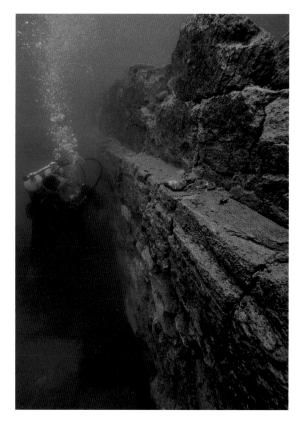

board were the Egyptologist Annibale Evaristo Breccia, the archaeologist Achille Adriani, like Breccia, an Italian, and at the time Director of the Greco-Roman Museum in Alexandria, as well as Dr Puy-Haubert, a physician from Alexandria who was regarded as a great connoisseur of ancient art. When the ship had reached the spot described to Toussoun, he ordered a halt, and the diver let himself into the water and reached the bottom at a depth of five metres.

He found himself standing in the middle of an area covered with ruins and all around him, he could see fallen statues hewn in marble and pink granite.

When he surfaced to report back to the dignitaries waiting in eager anticipation on deck, he brought up a marble head that had evidently once belonged to a statue. Excited, the men immediately began cleaning the object on board. It was Breccia, who, to everyone's surprise, ultimately identified it as a likeness of Alexander the Great.

For Toussoun, there could no longer be any doubt; he was certain he had found the lost city of Menouthis, although he did leave himself an open back door regarding the location: "The origins of Menouthis are veiled in obscurity," – this was the careful wording he chose a year later at a convention of the Royal Archaeological Society. "None of the classical authors has ever mentioned it, and its name only crops up in the second century of the Common Era. It certainly existed prior to that but it was obviously regarded as part of Canopus."

In any case, the discovery was hailed as a sensation. Three months later, the news had even reached the east coast of Australia. On Thursday, 10 August 1993, *The Central Queensland Herald* reported the event to its readers under the headline "Drowned City Near Mouths Of Nile" – and not without the requisite emphasis on the British role played in the discovery: "Vigilance of a Royal Air Force pilot at Alexandria is responsible for what is hailed as one of the most important archaeological discoveries in recent years (...) the exact site of Canopus – the Brighton of Alexandrians during Roman rule in Egypt."

Franck Goddio says that it was Toussoun's story that had prompted him to search in the Bay of Aboukir. "If there had been no Toussoun, I would not even have gone there." As it was, he began by making a systematic geophysical survey of the entire area under investigation in 1996. Compared with what awaited him and his IEASM team in the Bay of Aboukir, determining the ancient topography of Alexandria's harbour was little more than a warm-up for the actual match.

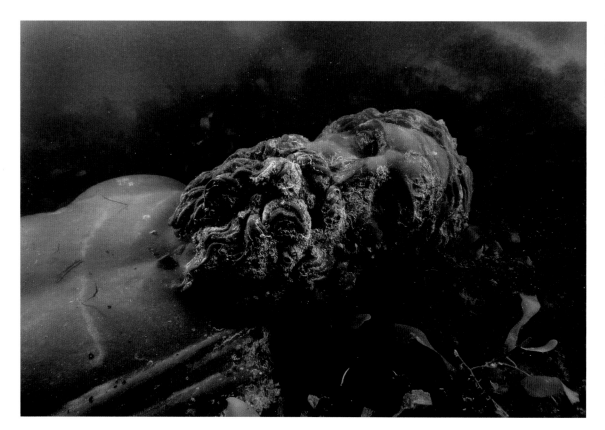

A statue of the Nile near the great temple in East Canopus. It dates from the Roman imperial period and has survived more than 1,800 years.

This king's head from the 26th Dynasty (664–525 BCE) is thought to be an image of the Pharaoh Apries or his successor Amasis.

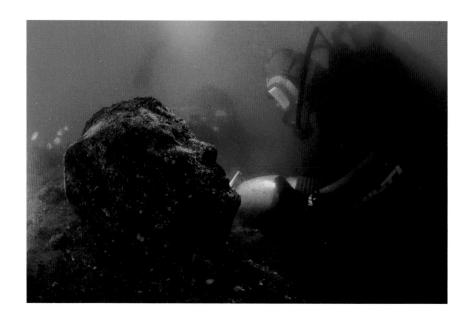

That was because, in response to Goddio's application, the Egyptian authorities had authorised him to explore an area measuring 11 by 10 kilometres in the western part of the long, narrow bay using every kind of technical instrument at his disposal. "What we found here," the maritime archaeologist admits, "was of a completely different dimension."

110 square kilometres of open sea. To map the topography of the land lying beneath this great expanse of water, Goddio chose the same method the IEASM researchers had used once before, in Alexandria. He divided the entire archaeological site into squares measuring ten by ten metres, and a boat carrying a torpedo-shaped magnetometer and towing other geophysical measuring instruments followed the grid lines of each square. That translates into 1,000 straight lines each eleven kilometres long, and 1,100 lines each ten kilometres long – making a total of 22,000 kilometres to be covered by the Zodiac. The catamaran Goddio and his team were using at the time sailed along these imaginary lines for months on end – often on choppy seas. At the same time, it was also important to ensure that the survey lines ran precisely parallel to each other, that the boat maintained a consistent speed, and that the magnetometer's detectors were always properly aligned and not subjected to any abrupt changes in elevation, such as sudden swell. That, in turn, meant that the research team needed the most consistent weather and current conditions possible if the measurements were to supply useful and preferably completely accurate indications of ruins hidden beneath the sediment.

The same applied to the work performed with the multi-beam echo sounder, with which both minimal differences in elevation on the seabed and artifacts lying on top of or protruding from the sediment could be depicted. For the echo sounder, Goddio chose a grid of squares 40 by 40 metres, with squares being reduced to just one metre over interesting spots, where more detailed images were required.

It was a jigsaw puzzle of measurements, a task that would take years. Finally, Goddio tells how they were able to identify two separate areas in which the magnetometric signals indicated particularly conspicuous structures. One of those areas lay roughly 1.8 kilometres from the shore, its eastern edge exactly where Toussoun had thought to have located the lost city of Menouthis, but which Goddio today considers to be the eastern part of Canopus. The other area lay further out to sea, some seven kilometres from the coast. Was this perhaps Heracleion? Or even the mysterious Thonis? Three more years had passed meanwhile, and only now

could the actual archaeological work begin. "We began in East Canopus," says Goddio. "It was easier for us to reach."

Canopus – at the time of the last pharaohs a magical city, the city of temples and taverns, houses of ill repute and divine festivals. It rose to become one of the most important religious centres under the Ptolemies: it was decried by Roman chroniclers as a den of iniquity and destroyed by the Christians in the year 391 CE; later they built monasteries and churches there. Legend has it that Canopus was named after Canobus, Menelaus of Sparta's helmsman. During the Greeks' odyssey that followed their victory over Troy, Canobus is said to have died and been buried on this spot. To the Egyptians, however, the place was known as Pe-Guti.

Every year in the final days of the month of Khoiak, the fourth month after the Nile flood – around mid-November according to our modern calendar – Canopus provided the setting for the festive climax of the celebrations of the god Osiris's reincarnation and his renewed descent into the underworld. The event lasted several days and was for many centuries up to the Ptolemaic Period one of the country's most important religious festivals.

A clay figure symbolising the lord of the underworld and god of fertility was traditionally borne along a Nile channel on a sacred golden barque the three and a half kilometres from his temple in Heracleion to Canopus. In a secret ritual in the Temple of Amun-Gereb, the figure would have been formed from

~~~~~~~~~~~~~~~~~~~~~~~~~~~~~~~~~~~~~~~~~~~~~~~

**Serapis and the Serapeum**

128

a mixture of Nile clay and barleycorn two weeks earlier so that the grains of barley would have begun to germinate and sprout green shoots just in time for the procession. Then the divine statue, oiled and festively decked out, was bedded in a sarcophagus of sycamore wood that bore the likeness of Horus, Osiris's son.

The heavy fragrance of incense hung in the air and thousands of cheering people assembled on the shore, many of them bearing offerings for the deity, which they would throw into the water on his arrival – such gifts could be precious, symbolic or nutritious. Sacrificial offerings of animals were made along the entire route followed by the procession. On arriving in Canopus, the figure covered with green shoots was carried into the temple and buried there – but most probably later cast into the channel outside the temple by the priests – until the Nile flood of the following year, when the god would rise from the dead once more in Heracleion.

Later, the Ptolemies designated the god Serapis their new God of the Empire and in his honour built a monumental temple of white limestone with walls more than a hundred metres long, the Serapeum, which immediately became the religious and social centre of Canopus. Seafarers and merchants carried the news of the new idol and his splendid temple far into Europe, and pilgrims arrived daily to dance and make sacrifices at the feet of the great statue of Serapis. The ancient pilgrimage tourism gave rise to the appropriate services, so that taverns and guesthouses, bathhouses and brothels, soothsayers and healers could be found on

"Canopus is a city that stands 120 stadia from Alexandria. It is the site of the Temple of Serapis, which was venerated as a most sacred building because it was also a place of healing, in which even the most respected men put their trust and either travelled there themselves to be healed overnight or sent someone else on their behalf. Some write of the healings, others of the effects of the oracular dreams they experienced there." If we can believe the Greco-Roman historian Strabo, who travelled the Egyptian coast east of Alexandria circa 25 BCE, the Serapeum in Canopus must have been an interesting sight after sunset: halls filled with sleeping people hoping to be delivered of their own ailments literally overnight "in the face of the god" – or for the ailments of those who had paid them to spend the night in that temple to be cured.

Of the deities in the Egyptian pantheon, Serapis, a syncretic god, was one of the youngest and, in fact, a migrant with a Greek background. It was not until the reign of Pharaoh Ptolemy I in the 3rd century BCE that Serapis was introduced by the pharaoh himself, originally most probably with the intention of making it easier for immigrants from the Hellenic world to combine Greek and Egyptian cult traditions. And so in Serapis, the Egyptian god Osiris and the sacred Apis bull – the name of the new god being derived from their two names – merged with the most important Greek gods, Zeus and Hades. According to Egyptian mythology, the soul of Osiris had survived inside the bull after his brother Seth had hacked his body to pieces.

Since the depiction of Osiris as a mummy did not correspond with Greek custom, Serapis was given the appearance and garb of Zeus, the Greek father of the gods: a man with streaming hair, a full beard and a long robe. On his head, Serapis wears a kalathos, a Greek vessel used to measure grain, the symbol of his capacity as god of fertility and the harvest. He was also a god of healing, an

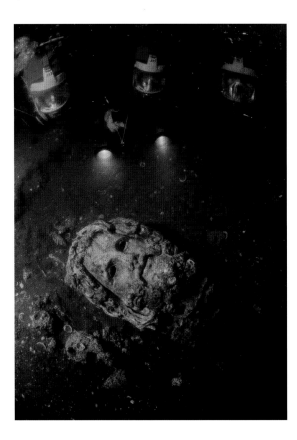

The detached head of the god Serapis comes into view in the light of the divers' torches. It once belonged to a marble statue over four metres tall that stood in the centre of the Serapeum, the great temple of Canopus.

oracle, and the god of the Nile flood. For his wife, he was given the goddess Isis, who in Egyptian mythology was also the spouse of Osiris – as well as being his sister, who helped him rise from the dead.

Since Serapis united the characteristics and personalities of key deities from both cultures, he became the patron deity of the Ptolemies and the God of the Egyptian Empire. However, he did not *replace* the gods from whom he was derived, and their temples and religious festivals continued to exist alongside the Serapis cult until the rise of Christianity. In its turn, the latter soon spread to many cities in Greece and under Roman rule even to Rome and other provinces of the empire. The Emperor Hadrian (76–138 CE) had his own Serapeum built at his villa near Tivoli.

The first Serapeum, a massive complex, was dedicated by Ptolemy I in Alexandria in 285 BCE. No accurate details exist of the construction of the temple in Canopus. During excavations close to Aboukir, however, a gold plaque was found with an inscription telling how Ptolemy III and his wife Berenice II were the dedicators of an Osiris sanctuary in Canopus – which is likely to have been the temple to Serapis. Ptolemy III ruled from 246 to 222 BCE.

A further clue was provided by the so-called Decree of Canopus, which was passed at a synod held in Canopus in the year 238 BCE, where the assembled priests provided for the introduction of leap years to correct calendrical errors, among other things. The synod, according to the inscription, assembled "in the temple of the benevolent gods in Pe-Guti". Euergetes, the Benevolent, was the byname of Ptolemy III; Pe-Guti, the Egyptian name for Canopus. Also, since such an assembly could hardly have taken place in a small, local temple, it is safe to assume that a large temple existed in Canopus at that time. And the "benevolent gods" mentioned in the decree were the pharaoh and his wife. As things stand, it is therefore probable that the temple in question was the Serapeum.

both sides of the canal in the direction of Alexandria. Anyone who came here celebrated with the blessing of the gods, as it were.

These goings-on came to an abrupt end in the 4th century CE, however, at the hands of representatives of a new religious power. When Emperor Theodosius I, a Christian, prohibited all heathen sacrificial cults in the Byzantine Empire, to which the Roman province of Egypt belonged, a band of black-clad men, spurred on by Theophilus, Bishop of Alexandria, stormed the Serapeum of Canopus, smashing its statues, sacrificial altars and shrines and finally razing the entire temple to the ground. To the adherents of the old religion, the Christians' sacrilegious treatment of their gods' statues was a particularly grave crime since they deemed the figure of a god to be the god himself, not merely his image or a symbol.

The Christian hordes ravaged other temples in the city and at once erected their own places of worship on the ruins. The patriarch Theophilus commanded that a church be built in place of the Isis temple, for example. Also, the Metanoia Monastery was erected close to the ruins of the Serapeum and soon enjoyed as high a standing among the faithful, as the Serapeum had a long time before.

When Goddio dived down with the rest of the team to the spot on the seabed where Toussoun had marked the ruins on a map, visibility was once again more than bad and the team could see only ten centimetres ahead. There was nothing the men could do but grope their way slowly forward. Yet what they found there was not what they had expected. "There really was a drowned city spread out in front of us," Goddio recalls, "we kept worrying that we might lose our way in the confusion of ruins." Amid the rubble, they unearthed sphinxes, seals, jewellery and statues.

Their most striking discovery, despite the fact that her hands, feet and head were missing, was a black granite statue of a woman. "After hauling her out of the water with ropes, we all stood there on deck, completely overwhelmed," Goddio reports. Why? Because the sculptor who had created the figure had evidently been a consummate master of his craft: the woman was "draped in a diaphanous, wet cloth that was knotted over her right shoulder and revealed a shapely and alluring body," Goddio writes in *Sunken Treasures*. The statue is presumed to depict Queen Arsinoë II, daughter of Ptolemy I, who was born in 316 BCE, died in 278 BCE, and, as the wife of her brother, Ptolemy II, became regent. The artist had transformed her into an Aphrodite, who appeared to be just stepping out of the water. A fascinating piece of work and one that belies the "goddess of love's" true nature – she

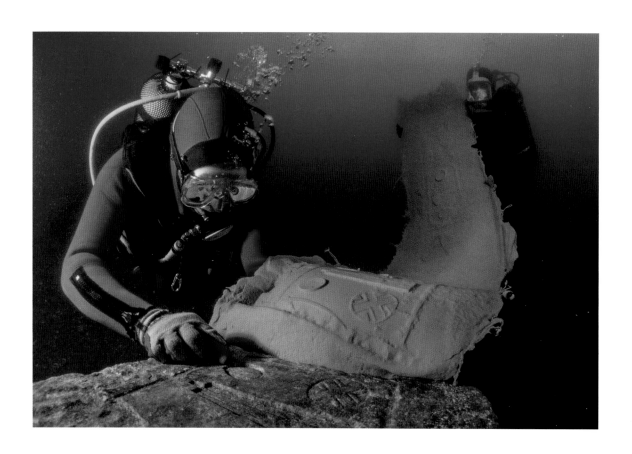

Silicone impressions of the unearthed fragments of the Naos of the Decades (below) and a stone block with inscribed hieroglyphs (above) make the texts reproducible and easier to decipher.

was reputedly utterly ruthless when it suited her. In her lust for power, she sacrificed her stepson, sister-in-law and a number of servants without a second thought.

A second site turned out to be far less sensual but no less exciting. The magnetometer signals had been strong here during the survey campaign – reason enough for the archaeologists to take a close a look at the spot.

To begin with, however, the divers could only make out a large area covered with a deep layer of soft sinking sand. "But," says Goddio, "there had to be something big there." So they decided to start digging. Layer by layer, they very carefully removed the sand, not only to avoid harming any small objects that might be hidden there, but also so as to stir up as little sediment as possible – it always takes an age for sediment to settle again. But then, two metres down, they came up against a wall three metres across made of large limestone ashlars and some toppled columns. In the immediate vicinity, they also found the detached head of a statue: Greek style, benevolent expression, curly hair and a full beard – it was Serapis, the God of the Empire.

The figure must once have been almost five metres tall, and a statue of such a size could only have depicted the chief god of a temple. Goddio was sure the walls, columns and god all belonged to the Serapeum.

Not far off, the team of underwater archaeologists made another significant find, several finds, in fact, each of them rather unremarkable in their own right – stone fragments covered with Egyptian figures and hieroglyphic texts some 2,500 years old. However, these fragments would solve a puzzle that had existed for more than 200 years since they matched a shrine of dark granite. Its pyramid-shaped roof had been dug up on the beach near Aboukir as early as 1777, while Toussoun had retrieved its base and other pieces from the underwater ruins in 1940. Now Goddio's finds supplied most of the missing pieces.

The shrine, as tall as a man, is known as the Naos of the Decades, a naos being a kind of tabernacle. In ancient Egypt, a naos would normally house the statue of a deity – it was literally the "home of god". But the Naos of the Decades was something very special: it is probably the oldest astrological calendar in the world. Its side walls reveal, amongst other things, that the Egyptian year was divided into 36 decades – ten-day periods – each of which was determined by the ascent and descent of particular stars. Each of those stars was assigned to the symbol of its own god. The decades, on the other hand, were assigned to prophesies, and thus each decade influenced nature, the animal kingdom

Precision work. The bust of the Nile from East Canopus is hauled on board the Princess Duda.

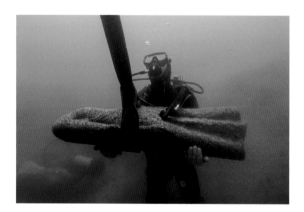

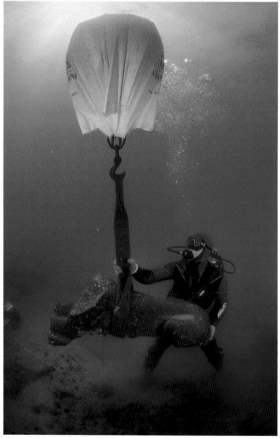

Left: a diver prepares for the raising of a heavy granite statue. Right: an air-filled balloon, here with a sphinx, makes it possible for stone sculptures to float in the water, as though weightless, and for them to be manoeuvred easily by just one person.

and human communities in a special way – the naos is a complex mythological construct that can be difficult to understand.

With the fragments raised by the divers, the experts were now, for the first time, able to read almost in their entirety the texts and images on the Naos of the Decades. "These texts illuminate the stages in the transition from pure observation of the heavens to mythology and ultimately to a kind of astrology that strives for divine protection," as Egyptologist Anne-Sophie von Bomhard writes.

The Naos of the Decades, once reverently read by priests and pilgrims to the Serapeum of Canopus, then smashed and its fragments scattered, is finally reassembled, piece by piece, more than a one and a half millennia later – a once-in-a-century jigsaw puzzle, and as such, also a symbol of the rediscovery of that legendary city, which like few others fired the imagination of the ancient chroniclers.

Yet the work of piecing together the puzzle from which Canopus and the suburb of Menouthis might someday be reconstructed has only just begun. The archaeologists are hoping for many more finds to be made there in the coming years, for the unveiling of countless mysteries that still lie buried deep in the sand, but which will have survived the ages all the more intact for that.

It was not until November 2014 that Goddio's team identified the channel in Canopus that had first connected the city with Heracleion and, under the Ptolemies, also with Alexandria, the waterway on whose banks stood the guesthouses, taverns and houses of ill repute described with such abhorrence by Strabo. Places of pilgrimage, therefore – temples of amusement in the ancient world. Soon we will likely discover what still remains of them.

One of Goddio's divers measures the foundations and perimeter walls of the great temple in East Canopus and makes a drawing of where the ashlars were situated.

The excavations in the temple area leave no doubt that human hands once dismantled and levelled the building.

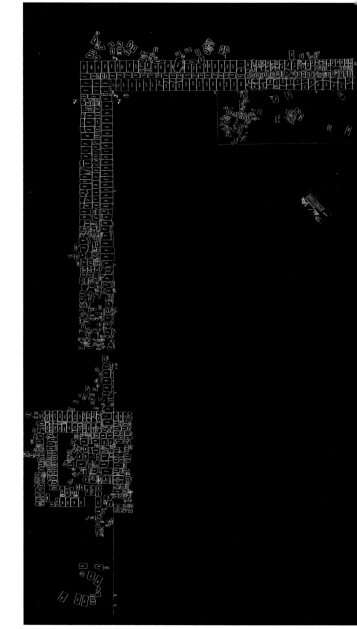

Fair drawing: the plan of a part of the altogether 103-metre-long perimeter wall of the great temple overlaid with a photo mosaic. The plan is not yet complete. Additions will be made to it whenever a new excavation is made on this spot.

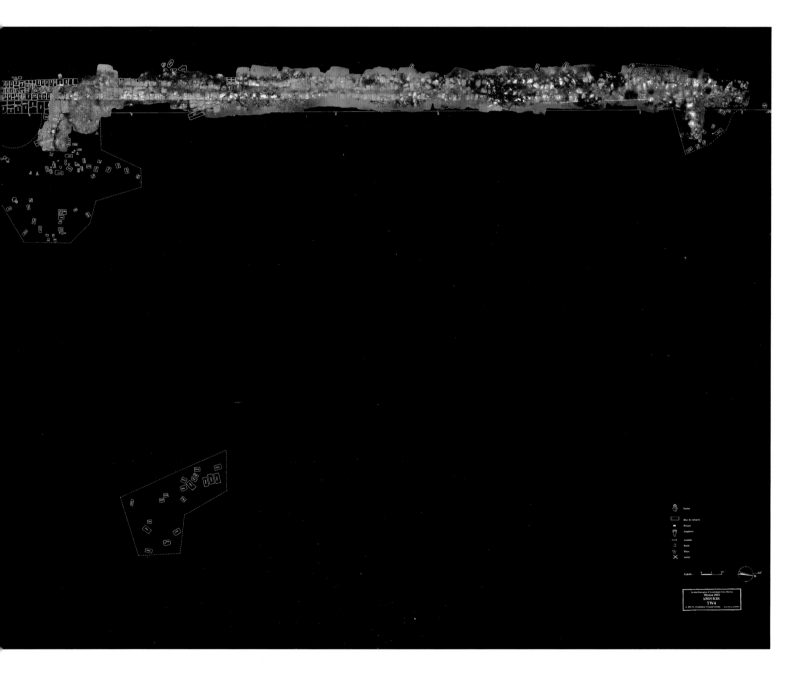

This section of a 3D photo mosaic shows columns and ashlars. The technology allows for later, more detailed examination on the computer screen of building sections and entire ruin sites.

Precision is an indispensable factor in underwater archaeology. Here, a diver in Canopus, measuring a toppled column.

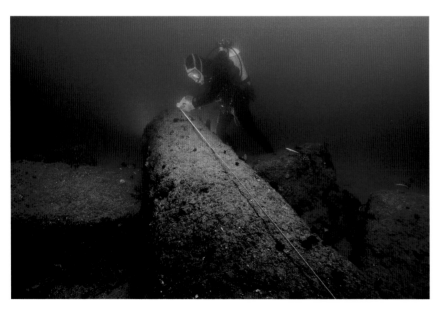

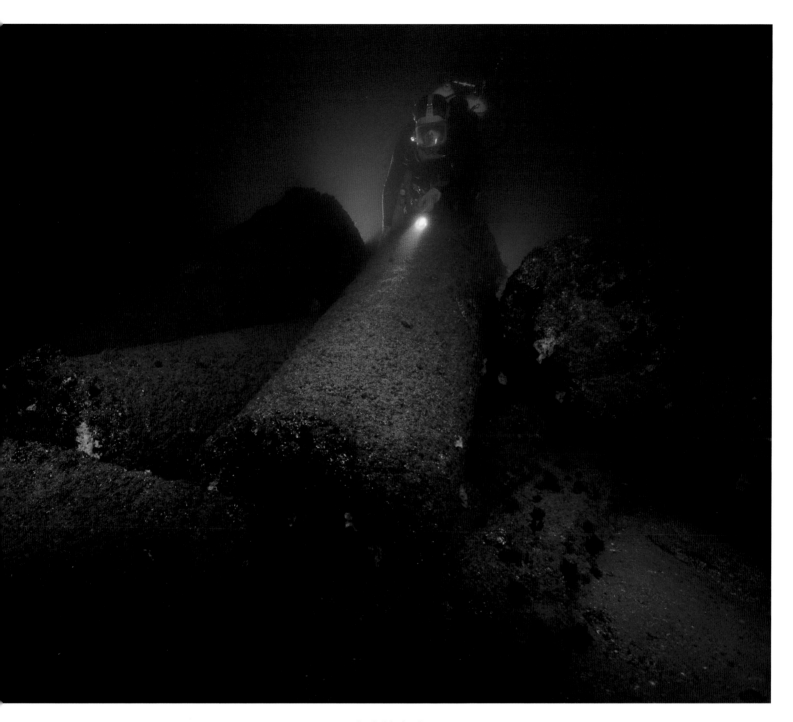

The field of columns in Canopus covers an area of roughly 1.3 hectares. Because visibility is usually poor, the archaeological divers have trouble keeping their bearings.

The prints of animals that ran across the clay soil many centuries ago are still clearly recognisable. Goddio's team found the imprints after clearing two and a half metres of sediment.

A cross-section of the sediments reveals their different layers: sand at the bottom, then limestone and clay, topped by new layers of limestone and sand. The limestone layers testify to building activity.

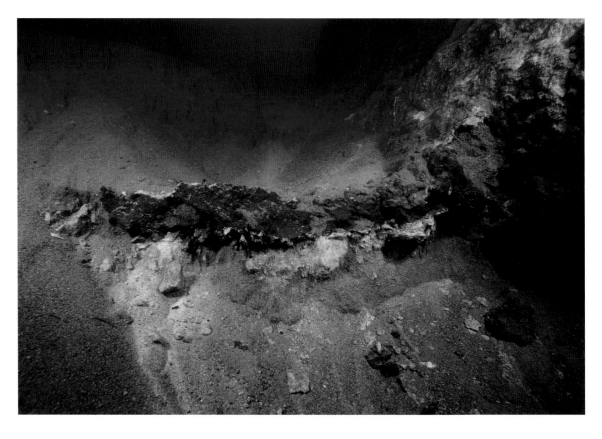

Golden jewellery that has been covered by sediment usually emerges as good as new – like this golden ring with a blue precious stone that was found during excavations in East Canopus in 2008.

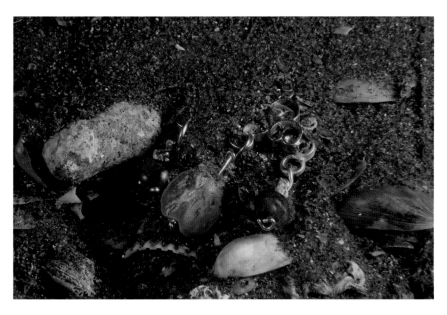

Finds such as this golden pendant are labelled and packed while still underwater (right). The labels contain precise details of where the objects were found.

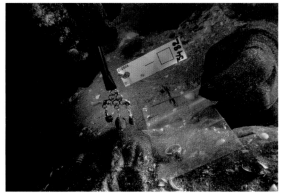

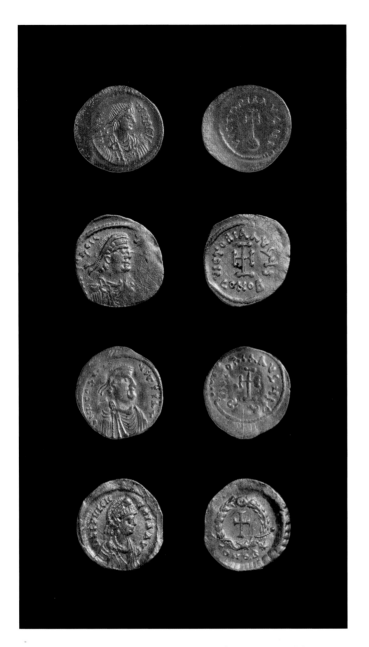

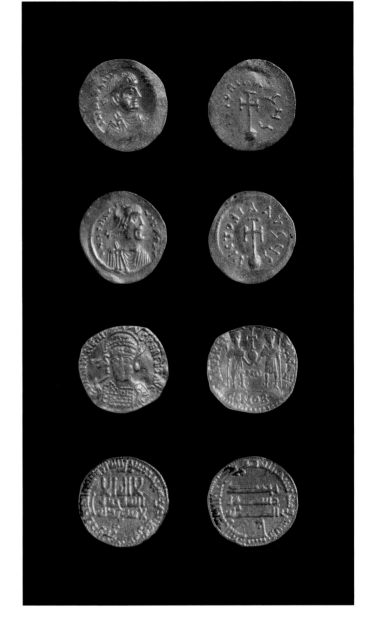

The precious gold coins the researchers retrieved from the sunken city of Canopus date from the Byzantine and Arab and Ottoman periods – proof of a long tradition of commercial and cultural exchange.

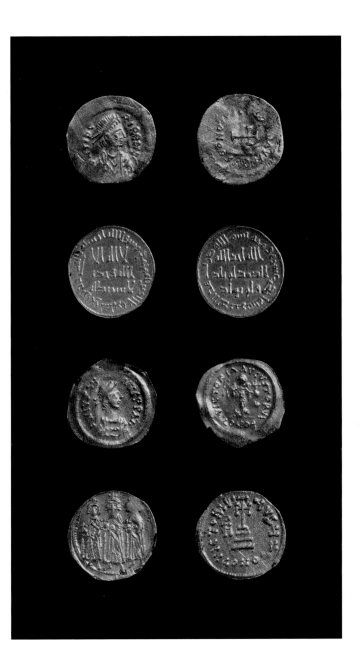

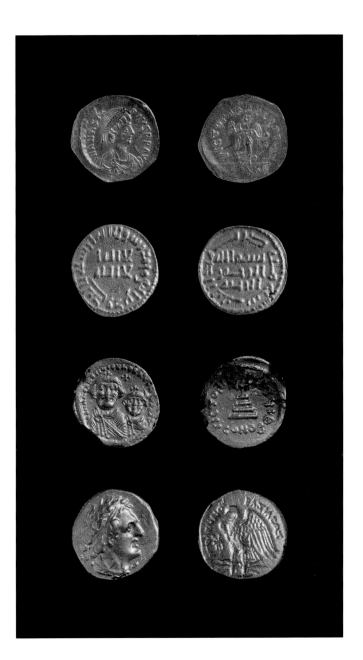

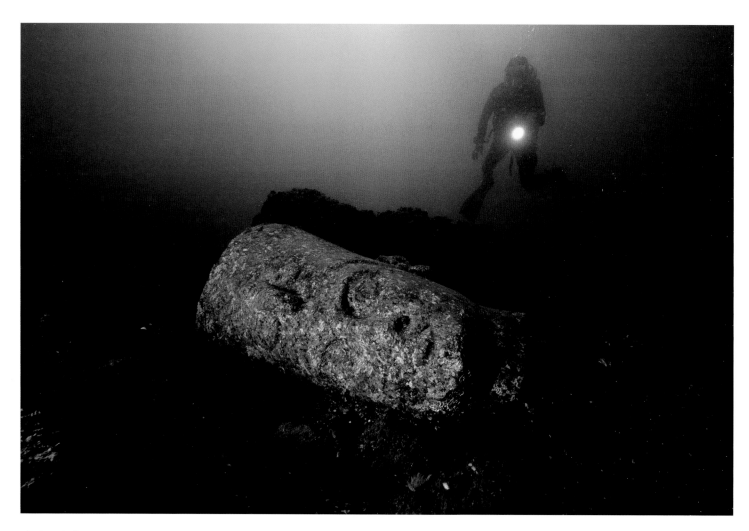

The head of a pharaoh:
the first photo Christoph
Gerigk took in the
submerged Thonis-
Heracleion, in 2000.
As would soon become
clear, it belongs to a
colossal statue.

# Thonis-Heracleion
# The Harbour of the Pharaohs

A Wednesday in late May, late afternoon. In the Bay of Aboukir, all is still quiet aboard the Princess Duda, the research vessel of the European Institute of Underwater Archaeology (IEASM). Franck Goddio has dropped anchor some six kilometres from the coast. From here, the haze over the land creates the impression that the high-rise blocks of Aboukir are obscured by frosted glass. Some distance from the floating excavation house, the open boats of the diving team bob on the long swell; there's a compressor chugging away somewhere – probably supplying the underwater suction device with which the divers are carefully removing sediment from a large find on the seabed.

In the boat's mess, three divers from the Archaeology Department of the Egyptian Ministry of Antiquities are sitting numbering for their records some finely wrought golden jewellery they have retrieved from the silt seven metres down. In the corner, Eric Wartenweiler Smith, the only American among Goddio's archaeological divers, is using a black cloth to improvise a small photo studio and photographing coins, one after the other, most of them dating from the Ptolemaic Period.

Goddio, wearing a faded polo shirt and his inevitable baseball cap, is standing in front of a screen mounted on the mess wall. All around, nothing but calm waters. "Once upon a time," he says, pointing to the monitor, "everything looked quite different here." The image shows land where today there is sea – it's a map of a city on a lagoon, Heracleion. Islands extended to form piers, warehouses and residential quarters, with straightened shorelines and moles that enclose small harbour basins between one large and a number of small channels. Hippopotamuses likely wallowed in the mud close to the bank (bones have been found there), where the Canopic arm of the Nile that has long since vanished enters the picture from the right. The Nile sediments it carried with it formed a spit across the lagoon, leaving only narrow channels for ships to pass through, but at the same time also efficiently protecting the harbour from the full force of the Mediterranean waves. At the centre of the city, below the east-west axis of the "Grand Canal", an extensive area is visible on the monitor. "This is

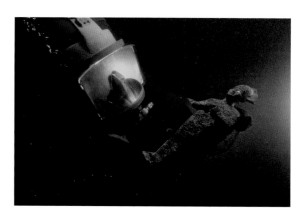

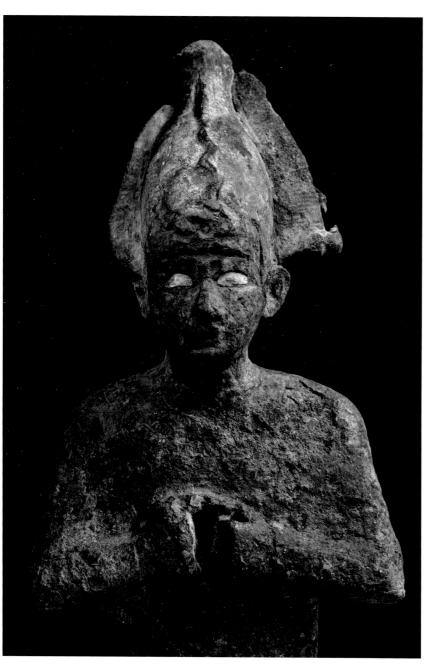

Found in Heracleion, this bronze statuette of Osiris, the god of the underworld, is just 24 centimetres long, and even after over 2,000 years his gold-plated eyes still gleam.

where the heart of Heracleion used to beat," Goddio explains, "it is right below where we are now," – the temple district.

This map, like those of Alexandria and Canopus, is the result of years of high-tech survey campaigns and subsequent seabed sampling using probe sticks. And it changes constantly as its details are altered to accommodate the maritime archaeologists' latest discoveries.

Heracleion is the IEASM's latest excavation – and the one that has produced the most spectacular finds to date. Not that it necessarily looked remarkable to begin with. In 1997, they decided to undertake the search for the cities of Thonis and Heracleion, says Goddio. Existing information about the location of these settlements was only very sketchy; texts on Thonis, especially, are rare. It was sometimes described as being the largest Egyptian port on the Mediterranean, located at the mouth of the Canopic branch of the Nile. But nowhere was there a concrete clue as to where Goddio could have begun his surveys. The information situation was better for Heracleion. Thanks to the trilingual Decree of Canopus, it was known that annual Osiris processions made their way from there across the water to Canopus. This indicated that a channel had once connected the two cities. Ancient writings also told of a large temple complex dedicated to the god Amun-Gereb. The texts mentioned the distance between the two cities, three and a half kilometres, and its location at the mouth of the Canopic arm of the Nile. After locating East Canopus and the Serapeum there, Goddio also had an idea where he should search – the measurements produced by the multi-beam echo sounder indicated that that arm of the Nile, today long gone, at the time flowed into the sea north-east of the temple.

In addition to this, the measurements that the nuclear resonance magnetometer (NRM) had produced in the geophysical survey of the 110-square-kilometre area of sea were a good guide. The NRM captor, developed by the French Atomic Energy Commission, measures the smallest changes in the earth's magnetic field, which may be caused by concentrations of metal in the sediment or by the foundations of or rubble from ancient structures. So the decision was made to investigate the area that appeared to be most promising.

In April 2001, the crew of scientists on board the research vessel dropped anchor close to the spot where the magnetometer had registered the greatest anomalies over the widest area: in other words, roughly where the Princess Duda was now. On deck, the divers prepared to climb into their neoprene wetsuits, strap on their tanks, having first checked the air pressure and that their

147

Resurrection preparations: in the murky water, surrounded by fish, the massive granite figure of the fertility god Hapi, finally celebrates its return to the surface.

An IEASM diver measures the pedestal and leg fragments of the deity that probably shattered during an earthquake.

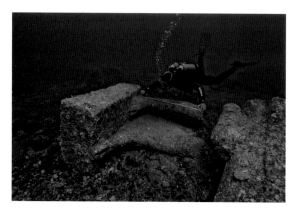

A so-called "garden tub" made of red granite dating from the pre-Ptolemaic Period in Heracleion. The tub probably played a key role in the Mysteries of Osiris, which were celebrated in Heracleion and Canopus every year in late autumn.

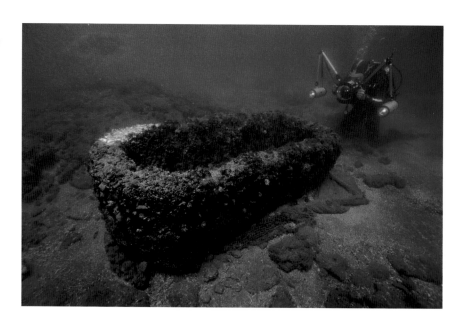

regulators worked properly. Finally, with their goggles securely in place, the divers let themselves down into the water one by one. Seven metres is not a long way if the conditions are good. In the clear waters off the Philippines, Goddio and his men moved in very different depths when they were searching for historical wrecks. But the conditions here were not favourable: yet again, visibility underwater was moderate to poor.

Once at the bottom, right on the spot the captor had indicated, they probed the ground – and immediately came up against stone. But this time it was not a rock, as in Alexandria. What lay before them were the foundations of an ancient, collapsed wall of sandstone blocks, which, as the divers measured, had once been 150 metres long and had fallen vertically.

The divers' anticipation grew. What had they found? A large warehouse? A palace? At the north end of the wall, they discovered the remains of a second wall that ran north, at right angles to the first, but was not quite as long, and finally a third, parallel to the first. These were evidently perimeter walls of the kind the ancient Egyptians erected around their temples – and judging by their length, this temple must have been a very large one.

So it was a temple. A wonderful find, of course, but in a country like Egypt not exactly a surprise – even underwater. But there was one open question Goddio asked himself: "Who was worshipped there: for which god had such a large building been built?" There had to be some clues somewhere. The divers started working as fast as they could, beginning their excavation at the point Goddio suspected to be the centre of the rectangle. The very next day they struck lucky. They unearthed a basin of red granite large enough to hold a reclining human being. Goddio believes it served ritual purposes. And close by, they found what was to explain everything: a naos, the shrine of the temple god, a monolith, hewn from red granite. It was as tall as a man and weighed a good three tons, and on its front was an eroded hieroglyphic inscription.

Goddio had a silicone impression taken of it underwater – using a technique developed especially for such purposes: once most of the sediments and sea shells have been cleaned off the relief, a cloth soaked in silicone and hardener is laid over the inscription and weighted with lead sheets. 18 hours later, the synthetic material has hardened and the cloth can be stripped away and taken to the surface. This way, inscriptions can be studied while the original remains on the seabed.

At that time, Jean Yoyotte, the great French Egyptologist and expert on ancient Egyptian religion, was also on board the re-

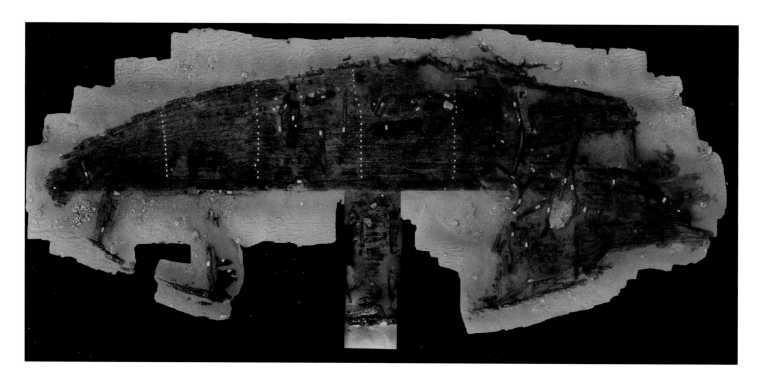

Since 2001, the divers have
come across the relics
of more than 70 ancient
ships in the harbour basin
of Thonis-Heracleion.
Here a photo mosaic of
shipwreck number 17.

## The Ships of the Pharaonic Kingdom

From the very beginning, ships and boats were the most
important mode of transport in the pharaonic kingdom;
the Nile is after all the country's main thoroughfare. It is
navigable all year round, and while the current moves
downstream, an often strong wind blows upstream
between March and the end of November, making sailing
relatively easy.

Part of a fresco in what was probably a royal grave
from as early as the Predynastic Period (circa 3500 BCE)
depicts boats. The tomb was discovered by archaeologists
excavating in the former Hierakonpolis, one of the first
cities to be built in Upper Egypt. In later centuries, boats
and ships became a central element in the images found
in tombs and mortuary temples. Alongside the Great
Pyramid of Pharaoh Khufu (also known as Cheops), who
probably died circa 2580 BCE, labourers happened upon
not one but two dismantled royal solar barques in 1954

search ship. He was just as curious about what this excavation would reveal as the entire team. Goddio brought him the silicone impression and Yoyotte bent over the hieroglyphs. After a while, he looked up and announced: "This is the naos of Amun-Gereb. You have found Heracleion!" It was the city that had been lost for more than twelve centuries, the city, in which a sanctuary had been built for *him*.

Amun, the creator of all things, the highest deity in the Egyptian pantheon. In his manifestation as Amun-Gereb, he assured every new pharaoh the existence of his kingdom, on earth as in heaven, and power over the world of creation. A reference to the Amun-Gereb Temple in Heracleion can be found, among other places, in the text of the Decree of Canopus, 238 BCE.

It was a fabulous temple, to which the pharaohs, even the Ptolemaic pharaohs, would make a pilgrimage after their enthronement, accompanied by the rattle of sistra and amid the fragrance of incense. There, they received the *mekes* sceptre, a cylindrical object thought of as an encased document symbolising their right to earthly sovereignty over Egypt.

Historians know that Amun's son Khonsu was worshipped at this temple, too. Greek mercenaries and seafarers who had settled in the region also worshipped Khonsu, the moon god, but as their own god Herakles from whom the city derived its name, at least with Greek chroniclers.

(out of a probable five). To date, one of them has been restored – its hull is over 43 metres long.

In the Egyptian religion, barques play a special role, and not only in ceremonies, such as the Osiris procession. The sun god Re, for example, appeared on the eastern horizon aboard his barque every day anew and then sailed along the "heavenly Nile" for twelve hours before being swallowed once more by Nut, goddess of the sky, when he reached the western horizon in the evening. During the twelve hours of the night, he sailed through the underworld, standing atop the solar barque, heading east once more.

As early as the regency of Pharaoh Hatshepsut (from 1479 to 1458 BCE), the Egyptians were well advanced in their shipbuilding techniques. River cargo boats that transported heavy loads were able to lower their masts in order to keep resistance to the current as low as possible

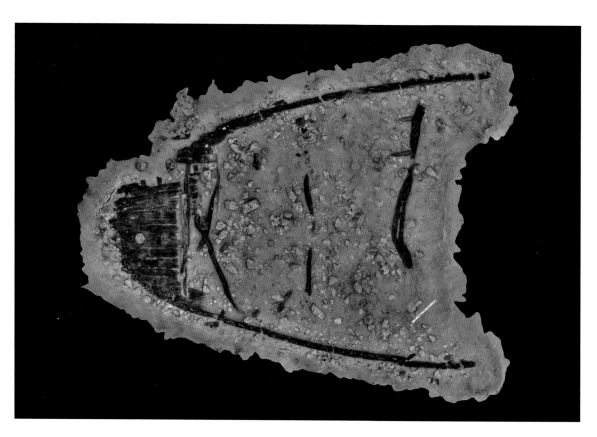

when sailing downstream. And there were seagoing ships whose planks were held together by mortise-and-tenon fastenings. This technique possessed indisputable advantages. As documented in the friezes on the walls of the Temple of Hatshepsut, carpenters in the shipyards of the Nile crafted the ships destined for expeditions to the so-called "Goldland Punt" (probably situated on the Horn of Africa), which were then transported as construction kits in long caravans through the desert. Only when they reached the banks of the Red Sea, in the harbour of Mersa Gawasis, say, were they assembled.

"Until now, we had a great deal of information about Egyptian shipbuilding in the time between the Old Kingdom and the New Kingdom," says Damian Robinson of Oxford University's Centre for Maritime Archaeology. "But archaeologically speaking, there was a black hole in the Late Period." That changed with the IEASM's excavations in Thonis-Heracleion because more than half of the good

70 shipwrecks which have since been found in the sunken harbour have been dated to the Late Period, in other words to the years from 664 BCE, when Pharaoh Psammetich I ascended the throne, to the Greek invasion under Alexander the Great in the year 332 CE.

In Thonis-Heracleion, the underwater archaeologists found some larger wrecks that had possibly been merchant ships, but above all one type of vessel that they had previously known of only from historical sources: the baris, a transporter of 24 to 26 metres' length, which with its not all-too-deep draught was ideal for operation in lagoon waters and above all on the Nile. It was probably used to transport goods from the merchant ships into the harbour and from the harbour up the Nile. The construction of the baris, says Robinson, "is completely different from anything we had seen before."

The boats were made of acacia, which in Roman times still grew in groves and small woodlands in the Nile Delta.

152

What Goddio's researchers could not know at the time was that the discovery of this sanctuary was only the beginning of a unique, an almost incredible triumph for underwater archaeology.

So there it lay, spread out before them, the seaport which for the pharaohs had been the gateway to the Mediterranean world, a gateway that had started out as a small, Egyptian guard post at the Canopic mouth of the Nile. The village later grew to be a settlement where many languages were spoken.

The reason for this was that towards the end of the 7th century BCE, Greek soldiers had helped Pharaoh Psammetich I to reunite the fragmented kingdom on the Nile, of which large expanses were under Assyrian occupation, and restore it to its old power and glory – at least for 139 years. By way of thanks, the ordinarily somewhat xenophobic Egyptians permitted the Greeks to settle in the city of Naukratis, higher up the Nile, where Greek merchants at once established lively trade with their mother country. The Greek cities needed the grain that grew in Egypt to feed their rapidly growing populations. And demand was also great for linen and papyrus, ivory and ebony. The Greek settlers in turn traded Egyptian commodities for lead, silver, oil and wine from their old homeland. These goods were transshipped – from seagoing ships to river barges or vice versa – in a small border post on the western Nile Delta, which grew into a veritable seaport as a result. Within a matter of decades, the village at the mouth of the Canopic branch of the Nile had become the city of Heracleion

Their growth, however, did not allow for long wooden planks to be cut from these trees. Hence the device to which the Egyptian shipwrights resorted: they sawed relatively thick planks of just one metre in length and laid them over each other in rows, offset like bricks in a wall. They gave the planks the necessary hold by hollowing out precisely measured holes on their narrow sides that went through several lines of planking and through which they could then pass the ribs. Technically, this was a fundamental innovation: the hull of a barque did not consist of planks secured with wooden dowels or nails, as in other boats, but of planks that were hollowed out and held in place by an inner framework. Among other things, this made the boats easier to recycle because the construction required a standardisation of sorts for its component parts.

And the wrecks found in Thonis-Heracleion also provided proof of a very special feature of Egyptian boat design: the spoon-shaped ship, in which the stern towers high above the water, as is well known from the many available illustrations of it. This type of boat was steered with a rudder passed through a hole in the hull – a gap in the stern, which is clearly identifiable in some of the wrecks found off Aboukir.

Now, says Robinson, they are hoping for an Egyptian warship. "We know that the Egyptians had a fleet of Greek-style triremes." Although the trireme was either a Greek or a Phoenician invention, from the 6th to the 3rd century BCE, nearly all of the Mediterranean powers used it. It was propelled by rowers, 170 men, sitting in three lines staggered one above the other, and on longer voyages also by an auxiliary sail. The hallmark of the trireme was its long, bronze-coated battering ram just above the waterline – it served to sink enemy ships.

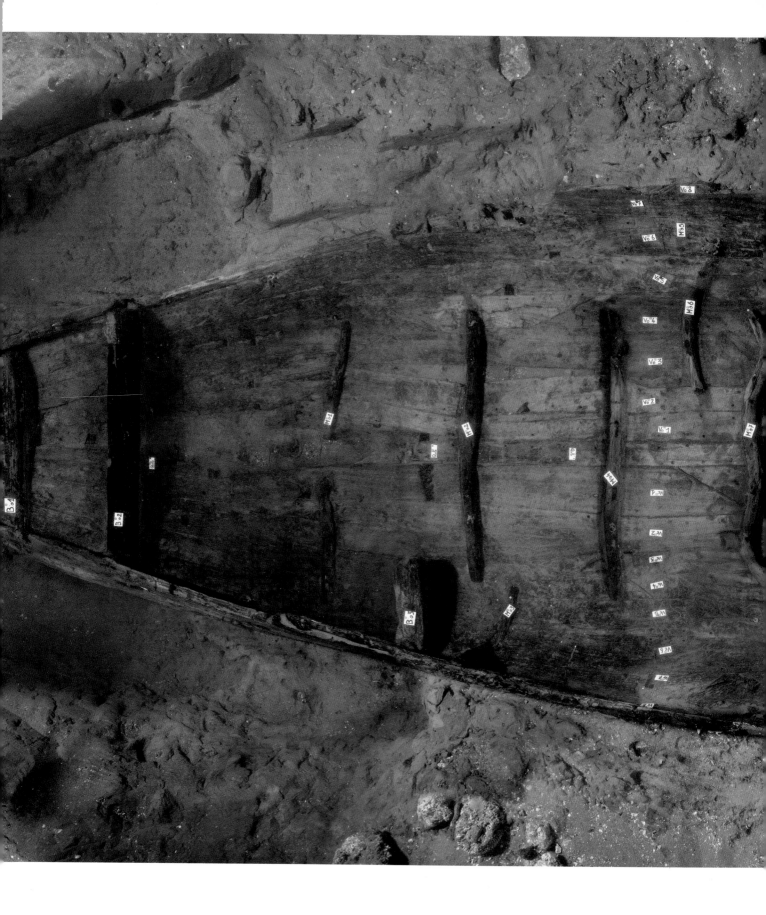

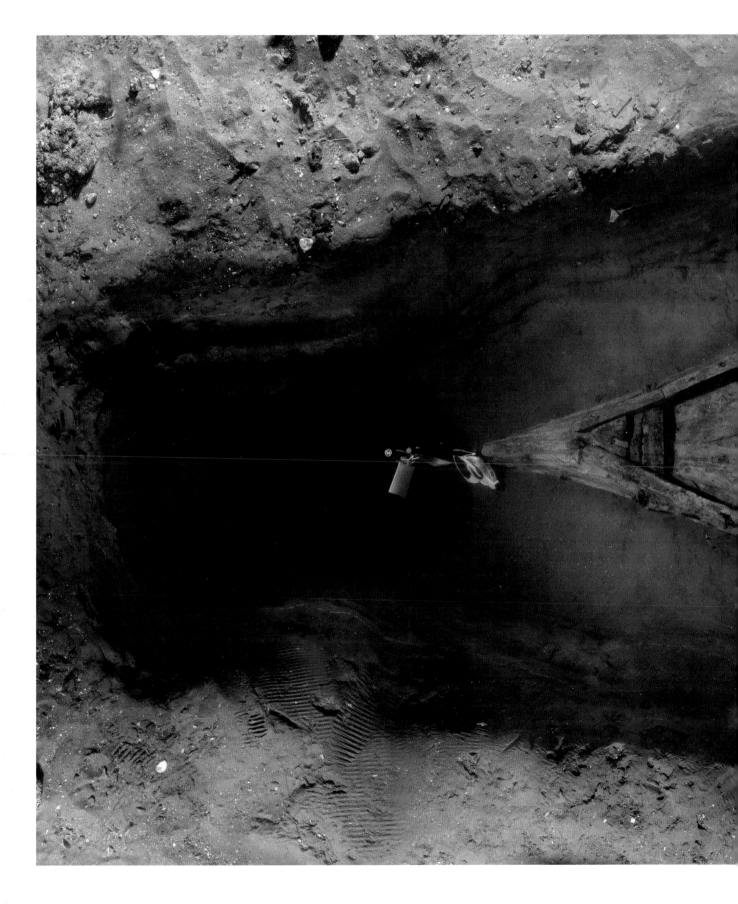

It was close to the entrance of the Grand Canal in Thonis-Heracleion that in 2010 Goddio's crew chanced upon the remains of a boat quite different from the other wrecks: wreck 11 was surrounded by sacrificial offerings. Could this have been a processional barque, ritually sunk during the Osiris celebrations? A ceramic from Greece may indicate that it dates from the 4th/3rd century BCE. Christoph Gerigk pieced a hundred individual images together to create the full picture of wreck 11 (see gatefold).

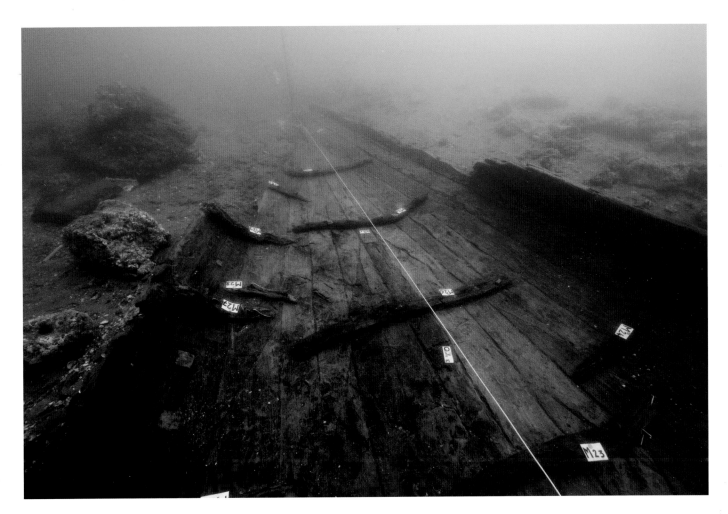

Instead of acacia, as was usual, the planking of wreck 11 was made of sycamore. The sycamore tree was sacred to the Egyptians and was directly linked to the rebirth of Osiris.

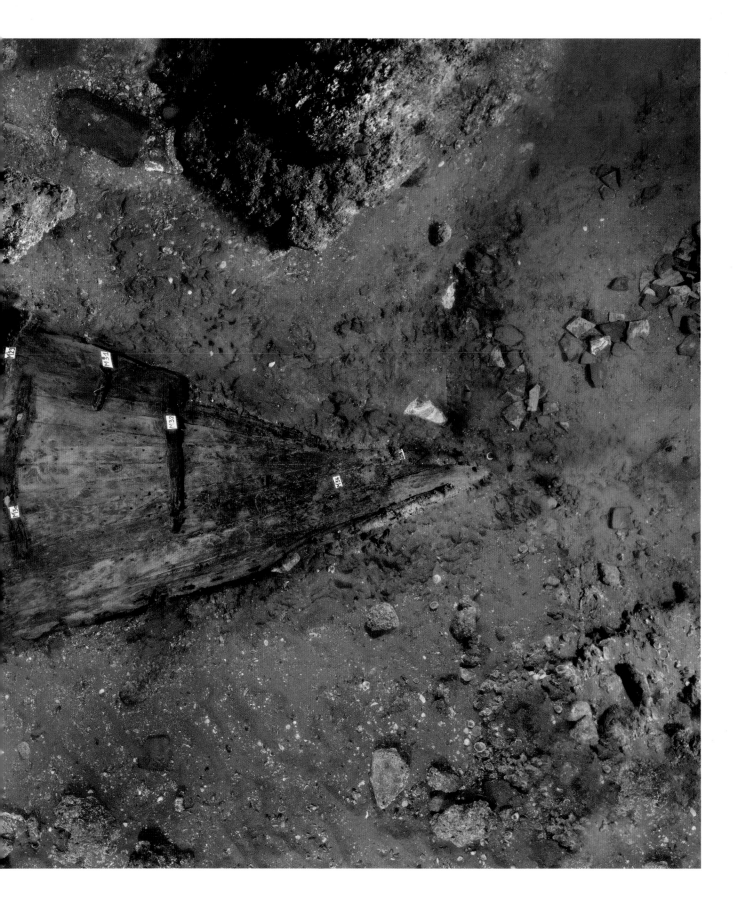

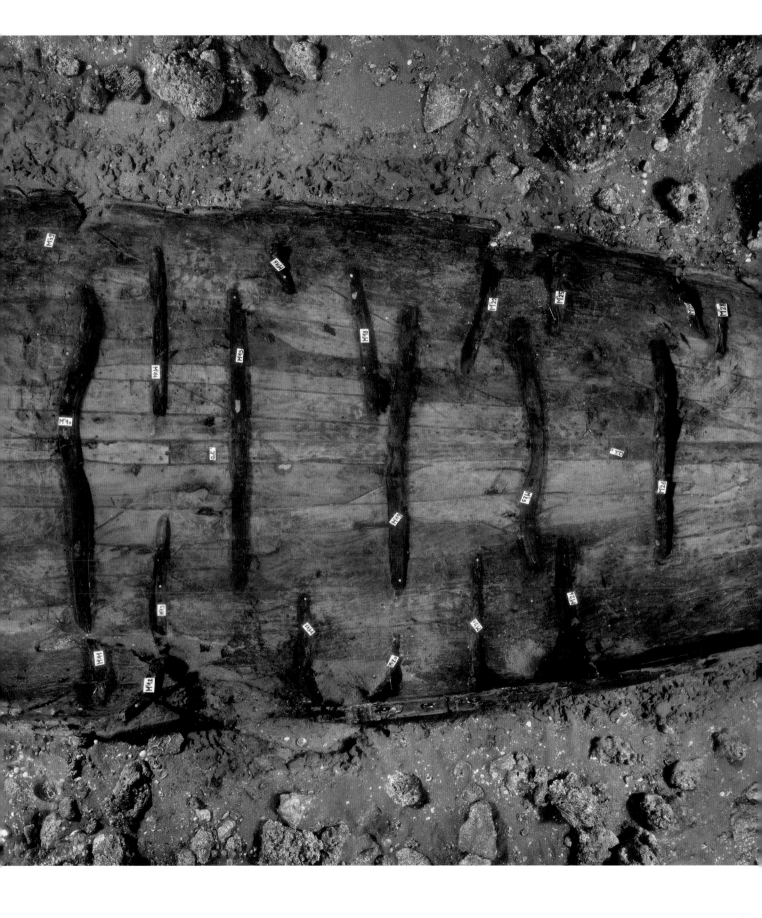

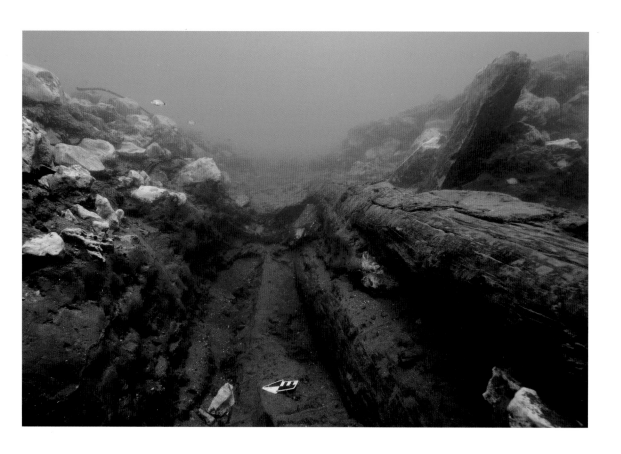

Timber planks (above) and layers of sediment (right) in Thonis-Heracleion. The clear demarcation lines between the layers make precise dating of the finds discovered there possible.

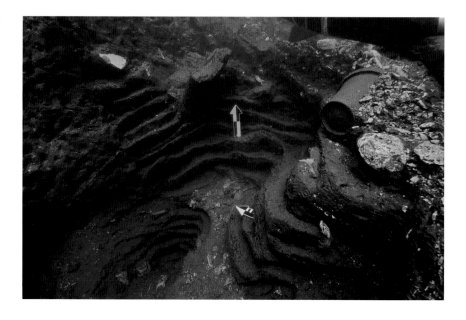

and Egypt's most important point of access to what was then known as the "Sea of the Greeks".

Its rediscovery by Goddio and the IEASM research team meant far more than merely a corroboration of ancient written sources because it unexpectedly revealed the pharaonic kingdom, hitherto considered to have been so self-contained, to have been a nation of maritime traders – and that long before the rise of the Ptolemaic Dynasty. It was shown to have been a state that had demonstrable contacts with the entire eastern Mediterranean region and was influenced by Greek culture just as it in turn influenced cultural life on Crete and in the Aegean. The important role Heracleion must have played is also impressively documented by more than 70 ancient shipwrecks the divers have happened upon during their explorations since 2001. They make the site in the Bay of Aboukir the largest ancient naval graveyard ever found.

In addition to these, there are the countless anchors, some made of stone, some of lead, which the underwater archaeologists were able to identify in the ruined city and enter on Goddio's maps after meticulously taking their coordinates using GPS data. The anchors they uncovered told the researchers more than simply which parts of Heracleion were expanses of open water and where the harbour basins in which the merchant ships were unloaded used to be; the shape, material and the way the ships were crafted allowed conclusions to be drawn about their origins. "Although it was difficult to make out the topography," says Goddio, "we have formed a very accurate impression of the city. We were able to identify the main temple and secondary sanctuaries, the warehouses, the channels, the harbour basins and the residential quarters."

Ultimately, they also succeeded in solving the puzzle that had accompanied them from the very first day: they found the answer to the question of where the mysterious Thonis had once stood.

Only a short time after discovering the naos of Amun-Gereb in 2001 – Yoyotte had already returned to Paris by then – the archaeological divers came across a slab of black diorite by the north wall of the Amun-Gereb temple. It was almost two metres high, 88 centimetres wide and rounded at the top. Evidently a stele, it was lying on the side bearing its inscription. "And it was intact, not a crack anywhere," Goddio recalls, "It was a magical moment when we turned it over." It had lain there in the sediment like that for over 2,000 years, but even after such a long time, the characters were still perfectly legible, the images needle-sharp – before the divers, seven metres below the waves, lay a pharaoh's decree.

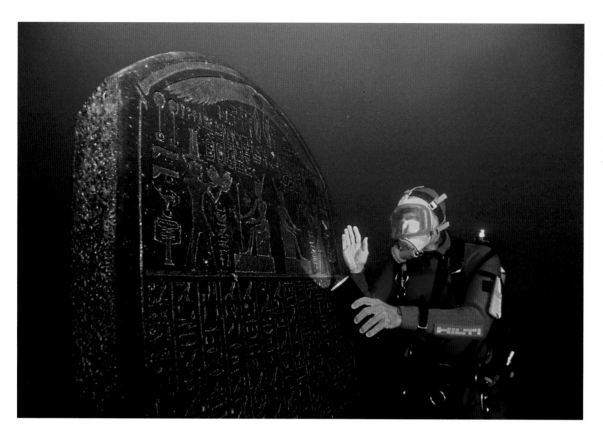

The black stele of Pharaoh Nectanebo I dating from the year 380 BCE is beautifully preserved and a sensational find, since it proves that Thonis and Heracleion, previously believed to be two different places, were in fact the respective Egyptian and Greek names for the same port.

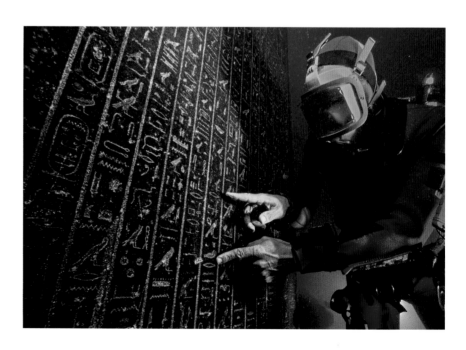

Goddio had Christoph Gerigk, the mission's photographer, called down. His pictures immediately went to the College de France, to Yoyotte.

The team in Aboukir did not have all too long to wait for the Egyptologist's answer. This stele, Yoyotte replied, was the exact copy of a text known as the *Decree of Saïs*, which Pharaoh Nectanebo I had had inscribed in stone and erected in the city of Naukratis in the year 380 BCE. It documented for perpetuity Nectanebo's decision that 10 per cent of the customs duty levied on gold, silver, timber and all other goods "which came from the Sea of the Greeks" must be given to the sanctuary of Neith, the patron goddess of Nectanebo's capital city of Saïs.

The Naukratis stele had been excavated there as long ago as 1899. It is of approximately the same size and shows the same layout as the one found in Heracleion – but differs from it in a single, but important detail: its site of erection. Whereas on the tablet found at the end of the 19th century the pharaoh had stipulated Naukratis as its designated site, the one found off Aboukir stipulated that it should "be erected at the entrance to the Sea of the Greeks, in the city named Thonis".

Here, therefore, was the solution – Thonis *was* Heracleion! For the Egyptians, the city was Thonis, the watchman – probably because it was where – in those days – the entrance to the main arm of the Nile really was guarded. And the Greeks, who recognised in Amun's son Khonsu their own god Herakles, named the city after him. Against this background, it is understandable that over the centuries the chroniclers from Greece and Italy who passed through – from Herodotus to Strabo – adopted the Greek name.

But the stele was not to be the last surprise in store for the excavators in Heracleion-Thonis, as they named the sunken city from that point on. At almost the same time as the discovery of the black tablet – and not at all far from it – a second team of divers happened upon a very large, oddly shaped piece of red granite in the murky waters. It took a while, Goddio remembers, for them to grasp that it was the base of a statue with two feet. Soon afterwards, they found a second pedestal, and then another. "That was when we realised that what we had here were evidently parts of colossal statues." They continued their search – and quickly found the remainder of the first statue. They began cleaning it and the body of a Ptolemaic pharaoh came to light. The statue was provisionally assembled while still beneath the waves.

Yet it was not until a few days later, when the water had cleared again and a film crew dived down with them, that the

Even reclining, its proportions are superhuman: the colossal sculpture of the Ptolemaic pharaoh from Thonis-Heracleion.

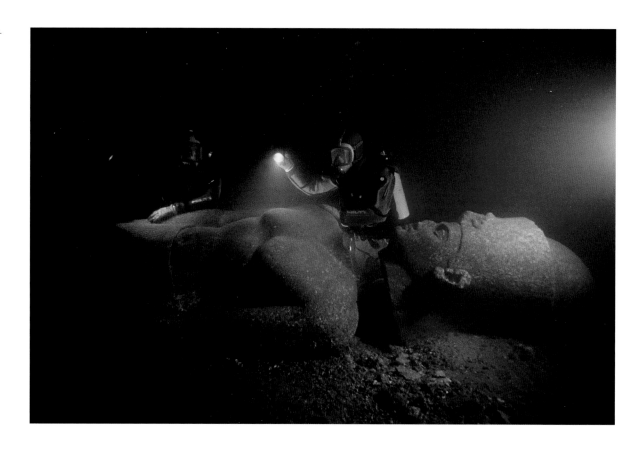

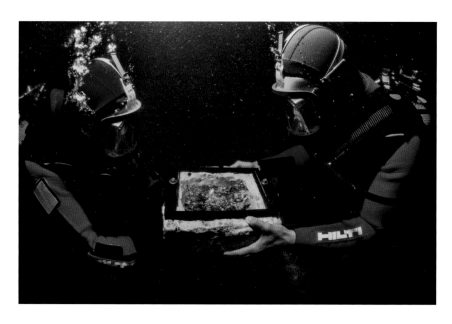

The city's riches drowned with it. Here, divers take the utmost care to raise a stone chest – with no inscription, but filled with gold.

excavators became aware of its true dimension: before them lay a granite colossus five metres long. Later, a second was found, the pharaoh's queen, depicted as Isis, and finally, a third – Hapi, god of fertility and the Nile flood. The monarchs and the deity must have stood on the square in front of the Temple of Amun-Gereb around 200 BCE. Monumental, they were awe-inspiring in all their superhumanity made stone.

These are among the best-preserved monumental statues from the Ptolemaic Period to have come to light in excavations. The statue of Hapi is, in fact, the largest statue of a deity to have been found to date in Egypt. In order to retrieve the sculptures, Goddio had a pontoon with a heavy-duty crane towed to the spot where the fragments of the shattered statues lay at the bottom of the sea. As the convoy of ships, boats and a barge headed back to Aboukir harbour, the press was already waiting. Photographers and film crews turned the raising of the statues into an international media event. Nor did the series of great discoveries in Thonis-Heracleion come to an end in the next few years. The team found sacrificial offerings that had been deposited in the water in the temple district, everyday household objects, ladles and bowls for ritual purposes, and in the remains of one building, probably once a temple, a stone chest full of gold – just metres beneath the waves. Was it an offering for the gods? Or a treasure rapidly hidden in the face of imminent disaster?

Some of the shipwrecks the IEASM divers found also posed puzzles. Ship 43, for instance, an Egyptian transporter made of acacia wood, had been scuttled, deliberately sunk by pegging its hull to the ground with four thick stakes, and other boats had suffered the same fate. Why?

Or take ship 11: shallow hull, only around ten metres long and roughly two and a half metres wide. It was not made of acacia, but of sycamore fig, otherwise known as fig mulberry. The tree was sacred to the Egyptians. The boat was found surrounded by sacrificial offerings – bronze ladles, golden jewellery, and votive barques made of lead and alabaster vessels. Two planks had been removed in order to sink it, and it must have gone down at once. What secret does this wreck hold? Could it perhaps be one of the golden barques on which, during the annual Osiris procession, the image of the god was shown to the people? Is what the archaeologists have found here the barque of a deity?

Even the Temple of Amun-Gereb throws up some questions because, while it dates from the 4th century BCE, the historian Herodotus describes in great detail the Herakles sanctuary in his work *Histories*, which he had already written between 50 and

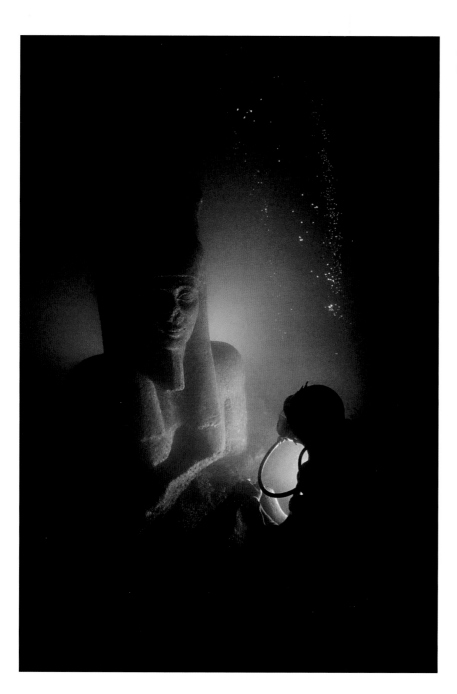

Hapi, the god of the Nile flood, shortly before he is brought to the surface

Wherever the divers' torchlight falls in the cloudy water, it picks out witnesses to a mysterious past.

100 years earlier. So which temple had the Greek seen? Goddio had the temple district searched for a building that might previously have occupied the site, but there was nothing there. In the year 2015, on the other hand, they discovered a site in the north of the city where the ground is covered with at least 900 limestone blocks, some only 70 centimetres, others more than one and a half metres, long. If this was once a building, then it was a very large one. Judging by the position of the blocks, though, Goddio suspects that the former inhabitants of the city had deliberately dismantled the building. But why? And what was its purpose?

And then there's the small, Greek temple that stood on the temple island. It, too, the divers only recently unearthed. The archaeologists date its Doric columns to the early 4th century BCE. They, like the rest of the building, toppled into the canal, one column sinking one of the boats tied up there in the process. The entire ensemble, says Goddio, now lies there like a collapsed house of cards, a thoroughly Pompeian snapshot of the catastrophe that must have befallen the city and its temples over 2,000 years ago. But how did that catastrophe come about? What had happened?

In the geophysical surveys conducted by the IEASM in collaboration with the scientists of the Smithsonian Institution in Washington and Stanford University in California, the evidence they gathered showed that a very long time ago the seabed in this part of Aboukir Bay must have been hit by a series of landslides. The reason for this is its unusual structure: beneath the sediment there is a layer of clay with a water content of up to 50 per cent locked into its structure. The ancient city was, after all, built on a lagoon-like wetland area. When tremors occurred, called forth by seismic waves or high Nile floods which exerted additional pressure on the ground, the city could easily lose its "footing". Then, reinforced by the great weight of the monumental buildings, the water suddenly burst out of the sediments, so that the entire seabed began to slip as though on an oil slick, dragging everything with it that was built on it.

"We have indications of several such catastrophic events having taken place between 450 and 380 BCE, when Nectanebo I ascended the throne," says Goddio.

But every time nature fell upon the city, devouring houses, animals and people, the buildings were rebuilt, and quite often using the rubble from those which had been destroyed. That may be the reason for the Herakles sanctuary evidently having been in

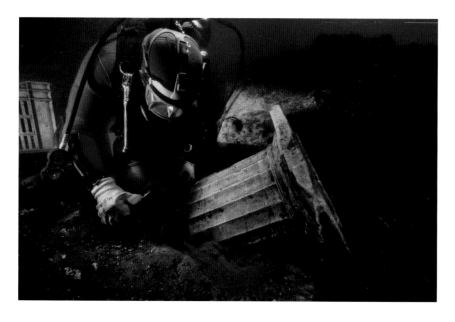

With infinite care, an archaeological diver uses a suction pipe to uncover a Doric column. The column once supported the roof of a small, round Greek temple from the 4th century BCE that stood near the Egyptian Temple of Amun-Gereb.

The archaeologists also found this statuette of Aphrodite in the ruins of the small Greek temple. Clad in Greek style, she has hitched up her tunic to reveal her genitals. The figure probably formed part of a fertility ritual.

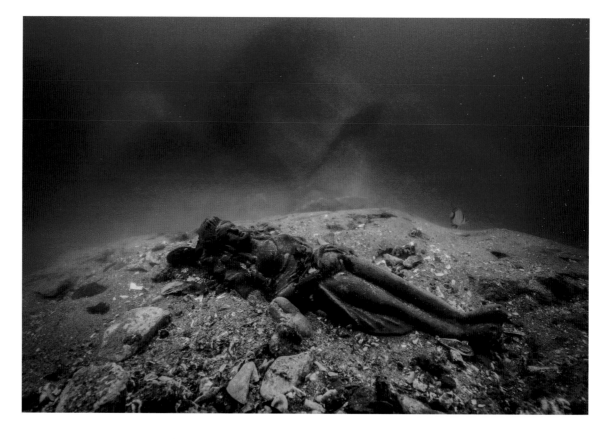

a different location in Herodotus's day than it was when Goddio found it in 2001.

It was probably more than 2,100 years ago that the great, fatal catastrophe arose. It swallowed the Temple of Amun-Gereb and Khonsu-Herakles, the colossal statues and likely also the small Greek temple next door. "Everything collapsed at the same time," says Goddio, "and we found no ceramics at all from the centuries that followed." Life in Heracleion had been for the most part extinguished, as the archaeologists' findings revealed. Even though the site was repeatedly settled during the Roman and Byzantine Periods, those people also abandoned it at some point.

The last find the researchers brought up from Thonis-Heracleion was a small gold coin. It dates from the end of the 8th century CE, from the time, therefore, when the mighty tsunami rolled across the Egyptian Mediterranean coast and also destroyed proud Alexandria.

Thonis-Heracleion, once the pharaohs' gateway to the world, had long become history.

The goddess Isis, nursing the baby Horus, lies half hidden in the sediment. Horus, in mythology the son of Isis and Osiris and later the first of the pharaohs, receives divine powers from his mother's milk.

The bronze oil lamp has been dated to some time between the 4th and 2nd centuries BCE. What resembles smoke here is in fact clay sediment.

One of the latest finds in Thonis-Heracleion: a situla, a ritual bronze vessel used in the cult of the mother goddess Isis. A situla was used for the symbolic scooping of water from the the Nile.

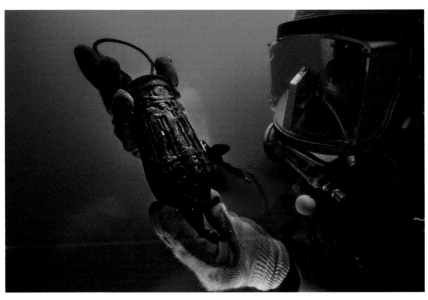

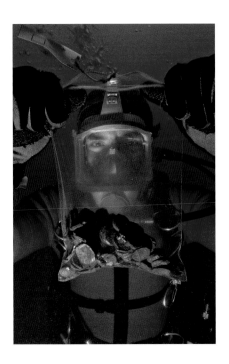

IEASM diver Gregory Dalex with ancient bronze coins he discovered on the seabed

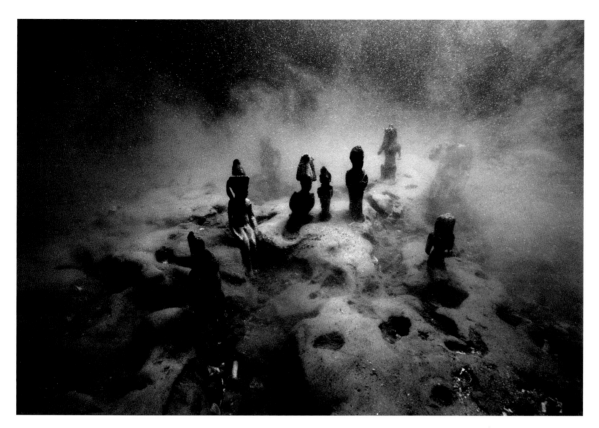

Divine rendezvous at the bottom of the sea. The photographer's arrangement is composed of sacrificial offerings found in different locations in Thonis-Heracleion. The gods assembled here include Harpokrates (left, sitting), Osiris (centre) and Isis (front, right).

This plaque from Heracleion is 11 centimetres wide and made of pure gold. On it, Pharaoh Ptolemy III (246–222 BCE) dedicates a *gymnasterion,* an institute of sport and education, to the god Herakles, patron of athletics.

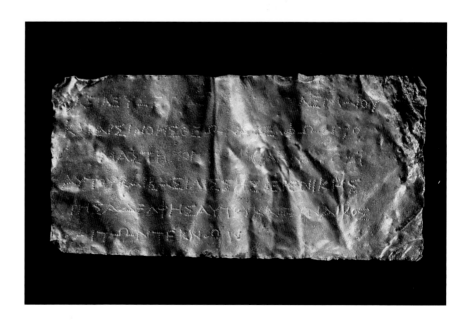

A votive barque, some 30 centimetres long. The archaeologists of the IEASM found several of these model boats made of lead at the bottom of what used to be the canals and harbour basin of Thonis-Heracleion. The barques are sacrificial offerings, models of those papyrus boats that accompanied the holy procession on the water during the Osiris celebrations.

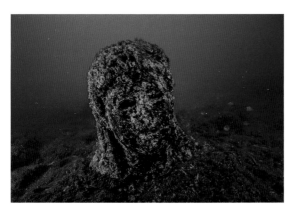

Covered with algae and barnacles, this woman's head rises from the sediment in the ruins of Thonis-Heracleion.

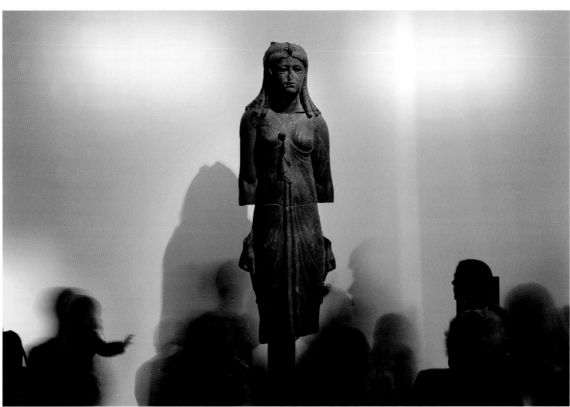

When the divers start digging, it becomes clear that the head belongs to a black granite statue depicting a queen of the Ptolemaic Period.

# Restoration of the Ancient Finds
## The Resurrection

It is not a royal litter, nor is it a magnificent barque that bears the pharaoh to the site of his intended resurrection. In the spring of 2001, the Ptolemaic king travelled prosaically atop a flatbed truck, feet first, head to head with his queen. The pharaonic couple closely followed a second lorry bearing Hapi, the god of the Nile flood; he, too, is also securely strapped to a flatbed. The convoy bearing the three monumental pink granite statues retrieved in Thonis-Heracleion, each of them some five metres high and weighing more than four tons, takes the shortest route from Aboukir to Alexandria. It rolls past the high walls surrounding the extensive grounds of Montazah Palace, turns left at the Sheraton Hotel and into El-Gaish Road, which follows the Bay of Alexandria for several kilometres, past beaches, restaurants and the turquoise waters of the Mediterranean on its right, but is lined on the left by a seemingly endless parade of alarmingly dilapidated concrete towers and the occasional luxury hotel.

Passers-by stop and gaze in awe at the two lorries with their unusual freight. Shortly before reaching the spectacular building housing the New Library of Alexandria, the royal convoy turns off El-Gaish in the direction of the stadium before finally entering the drive leading to the ruins of the Roman theatre in Omar Toussoun Street. On the left, the bath prepared for them by the Egyptian authorities awaits the royal couple: this is, in fact, a series of large basins measuring 20 square metres each, which have been filled with fresh water and into which the stone giants are now gently lowered.

For the statues, this is the beginning of a process that will take four years to complete, during which they will first undergo conservation treatment and then restoration. All the other finds brought up from the seabed by the IEASM's archaeological divers require lengthy, expert cleaning, stabilisation and restoration before they can be put into storage or shown in exhibitions. The reason is that objects which have spent thousands of years in salt water have often been damaged by the salt but are otherwise comparatively well preserved – for as long as they remain underwater. That's because the oxygen necessary for corrosion and pu-

171

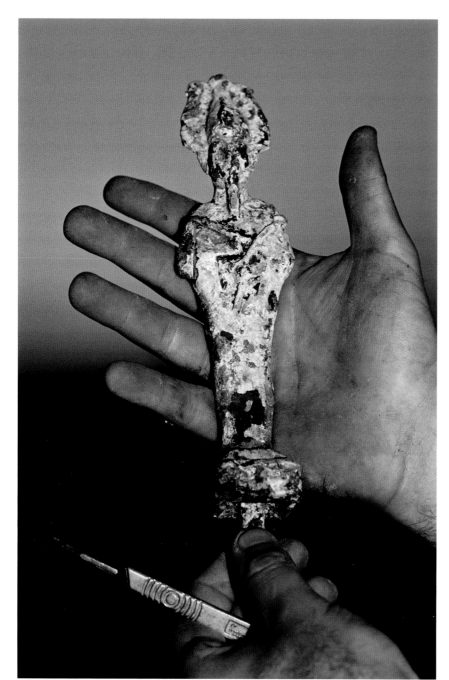

A bronze statuette of
Osiris – left, as thè divers
found it; below, after desali-
nation and restoration

trefaction does not exist on the seabed. Over the millennia, metals, stone and other organic materials have come to terms with their wet, salty environment and achieved a kind of inner balance. Saturated with saltwater, covered with sediment, wooden objects, for instance, preserve their stability, whereas those made of stone or ceramic become encrusted with barnacles, coral and other marine organisms, whose calcium carbonate skeletons protect the objects from mechanical damage.

Once the finds are taken out of the water, however, they come into contact with the air and that balance is promptly destroyed. Wood begins to rot, for example, and the inner structure supported by the water caves in, leaving ancient carvings, part of a stanchion, or a piece of ship's decking irretrievably lost. Metals – with a single exception, that of gold – corrode quickly and are eaten away by the salt. Bronze, for instance, can be entirely destroyed. And in the case of stone or ceramic objects, when the water evaporates, the salt crystals can cause dangerous cracks that may split the material.

That is why cleaning, stabilising and conserving the finds calls for great experience and a keen sense of the right moment from the restoration team. Any mistake made in the treatment of the objects can lead to irreparable damage and, in the worst case, to complete destruction.

There are also strict ethical principles to be observed. These include the methodical preliminary analysis and painstaking documentation of every step in the work process. The treatment of an object must also be restricted to the reconstitution of a certain historical state or aesthetic appearance. This means that it is permissible for the restorers to piece together the fragments of a shattered statue, but not to substitute its missing nose as they see fit.

A collection of colourful, water-filled plastic basins is arrayed on the upper deck of the Princess Duda. One of them contains a sacrificial bowl, pieces of amphorae and ceramic sherds; in another, there are metal rings and fragments of small figurines. In the basin alongside, there's a finely wrought marble object with a wooden core, and a fourth is filled with animal bones. Angélique Laurent is crouching between the basins, taking photos. Laurent is a conservator. Before joining Goddio, she had spent two decades working for museums in Paris, for the Louvre and the Musée d'Orsay, and she had also worked as a curator in Qatar and for UNESCO in Afghanistan.

All of the finds, whether a coin, stone headrest or bronze figure, were put straight into the water after being registered for

173

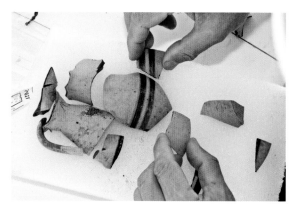

Still on board the Princess Duda, the finds are carefully cleaned of coarse encrustations (left) and the sherds of broken ceramics laboriously pieced together (right).

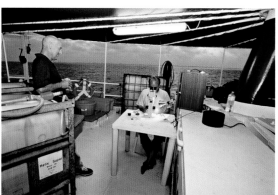
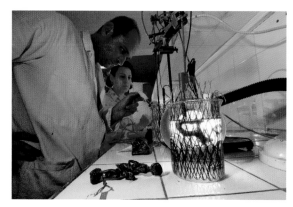

A microscope (left) is one of the pieces of equipment available to the restoration team on the aft deck of the excavation ship. More complicated jobs, such as cleaning metal objects in electrolysis baths (right, a small bronze statuette of the god Anubis), are reserved for the lab.

In the restoration lab of the Maritime Museum in Alexandria, the artifacts raised from the seabed must first spend weeks in a desalinisation tub before they can undergo further treatment, chemical or mechanical.

lengthy desalination, says Laurent. This takes place according to the laws of osmosis. The freshwater molecules like to move to where the concentration of salt is highest, while the salt moves in the opposite direction. The water in the tubs on board the Princess Duda has to be changed as frequently as the process of osmosis requires.

It is a complicated process in which metal objects, coins and figures can only be immersed with others of their kind: silver always with silver, conservator Laurent explains, never, for example, in the same water as bronze. Some objects are additionally at risk from an invisible foe: bacterial contamination. A silver preparation, which Laurent adds to the water in the tubs in precise doses, helps to combat this. Other objects are barely recognisable as such and can only be identified once they have been carefully freed of shells, barnacles and calcium deposits.

Sitting at a wooden table a couple of steps up from the watering tubs is archaeologist Catherine Grataloup, an acknowledged expert on ancient ceramics. Lying on the table in front of her are sherds she has taken from the tubs. She is dating the fragments, identifying and correlating them so that she can perhaps piece them together to form a vessel once they have been treated.

From the sherds, Grataloup draws their stories. One clay fragment, for example, was once part of the handle of a wine amphora, she says, pointing to a barely visible stamp: the amphora was imported, produced on Rhodes and shipped to Thonis-Heracleion. Then the archaeologist pulls over two sherds of black pottery. She recognises their Ptolemaic design, which actually imitated far older Greek forms – ancient Egyptian retro. To preserve the black colour, the potter had fired the vessel in a reducing atmosphere. Grataloup takes a photo, enters her findings in the database and puts the sherds back in the water.

Laurent's workplace is on the quarterdeck – a wooden board supported by two trestles with three panels of chipboard to shield it from the wind. It's a workplace with a view – on the horizon, the chimneys of refineries and power stations and the high-rise blocks of Aboukir; on the sea, fishing boats and small, wooden ferries sailing past. Laurent's tools are laid out on the table like surgical instruments. A pneumatic mini-chisel, scalpels, brushes, tiny hammers alongside a binocular or stereo microscope. The piece she has selected for cleaning might once have been a bowl, but now it is covered over and over with barnacles. As ever, she is curious to know what will come to light.

She taps it gently with a tiny hammer, applies the chisel and scrapes at the surface with a scalpel – this is a job that can take

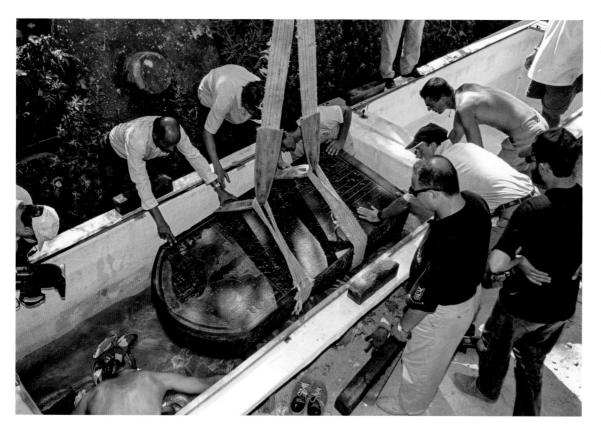

In the Roman theatre in Alexandria, the granite stele of Nectanebo found in Thonis-Heracleion is lowered into a specially built desalination basin.

The recovered fragments of the Naos of the Decades are coated with silicone to produce an impression of its surface that is correct in every detail.

176

hours. When she's finished, she has uncovered a ceramic dish that is thousands of years old. It needs to go straight into a watering tub. It's easy to get salt out of ceramics, Laurent explains, because they are porous, so they have plenty of space for molecular exchange. It can sometimes take years, however, for metals and stone statues to be cleansed to the core.

After their initial treatment on board the research ship, the finds, still immersed, are sent to Alexandria. Their destination is situated in a side street near the city centre and hidden behind a wall: it's the conservation laboratory. This is Laurent's second workplace. Along with the head of the lab, chemist and conservator Tahany Moustafa, she can now devote herself to giving the retrieved objects the intensive treatment they need.

A bright, oblong room, with a white, tiled workspace along all four walls. On an old wooden shelf near the door, there are some bottles containing chemicals: hydrochloric acid alongside ethanol, and beneath them, plastic pots containing bicarbonate of soda and an acrylic solution. Ancient artifacts owe their revival largely to chemical reactions.

The finds are now transferred to transparent plastic containers, one for each item and closable to guard against contamination. Some of the objects first have to be cleaned, either mechanically with the conservation team's surgical instruments or in the electrolysis bath depending on their condition and material. Then they also go into their isolation tub for final desalination.

Every single object requires its own individual therapy, Moustafa explains, depending on its material, condition and where it was found. Wood is particularly tricky, and the most difficult artifacts are those in which wood is combined with metal or marble. The water in the containers is distilled and so initially free of salt. This allows the conservators to measure precisely how much salt has already been extracted from the objects by osmosis. By regularly renewing the water, they can very slowly but steadily reduce the amount of salt. Not until there are only roughly 15 salt particles in a million water molecules can the experts begin the drying procedure.

Not every object that comes out of the sea takes kindly to a human extracting its moisture, however, so stone objects, for example, which are susceptible to weathering, are infiltrated with an acrylic resin to make them more resistant. Ceramic sherds, on the other hand, may crack or shatter if they are dried out too quickly. And in wood, the water is gradually substituted by a special resin that prevents its collapse so that it survives the deprivation.

177

The history of a find. In 2015, Goddio's divers discovered this roughly 2,400-year-old statue of Aphrodite.

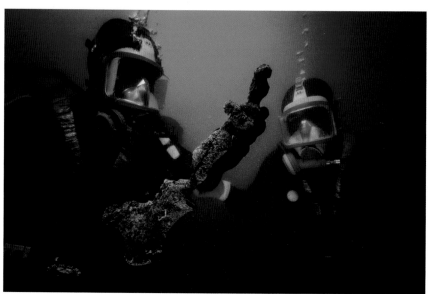

They brought the figurine of the Greek goddess of love carefully on board the excavation ship.

The bronze statuette was
encrusted with a solid
layer of deposits. After
painstaking restoration,
she now displays all her
original grace and charm.

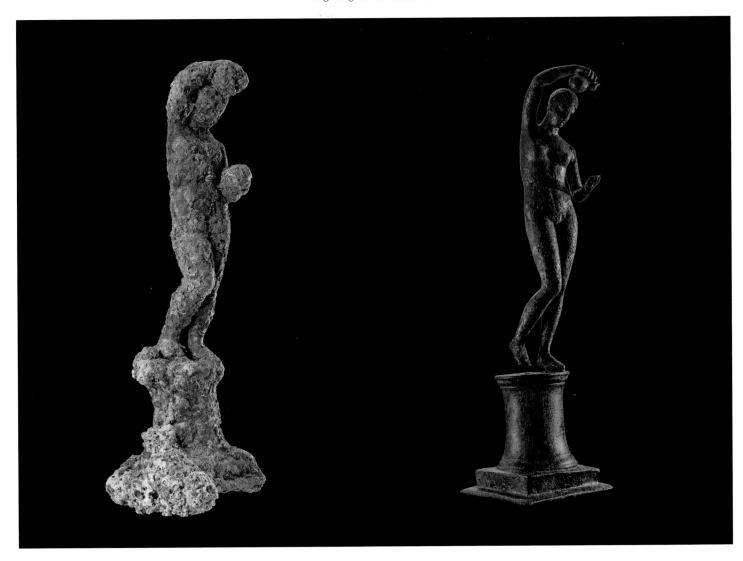

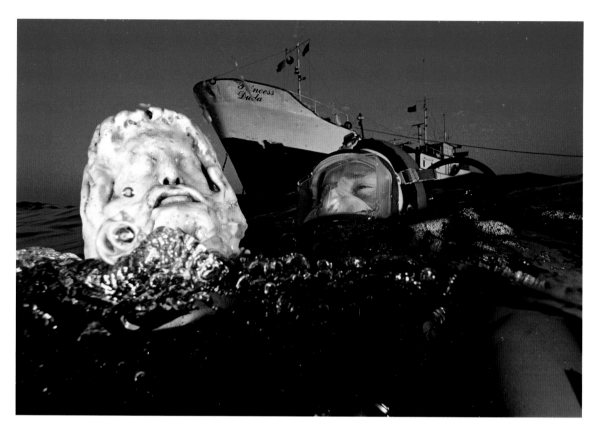

The conservators are already waiting. The head of the god Serapis that was found in Canopus on its way to the Princess Duda.

Metals are treated with chemical solutions to eliminate the effects of corrosion. Afterwards, the conservators treat the bronze vessels, iron dagger and dainty silver dishes using tiny diamond cutters, glass-fibre brushes and ultrasonic scalpels – sometimes over a period of several days, mostly peering through a stereo microscope, until at last the precious pieces again look as near as possible to how they originally looked. A fine coating of wax applied at the end of the procedure protects their surface from contact with air and moisture. Earthenware and ceramic fragments can also only be pieced back together again as pitchers, dishes and amphorae once they have completely dried out.

Then, like all the other objects, they are transferred to the building next door: the interim store. There they lie on high shelves, carefully arranged according to their place of origin and material, along with the statue of Pharaoh Sethos I, father of Ramses II, who ruled in Egypt around 3,300 years ago; the bronze statuette of the goddess Isis and her brother-husband Osiris, the god of the afterlife and reincarnation; with lead votive barques, and with three small limestone coffins that were found in Thonis-Heracleion. Mummies of ibises and falcons, both sacred creatures to the Egyptians of the pharaonic kingdom, were once laid to rest in these. The coffins were found at the small shrine dedicated to Khonsu on the temple island; the god was often depicted with the head of a falcon.

The stone royal couple from Thonis-Heracleion has found a new home in the laboratory grounds, and this is where they return to from their extensive travels to museums and exhibitions in Paris, Berlin and London; from Japan or the USA. It was some time, however, before the two were in a fit state to be transported. Desalination in the watering basins alone took ten months. Then they were pampered and cared for by a royal household of conservators, stone specialists, metal technicians, engineers and ultimately a carrier with expertise in handling sensitive art. The granite statues had not been retrieved in their entirety, after all, but in pieces: the head of the pharaoh was separated from the body, the legs of the statues were broken, the queen was without her crown, the sun disk between the horns of the Hathor cow, the symbol of her divinity. Even today, the 4.90-metre statue is still missing its right arm.

In order to make the statues look as they must have looked when they stood in the square before the Temple of Amun-Gereb more than 2,000 years ago, their broken bodies are lashed onto specially built sledges so that they can be pieced together horizontally. The cracks in the stone are stopped with a cement of

A bronze statuette of
a pharaoh, excavated
in Thonis-Heracleion

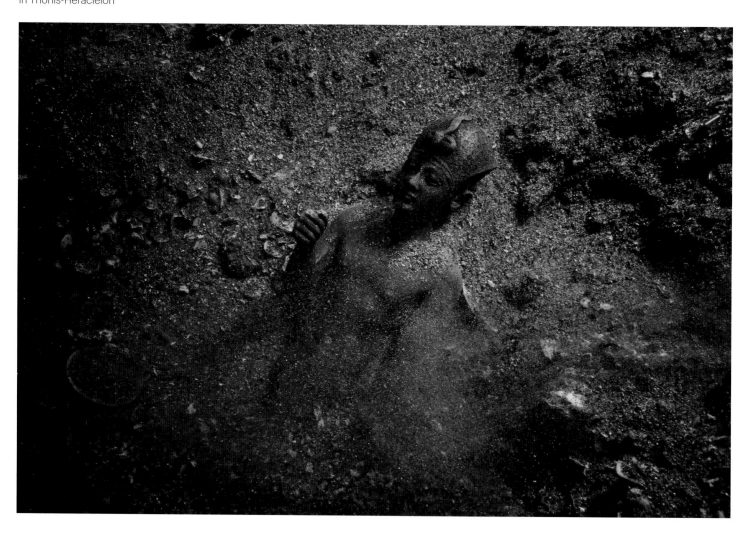

reversible resin and granite powder, then the statue fragments are precisely measured before holes are drilled in them to take stainless steel dowels and pins. This way, the pieces can be taken apart again if necessary. So that they can be erected and kept standing, each of the monumental statues is fitted with its own, made-to-measure exoskeleton, a steel corset that supports the statue's back.

Then one evening in Alexandria, the Ptolemaic pharaoh and his queen are finally permitted to stand erect once more after an eternity spent in the horizontal, millennia in a watery grave. A crane provides assistance. The queen slowly rises, followed by the pharaoh, so that they stand next to one another again, their eyes gazing towards the evening lights of the city.

Franck Goddio has travelled in especially for the event. He follows the work in silence. Only when both figures are standing safely, does he find words. "This here," he says, with a sweeping gesture, "this is the true magic of Egypt."

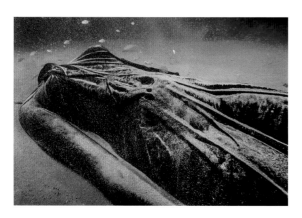

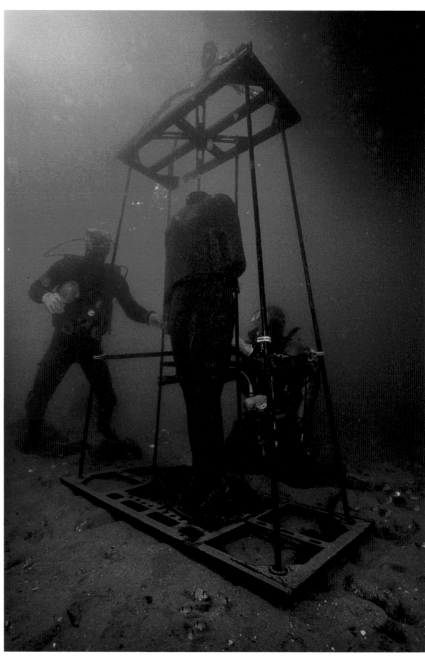

Stretched out on the
seabed: the statue of
Arsinoë, whose head
to this day remains
undiscovered. To be
brought to the surface,
the statue is stood up and
secured inside a frame
while still under water.

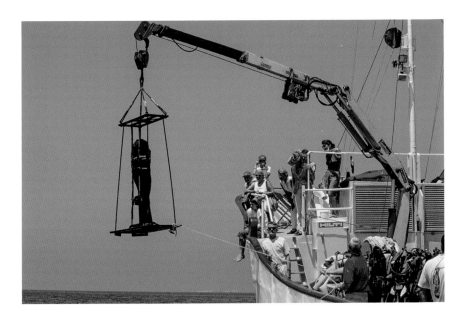

The deck crane hauls
the queen on board ...

... and this is how she looks
today, after restoration.

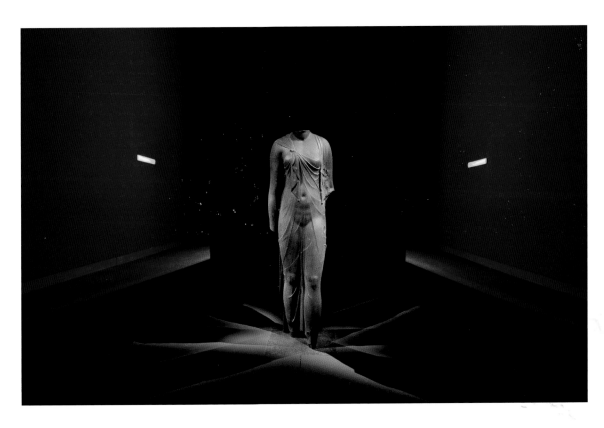

Franck Goddio under
water with a statue of the
Osiris-Canopus. According
to ancient writings, worship
of Osiris in the form of
a vase from which he
appears to rise is particular
to the region of Canopus.

# Franck Goddio on a Task That Gains Significance With Every New Discovery

~~~~~~~~~~~~

Paris in summer. The city is full of tourists, there's not a place to be had in the bars along the banks of the Seine. The queues for tickets at the Louvre are even longer than usual, the restaurants in Montmartre and Le Marais are doing fantastic business. I meet Franck Goddio in his apartment on the first floor of a 400-year-old mansion.

A suite of high-ceilinged rooms with old windows through which we hear the sounds from the street below. In the library, on shelves reaching right up to the ceiling, books on geography, history, archaeology, most of them antiquarian and all in hand-stitched brown leather, stand in well-ordered rank and file. At the far end of the suite, the living room and green plants that seem to be surging out onto the terrace and creating a tiny woodland there. In the middle, there's the drawing room. On the walls, paintings dating from the late 18th century, romantic country scenes, park landscapes. On the mantelpiece, beneath a large mirror squats a Buddha, his gaze stoic, rapt.

At the centre of the room, there's a large table, mid-19th century. The castors must have been highly innovative in those days. So this is where the man of the house discussed his work with the Egyptologist Jean Yoyotte; this is where the historians André and Étienne Bernand explained to him the Ptolemaic Period and Greek politics in ancient Egypt. Among the objects on the table is a box containing the galley proofs for a book, an accompanying volume for the great Osiris exhibition. Goddio leafs through the pages, makes the odd note. When it's a question of his research findings and how they are presented to the public, Goddio is painstaking; not a detail passes him by.

You once said "Every find we make throws up new questions." Isn't that frustrating for a researcher, an explorer: you are looking for answers and instead find yourself faced with the next question?

No, not frustrating. It's a game that is never over, a never-ending challenge. But that is actually the fate of all archaeological excavations, that is the nature of all scientific research: you frequently find an answer to a question only to discover that, unfor-

187

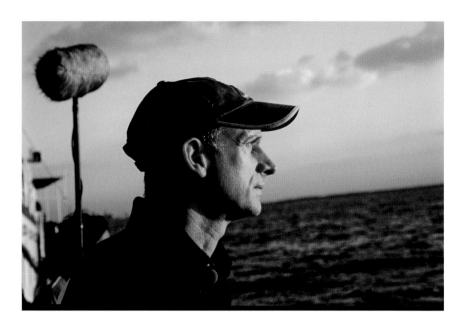

Franck Goddio

Goddio's catamaran
the Kaimiloa

tunately, it does not fully solve the problem – and that everything is even more complicated than you thought.

The ancient harbour of Alexandria, the palace on Antirhodos, the Serapeum in Canopus, the Amun-Gereb temple and the three monumental statues from Thonis-Heracleion – any other archaeologist in the world would be overjoyed to have made just one of these finds ...

Ah yes, but these things were not what I was really after. It sounds strange perhaps, but we recently found a cultic object that was used in the Osiris ceremonies. That electrifies me far more than, let's say, discovering a city. It's how things are related, the knowledge of what, for instance, such processions consisted of, that interest me. Discovering a city is fantastic. But it is far more satisfying to find out what went on in that city. It's like wandering through an area and finding a house that isn't marked on any map. You look at it, think it's interesting, well-built – but empty, deserted. Then you open a door and see all of the things the inhabitants left behind. And from then on things gets really exciting because from the objects you form an impression of the people who once lived there – how they worked, what they believed in, how they behaved towards each other. It's exactly the same with archaeology – discovering those things is really what makes it so fascinating.

But you will probably have to live with the reputation of being the man who discovered Alexandria's palace island and the sunken city of Thonis-Heracleion ...

I would far prefer to be recognised for *how* we found it and *why* we found it. Our method was what was really new about the research. And the fact that we always exhibit the finds, too; that we present them to public. That is very important to me.

Isn't it sometimes rather a shame that you cannot show all of the buildings, temples and public squares that you uncovered underwater?

Perhaps we will someday have the chance to reconstruct one of the smaller monuments on land. This little tholos, for example, the round temple we discovered in Heracleion in 2015, very many parts of which we found in good condition. They could be gradually raised and the temple reconstructed. But to do so, we would have to uncover far more than we have so far. The ruins of the large monuments on the seabed will remain underwater, though.

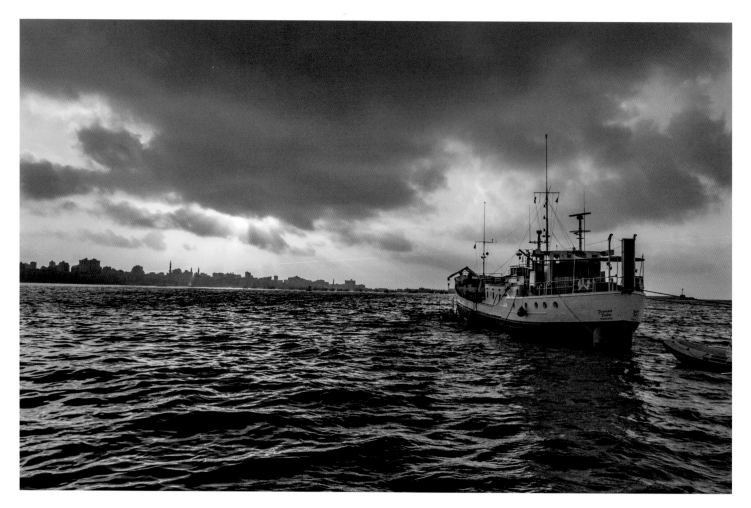

The excavation vessel
Princess Duda heading
for Alexandria

Lost forever.

No, they are not lost, they are there! They will simply soon be covered by sediment once again – and no one will ever be able to see them. They will be invisible again, so to speak. The sand is an equaliser, it levels everything.

And I would love to have a museum for all of the artifacts that we retrieved from the Portus Magnus of Alexandria, from Thonis-Heracleion and from Canopus. Alexandria, a city with four-and-a-half million inhabitants, would be a fitting place for such a museum. And it would be even better if that museum could also show people some of the things we had to leave below the waves. The best thing would be to build an underwater museum over the submerged island of Antirhodos. Technically, that would be possible, and it would be a real attraction. There is nothing of the kind anywhere in the world.

When do you think the time will come when you can say: my work in Egypt is over, I have finished now?

That is not an easy question to answer. Everything has become so much bigger. To begin with, I had a goal – and when that had been achieved, the next one had already presented itself. The more we uncover, the more we learn. When I look at these three excavation sites today, I realise just how much more we have to learn than I originally imagined we could ever learn. My list of questions is now much longer than at the start of our research. What conclusions can we draw from the everyday objects we have found? What purposes did the harbour basin serve? What did the rituals consist of? There are so many questions we originally never expected to encounter.

Is there anything else you hope to find at these excavation sites?

No. These places are what I had hoped to find – and I have found them. Now we are looking at the details. Each of these monuments – the Amun-Gereb temple in Thonis-Heracleion, the Serapeum in Canopus, Antirhodos in Alexandria – could fill the entire life of an archaeologist. I suspect that their research will be never-ending.

Epilogue
Sir Barry Cunliffe

~~~~~~~~

Michael Hilti, without your farsightedness, little of the remarkable work of discovery outlined in this book would have been possible. Your constant support, through the Hilti Foundation, has enabled Franck Goddio and his team to put before the world a picture of Egyptian life, on the edge of the Mediterranean, in a detail and with a vividness that few could even have begun to imagine a few decades ago.

From the moment you met Franck Goddio in Tulsa, Oklahoma in 1994 you were inspired, as we all are, by his brilliance and infectious enthusiasm, but you had the wisdom then to see that if Franck's vision was to be realised in full he had to be supported long term, not only technically but with sufficient means to present his stream of astonishing finds to the general public, eager to be kept informed by the most recent archaeological discoveries, and to make the record permanently available in the academic literature for future generations of scholars. Without these two essential strands of outreach, archaeological discovery remains little more than self-indulgence.

To help Franck put his work before a worldwide public you saw at the outset that he needed the services of a professional public relations organisation. The selection of salaction was inspired and the results have been spectacular. Not only have magazine articles been written and television films produced, but major exhibitions have been staged across the world, most recently *Sunken cities: Egypt's lost worlds* at the British Museum, each with its own beautifully illustrated catalogue. You also understood the needs of the scholarly world in wishing to see the underwater structures and the tens of thousands of associated artifacts published in detail – research which would need the input of large numbers of specialists. In considering a university to work in collaboration with Franck to achieve this you approached the School of Archaeology at Oxford. I have a very fond memory of the dinner we attended in 2003, hosted by the Vice Chancellor of the University, to celebrate our agreement to work together. The Oxford Centre for Maritime Archaeology, which the university set up with the support of the Hilti Foundation, has gone from strength to

strength, organising conferences, training postgraduates to study and to publish finds recovered from the Egyptian sites, and producing a distinguished series of publications.

Michael, just over 20 years ago you saw the enormous potential of Franck's vision for underwater archaeology and immediately understood what was needed to enable it to happen. We all, the public who avidly follow archaeology and the academic world whose business it is, owe you an enormous debt of gratitude. Without your foresight the study of underwater archaeology would be the poorer. We hope these essays go some way in expressing the esteem in which you are held by us all.

Sir Barry Cunliffe CBE
  Emeritus Professor of European Archaeology,
  University of Oxford

# Bibliography

**Historical Sources**

Diodorus Siculus. *Bibliotheca Historica:* penelope.uchicago.edu/Thayer/E/Roman/Texts/
Diodorus_Siculus/home.html
Herodotus. *Historica, Book II:* www.gutenberg.org/
Strabon. *Geographika:* www.chufu.de/ und www.perseus.tufts.edu/hopper/,
Perseus Digital Library

**Books**

Anne-Sophie von Bomhard. 2012. *The Decree of Säis, the Stelae of Thonis-Heracleion and
Naukratis,* Oxford Centre for Maritime Archaeology Monograph Series
Walter M. Ellis. 1994. *Ptolemy of Egypt,* Routledge, London
David Fabre. 2004/2005. *Seafaring in Ancient Egypt,* Periplus Publishing, London
Franck Goddio. 2005. *Versunkene Schätze,* Konrad Theiss Verlag, Stuttgart
Franck Goddio (ed.). 2006. *The Topography and Excavation of Heracleion-Thonis and East
Canopus,* Oxford Centre for Maritime Archaeology Monograph Series
Franck Goddio / Manfred Clauss (eds.). 2007. *Ägyptens versunkene Schätze,* Prestel Verlag,
Munich
Franck Goddio / David Fabre. 2015. *Osiris – Egypt's Sunken Mysteries,* Flammarion, Paris
Franck Goddio / Damian Robinson (eds.). 2015. *Thonis-Heracleion in Context,*
Oxford Centre for Maritime Archaeology Monograph Series
Günter Grimm. 1998. *Alexandria,* Verlag Philipp von Zabern, Mainz
Carl Richard Lepsius. 1866. *Das bilingue Dekret von Kanopus,* Wilhelm Hertz, Berlin:
www.digitalisierungszentrum.de/
Siegfried Morenz. 2009. *Egyptian Religion,* Reprint, Routledge, London
Damian Robinson / Andrew Wilson (eds.). 2011. *Maritime Archaeology and Ancient Trade in
the Mediterranean,* Oxford Centre for Maritime Archaeology Monograph Series
Damian Robinson / Andrew Wilson (eds.). 2010. *Alexandria and the North-Western Delta,*
Oxford Centre for Maritime Archaeology Monograph Series
Jean-Daniel Stanley et al. 2007. *Geoarchaeology,* Oxford Centre for Maritime Archaeology
Monograph Series

**Articles and Scientific Publications**

Adel E. Abdelnaby. "Integrity Assessment of the Pharos of Alexandria during the AD 1303
Earthquake", *Engineering Failure Analysis,* Vol. 33, 10/2013
Lars Abromeit. "Atlantis am Nil – Die versunkene Hafenstadt der Pharaonen", *GEO,* 10/2014
Alexander Belov, *Navigational aspects of calling to the Great Harbour of Alexandria,*
Centre for the Egyptological Studies, 2014: halshs.archives-ouvertes.fr/
halshs-00845524
Alexander Belov, "New Evidence for the Steering System of the Egyptian Baris", *The Inter-
national Journal of Nautical Archaeology,* 2014
Ibrahim Darwish / Mohamed Mostapha Abd-el-Maguid. *Underwater archaeology in Egypt,*
Tropis VII: Seventh International Symposium on Ship Construction in Antiquity,
Greece, 1999

Amy Elshaarawy. *The Mapping of Alexandria – Mahmoud El Falaki's Legacy,* Newsletter Bibliotheca Alexandrina, 11/2008 – 01/2009

Anja Herold. "Herakleion – Die Auferstehung der Götter", *GEO,* 01/2002

Anja Herold (conception). "Das Alte Ägypten", *GEO EPOCHE,* No. 32, Hamburg 2008

Lucas Livingston. *Greek and Egyptian Religious Parallels,* www.artic.edu/~llivin/research/greeks_egyptian_gods/

Bertrand Millet / Jean-Philippe Gioran. "Impacts of Alexandria's Heptastadion on coastal hydro-sedimentary dynamica during the Hellenistic period", *The International Journal of Nautical Archaeology,* 2006

Steve Mirsky. "Cleopatra's Alexandria Treasures", *Scientific American,* January 31, 2010

N. N., "Weltwunder in der Kloake", *Der Spiegel,* 46/1996

N. N., "Herrscher der bewohnten Erde", *Der Spiegel,* 44/1997

Diamantis Panagiotopoulos. 2005. "Chronik einer Begegnung – Ägypten und die Ägäis in der Bronzezeit", in: *Ägypten, Griechenland und Rom. Abwehr und Begegnung*

Jens Rehländer. "Duell um ein versunkenes Königreich", *GEO,* 11/1998

Judith Reker. "Der Schatzmeister", *mare,* No. 36, 02/2003

Yvonne Stolz. 2006. *Kanopus oder Menouthis? Zur Identifikation einer Ruinenstätte in der Bucht von Abuqir in Ägypten,* lecture, Berlin

Omar Toussoun. 1934. "The Submerged Ruins of the Bay of Aboukir", *Bulletin de la Société Royale d'Archéologie d'Alexandrie,* No. 29, 1934, in: *Prince Omar Toussoun and His Archaeological Legacy,* Bibliotheca Alexandrina, www.bibalex.org

Jean Yoyotte. 2000. *Das Naos der Dekaden,* www.aegypten-online.de/special/aboukir/naos.htm,

Tobias Zick, *Götterdämmerung – Ein untergegangener Kultort erwacht, GEO,* 05/2006

## Websites

*Ägypten – Land am Nil,* www.chufu.de/

*Alexandria Bibliography,* www.classics.uc.edu/~vanminnen/Alexandria/Ancient_Alexandria.html

*Das Altägyptische Totenbuch,* Digitales Textzeugenarchiv der Universität Bonn, totenbuch.awk.nrw.de/

*Das Alte Ägypten,* www.aegypten-geschichte-kultur.de/

*Franck Goddio,* www.franckgoddio.org/projects/sunken-civilizations/introduction.html

*Geschichte Ägyptens,* www.aegypten-online.de/geschichte-aegypten.htm

*Hilti Foundation,* www.hiltifoundation.org

*Institut Européen D'Archéologie Sous-Marine,* www.ieasm.org

*Oxford Centre for Maritime Archaeology,* www.arch.ox.ac.uk/ocma.html

*Supreme Council of Antiquities,* www.sca-egypt.org/eng/sca_history.htm

*UNESCO Network for Underwater Archaeology,* underwaterarchaeology.net/

| Old Kingdom 2700–2200 | | Middle Kingdom 2033–1710 | | New Kingdom 1550–1069 | | Late Period 664–332 | |
|---|---|---|---|---|---|---|---|

〜〜〜〜〜〜〜〜〜〜〜〜〜〜〜〜〜〜〜〜〜〜〜〜〜〜〜〜

**1st Intermediate Period** *2200–2033*   **2nd Intermediate Period** *1710–1540*   **3rd Intermediate Period** *1069–664*   **Ptolemaic Period** *332–30*

## New Kingdom

**XIXth dynasty** *1295–1186*
*Ca. 1183 Trojan War (according to tradition). Legendary visit of Helen of Troy and Menelaus, King of Sparta, brought into the Nile Delta by Canôpos.*

## 3rd Intermediate Period

**XXIst dynasty** *1069–945*
*Division of Egypt into two. Tanis capital under Psusennes I.*
**XXIInd dynasty** *945–715*
**XXIIIrd dynasty** *818–715*
**XXIVth dynasty** *727–715*
*Saite dynasty, resistance to the Kushites of Tefnakht and Bocchoris. 8th century: foundation of Thonis-Heracleion. Homer writes the Iliad and the Odyssey.*
**XXVth dynasty** *780–656*
*Kushite or Ethiopian dynasty. Empire of the kings of Napata (Shabaka, Taharqa, Tanutamun); artistic renaissance, opposition to the Assyrians in Asia.*
*671 Conquest of northern Egypt by Assarhaddon, Memphis taken.*
*664 Assyrian conquest (pillage of Thebes), followed by retreat after conclusion of an alliance with the Saite princes.*

## Late Period

**XXVIth Saite dynasty** *664–525*
*Egypt reunited under King Psamtic I; Memphis becomes the capital again; Greek influence, cultural and artistic traditionalism; economic development, rising Persian menace.*
• **Psamtic I** *664-610*
• **Nekau** *610-595*
• **Psamtic II** *595-589*
• **Wahibre (Apries)** *589-570*
• **Ahmose II (Amasis)** *570-526*
• **Psamtic III** *526-525*
*6th century: visit by Solon the Athenian.*
**XXVIIth dynasty** *525-404*
*(first Persian occupation)*
*Egypt becomes a Persian province (satrapy).*
• **Cambyses** *525-521*
• **Darius I.** *521-485*
*Digging of the channel of the Red Sea.*
• **Xerxes** *485-464*
*450 Herodotus of Halikarnassus visits Egypt; his Book II of The Persion Wars describes Egypt.*
• **Artaxerxes I** *464-423*
• **Darius II** *423-404*
**XXVIIIth Saite dynasty** *404-399*
• **Amyrtaeus** *404-399*
**XXIXth dynasty** *398-379*
• **Nefaarud I** *398-379*
• **Haktor** *392-379*
• **Nefaarud II** *378*
**XXXth dynasty** *378-341*
*Last independent dynasty; consolidation of royal power.*
• **Nakhtnebef I** *378-361*
• **Djedhor** *360-359*
• **Nakthoreb II** *358-341*
**Second Persian occupation** *340-332*

## Ptolemaic Period

• **Alexander the Great** *332-323*
*331 Alexander founds Alexandria. The economies of Thonis-Heracleion and Canopus decline but they continue as sanctuaries.*
*323 Alexander dies at Babylon. His body is buried in Alexandria.*
*323-305 Ptolemy, one of Alexander's generals and satrap of Egypt, becomes pharaoh Ptolemy I Soter and creates the Lagid dynasty.*
• **Ptolemy I Soter** *305-282*
*Organisation of the cult of Serapis, creation of the Great Library and the Museum at Alexandria.*
• **Ptolemy II Philadelphus** *283-246*
*283 Inauguration of the lighthouse, one of the seven wonders of the Ancient World. Construction of the Heptastadion and the palace district.*
• **Ptolemy III Euergetes I** *246-222*
*(Re)-foundation of the temple of Heracleion.*
*238 Decree of Canopus.*

## Roman Period
*30 BCE – 395 AD*

## Arab and Ottoman Period
*641–1798*

## Byzantine Period
*395–641*

## Modern Egypt
*1798–*

### Ptolemaic Period

• **Ptolemy IV Philopator I** *222–205*
• **Ptolemy V Epiphanes** *205–180*
*196 Decree of Memphis
(the Rosetta Stone).*
• **Ptolemy VI Philometor** *180–145*
• **Ptolemy XII Neos Dionysos
Auletes** *80–51*
*60 Visit by Diodorus Siculus.*
• **Ptolemy XIV Philopator II** *47–44*
• **Ptolemy XV Caesar
(Caesarion)** *44–30*
• **Cleopatra VII** *51–30*
*48–47 Caesar re-establishes
Cleopatra VII on the throne. War of
Alexandria. Great fire.
44 Caesar assassinated.
41-31 Mark Anthony and Cleo-
patra VII reorganise the Orient with
Alexandria as capital.
40 Mark Anthony settles in
Alexandria.
34 Mark Anthony celebrates his
triumph in Armenia.
31 Octavian wins the Battle of
Actium.
30 Mark Anthony and Cleopatra
commit suicide. Murder of the
17-year-old Caesarion.*

### Roman Period

*30 BCE. Octavian in Alexandria.
Egypt becomes a Roman province.
Strabo visits Egypt.*
• **Julio-Claudian dynasty** *27 BCE –
69 AD*
• **Augustus** *27 BCE – 14 AD*
• **Flavian dynasty** *69–96*
*70 Plutarch stays in Egypt.*
• **Antonine dynasty** *96–192*
• **Hadrian** *117–138*
*125–134 Construction of Hadrian's
villa at Tivoli in Italy as a replica of
the Serapeum of Canopus.
130 Hadrian in Egypt.*
• **Marcus Aurelius** *161–180*
*170 Claudius Ptolemy dies at
Canopus.*
• **Constantinian dynasty** *306–364*
• **Constantine I the Great**
*306–337*
*323 Saint Pachomius, one of the
"fathers of the desert", establishes
an order of monks near Canopus.
330 Constantin I founds Cons-
tantinople, the new capital of the
empire in the Orient.*
**Valentinian and Theodosian
dynasties** *364-455*
*371 Invasions of the empire by
barbarian tribes including Huns,
Goths and Vandals.*
• **Theodosius I
(emperor in the Orient)** *378–395*
*391 Theodosius I declares Chris-
tianity the official religion of the
empire and decrees the closing of
pagan temples. Destruction of the
Serapeia of Alexandria and Cano-
pus and creation of a Christian
monastery dedicated to Saint John
Chrysostom and Saint Cyril.*

### Arab and Ottoman Period

**Abasside Caliphate** *750–969*
*8th century. Successive natural
catastrophes end up swallowing
Heracleion, Canopus and the
grand harbour of Alexandria.*
**Mamelouk Sultanate** *1250–1517*
*1300: An earthquake destroys the
Alexandria lighthouse.*

### Modern Egypt

*1798–1801 Napoleon Bonaparte's
Egyptian expedition. Battle of the
Nile.
1805–1952 Autonomous kingdom
under British protectorate.
1828-1829 Champollion's scientific
mission.
1933 Prince Omar Toussoun begins
to explore the Bay of Aboukir.
1952 Proclamation of the Arab
Republic of Egypt.
1992 IEASM starts electronic
survey which should lead to the
re-discovery of the sunken ruins of
Alexandria's grand harbour and – in
1999 and 2001 – to the localisation
of the cities of Thonis-Heracleion
and Canopus.*

## How This Book Was Made
## Gerhard Steidl

~~~~~~~~~~~~~~~~~~~~

The typeface: Graphic Light.
The photographs: Christoph Gerigk's digital photographs were separated for the CMYK process by Steidl's digital darkroom. Colour calibrations and proofs were made with software from GMS, Munich.
Printing: Sonora XP chemical-free, computer-to-plate printing plates from Kodak.
Highly pigmented inks from Jänecke+Schneemann, Sehnde.
Printed by Gerhard Steidl, Göttingen.
The paper: BVS Matt 170 g from Scheufelen, Lenningen.
"F-Color glatt" endpapers from Gebr. Schabert, Strullendorf.
Binding: Headband from Güth & Wolf, Gütersloh.
Colour foil for embossing from Kurz Stiftung, Fürth.
Binding by Lachenmaier, Reutlingen.

All suppliers of materials for this book are based in Germany.